The Elements of Photography

FOR CLAY (... as in dirt, mud, pottery, sand...) WHEREVER YOU ARE.

THE ELEMENTS OF PHOTOGRAPHY

Understanding and Creating Sophisticated Images

ANGELA FARIS BELT

AMSTERDAM • BOSTON • HEIDELBERG • LONDON
NEW YORK • OXFORD • PARIS • SAN DIEGO
SAN FRANCISCO • SINGAPORE • SYDNEY • TOKYO

Focal Press is an imprint of Elsevier

ELSEVIER

Focal
Press

Acquisitions Editor: Diane Heppner

Developmental Editor: Valerie Geary

Publishing Services Manager: George Morrison

Project Manager: Kathryn Liston

Assistant Editor: Doug Shults

Marketing Managers: Christine Degon Veroulis

Cover and Interior Design: Joanne Blank

Focal Press is an imprint of Elsevier

30 Corporate Drive, Suite 400, Burlington, MA 01803, USA

Linacre House, Jordan Hill, Oxford OX2 8DP, UK

∞ Recognizing the importance of preserving what has been written, Elsevier prints its books on acid-free paper whenever possible.

Library of Congress Cataloging-in-Publication Data
Application submitted

British Library Cataloguing-in-Publication Data

A catalogue record for this book is available from the British Library.

ISBN: 978-0-240-80942-7

For information on all Focal Press publications visit our website at www.books.elsevier.com

08 09 10 11 12 10 9 8 7 6 5 4 3 2
Printed in China

Contents

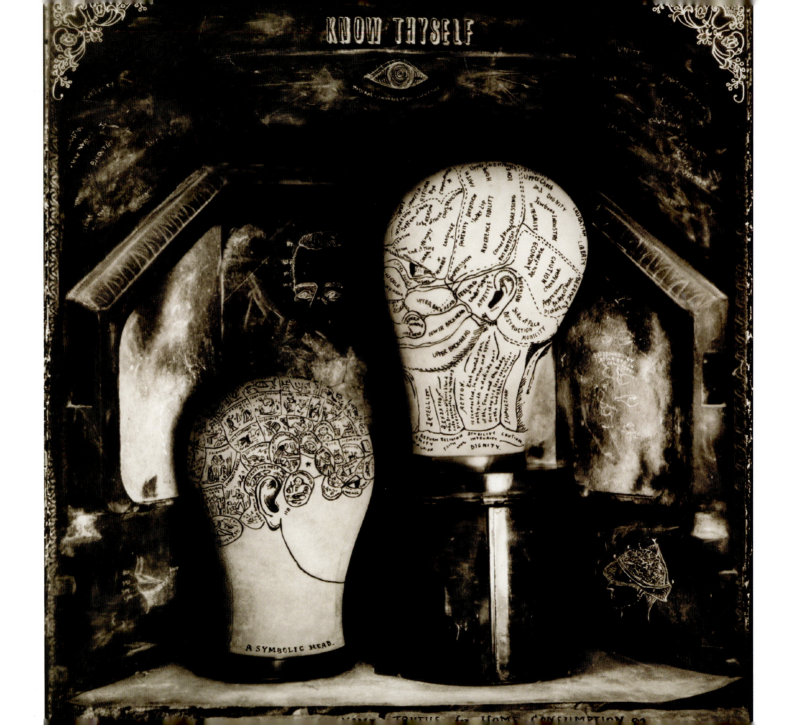

"One fact that is not in dispute is that there is a widening gulf opening up between art and commercial photography, between professors and professionals."
—Bill Jay in *Occam's Razor*

It is no new observation that throughout the history of photography its practitioners have been segregated into one of two distinct disciplines, professional or fine art practices. That this self-conscious distinction creates limitations for practitioners on both sides is evidenced by the large percentage of fine artists who attempt more or less successfully to support themselves in the professional fields and an equal percentage of professionals who vie for acceptance of their art work in galleries. The separation of photographic practices is perpetuated through a higher education system in which the overwhelming majority of photography programs emphasize one of the two disciplines: technical education (the goal of which is to train students to become successful professional photographers) or fine art practices

(whose primary structure prepares students for success as fine artists). Although ideal in many respects, the system's inherent drawback is that while the marketplace offers vast opportunities for both professionals and fine artists, academia's singular-focus approach limits graduates' chances of success, and inhibits the useful carry-over of techniques and ideas from one discipline to the other.

College photography programs situated within Technical Schools (those offering degrees in commercial, editorial, consumer portraiture, etc.) tend to organize curricula around the mechanics of the medium, producing graduates whose images demonstrate skilled craft and technical proficiency. Adept at using the most complex, state-of-the-art equipment and materials, the best graduates of these programs produce images demonstrating feats of technical perfection with eye-catching style. However, many of their best photographs lack any substantive meaning, and at worst their images miscommunicate, because these

IMAGE © CAROL GOLEMBOSKI, *OBJECT LESSON IN HEADS*, 2004.

photographers are undereducated in the areas of photography and art history, visual literacy, critical theory, and aesthetics. These indispensable aspects of photographic study simply do not permeate most technical school curricula. As conceptual photographer Misha Gordin states, "The poor concept, perfectly executed, still makes a poor photograph." (See Misha Gordin's work in the Portfolio Pages of Chapter 1.) This fact is not lost on visually literate viewers such as editors, publishers, graphic designers, art buyers, gallery and museum directors and curators, not to mention the media-viewing public. On the other side of the educational spectrum, photography programs situated within Fine Art Departments emphasize the communicative nature of photographs—their content, theoretical and historical positioning, and meaning—but they do so often at the expense of time spent practicing the medium's technical/mechanical side—its equipment and materials and their specifications, benefits, and limitations. The students of these programs produce images filled with intelligence, insight, passion, and depth, much of which is often lost owing to sheer lack of sophisticated technical accomplishment. Again, to quote Misha Gordin, "The blend of a talent to create a concept and the [technical] skill to deliver it," is the necessary balance of ingredients for making successful photographs. I equate fine art photographers who create

technically poor images to poets possessing limited grammatical skills; they may have volumes of insight to share with the world about a subject, but they lack the proper tools needed to successfully convey it to others. Taken to the extreme, the photographers emerging from most photography programs have for decades possessed a completely lopsided perspective of the medium; they practice professional or fine art photography in relative ignorance of the myriad ways the medium's "other half" could inform and enhance their work.

To complicate matters, with the advent and rapid adaptation of digital technology, it seems that a new fissure has been created, this one based on photographic media itself. During the last decade it has come to pass that academic programs have literally begun choosing between two discretely defined light-sensitive media—traditional or digital. This pressure to choose seems largely based on the desire to conform to their particular discipline or industry's media focus, as well as the financial pressures that ultimately come to bear on academic institutions such as faculty areas of expertise, limited time to cover curricular material, and the simple matter of space limitations for either darkroom or digital facilities. Many programs (and practitioners) have rushed too quickly to recommend an either/or approach,

suggesting that the decision to abandon traditional media and convert completely to digital media will advance those leaders who embrace it, and retire those relics who do not. This approach is short sighted in several ways: students tend to learn and practice only the technologies available to them through their academic program, so the richness and diversity of alternative media options go unconsidered. Also, an either/or approach neglects careful examination of the broader potential offered by maintaining *both*. History is full of examples of bad outcomes made so because of decisions that lacked proper *balance*, and there are simply no good reasons for photographic expression to suffer the same.

In addition to photography's polarized academic structure and the advent of digital media, many students unwittingly set themselves up for failure in a particular branch of photography because they are unfamiliar with the dual nature of the medium when they enter a college program. Every professor knows scores of students who did not consciously choose the photography program they found themselves in. That is, they did not make informed decisions by sufficiently defining their future goals and applying to institutions that, through research, they learned would best meet those goals. Two years and tens of thousands of tuition dollars later, these students begin to understand (thanks

to some formal education and practice in the medium) what direction they want to take in terms of their photography career. Unfortunately, too many of these students simultaneously discover that they are not in a photography program best designed to help them succeed.

The negative effects of these combined problems—polarized academic program emphasis, the pressure on programs to convert solely to digital media, and student ignorance of the range of potential careers in photography—can be mitigated by the actions of dedicated professors through course offerings which seek to simultaneously balance and broaden the way students engage in photographic practices. By designing a more holistic approach to photography education, graduates emerge armed with sound knowledge of the range of available tools, and are better able to define, choose, or change the emphasis of their photographic practice throughout their careers. One aspect of this type of mitigation is to *develop courses based on the interconnectedness of photography's technical and aesthetic elements,* beginning with the primary technical elements from which *all* photographic images are made. By integrating hands-on practice with these technical elements with study and discussion of their inherent visual outcomes, photography programs offer students a more well-rounded education in the medium.

With this premise in mind, I created a portfolio development course for intermediate-level photography students; this course grounds technical understanding while deepening conceptual awareness and expanding aesthetic and visual literacy. The course has had incarnations as intermediate-level photography electives in technical programs, as well as aspects of intermediate-level required courses for photography majors in BFA programs. In addition to meeting with equal success in both technical and fine art programs, this course has made a remarkably seamless transition from traditional to digital media and everything in between because it is based on four immutable elements (which I discuss in the Introduction) inherent to the making of *all* photographic images. The success of this method of photographic training didn't diminish with the inclusion of digital media because digital media didn't change the elements that govern photographic image making. Even as the light-sensitive materials we use continue to change and evolve, the principles that make a photograph . . . well, photographic . . . stay the same.

The approach outlined in this book is based on a single bottom line: *photography is a unique form of visual language, and as such is based on a specific visual grammar.* The principles that govern photographic language have been understood and documented in various forms by many practitioners and theorists, notably in John Szarkowski's *The Photographer's Eye,* and Stephen Shore's *The Nature of Photographs.* Anyone who studies a language intently and for a long enough time begins to know its grammatical structure. And a photographer who understands the grammar of photographic language, and who also has a curious and conceptual mind, can use it effectively as a communicative tool for the purpose of sharing their insights and interests, rather than merely demonstrating a particular brand of training. The most successful fine art, documentary, and professional photographers—those who produce work that transcends mere technical or visual accomplishment and has the power to enlighten, to educate, to heighten our perception of people, places, events, and things—share a common practice; they acknowledge through their work that the power of photographic image making lies in the interconnectedness of the medium's technical nature and visual outcomes. When student-photographers are educated in an environment that emphasizes integration of technique and aesthetics, they are better able to create successful, meaningful images in any branch of the profession.

I have shared this course and its methods with other photography educators, and the quality of their students'

images and growth in understanding have been as impressive as that of my own students. Use of these simple techniques helps educators to bridge the institutional gap between technical and fine art practices, as well as the gap between traditional and digital media, and helps to ensure that students receive a comprehensive education in photography that will serve them well in the profession.

"Like all art, photography creates its own reality. And the best photos are not those which succinctly record what has been seen, but those which understand how to structure this according to rules and laws specific to the genre." —From Icons of Photography

There is just "something about" certain photographs, isn't there? If you're like me, you pause at the sight of a small percentage of photographs you see in magazines and journals, on gallery and museum walls, in family archives and in antique stores, and marvel at that something. That "something" is hard to describe linguistically; it exists strictly as a visual construct. Perhaps the English language lacks a specific term to describe it. It occurs when the form of a photograph inextricably ties its subject and content together *(more on subject, content and form in Chapter 1)*. This cohesion, accordance, or wholeness particular to photographs possessing "that something" is brought about more often and more successfully by photographers who consciously approach photography as a visual language and who use its grammatical elements to assist them in communicating specific meanings.

This book examines four elements specific to every image created through the action of light. These elements form what I call *the grammar of photographic language*, since they comprise the technical foundation, as well as dictate the visual outcome, of all photographic images. These elements of photography's grammatical structure must be expertly addressed by photographers, regardless of media choice and the end use of the images; any practice of photography that does not consciously address the grammatical elements of photographic language fails to mine its potential.

IMAGE © SEAN WILKINSON, UNTITLED, 1999, LONDON, FROM HIS SERIES *TRACES*.

WHAT ARE THE ELEMENTS OF PHOTOGRAPHY?

Webster's Third New International Dictionary defines *grammar* as "the basic elements or principles of a science, art, discipline, or practice." So, in addition to its status as a subject which strikes fear into the hearts of grade-schoolers, grammar is the basis upon which *all* forms of language are built. And that is what this book is about—*the grammar of photographic language*—that is, the elements that comprise the technical foundation, as well as dictate the visual form, of all photographic images. This book identifies and examines four elements inherent to every image created through the action of light. These elements are: the photographic frame and its borders; quality of focus as determined by the aperture or lens; shutter speeds and their effects in relation to time and motion; and the physical media used to create the aggregate image. These elements do not operate in a hierarchical or sequential manner; they each play a unique role as they combine to form a coherent visual statement. This book explains the nature of these four elements of photographic grammar as well as how to control them technically; it demystifies their visual outcomes; and it examines their compositional, communicative, and conceptual implications. Consciously employed by a skilled photographer, these elements add advanced levels of depth, dimension, and meaning to all photographic images.

WHY DO THE ELEMENTS OF PHOTOGRAPHY MATTER?

In her critical text, *The Photograph: A Strange, Confined Space*, Mary Price poses a question whose answer defines the relative success or failure of a photograph: "The critical and important question is two-fold: what does this photograph convey as information, and what does that information mean?" (Price, 1994, p. 76). In answering these questions, one must recognize that a photograph based on the grammatical structure of photographic language as it relates to the content of the image is better able to convey information in a meaningful way. The photographer's control of the medium's four grammatical elements operates much like a filter through which the viewer of the photograph sees the world. Often transparent to the viewer, these elements are the primary means through which "the world in front of the camera is transformed into the photograph" (Shore, 1998, p. 17). Just as combining parts of speech dictates the form and meaning of any sentence, these elements dictate the technical and visual properties of any photograph, and in so doing help to delineate its meaning. The

significance of any filter lies in the ways in which it alters the outcome of something, and the photographer's command of these elements operates as a filter between the physical world and the viewer of the image. In this case, insofar as the photographer understands and manipulates these elements, he or she is able to more clearly communicate a specific view of the world.

Beyond the structuring and filtering of information, additional parallels can be made between photographic and written language, and their uses. For example, both types of language have utilitarian as well as abstract or impractical uses. We use both photographic and written language to describe the world around us in informative ways; further, we use them to encapsulate, summarize, and communicate that information in ways that others can understand. We use them to "sell" others on our ideas and commodities, or as a means of propaganda and influence. We use them as a way to record our personal and collective histories in order to preserve those histories and share them with others, carrying them into the future. We use both types of language to interpret and evaluate events as they happen in our lives and in the larger world; we use them to theorize, synthesize, conjecture, and even to obfuscate. We also use them for the purpose of making art, as a means to express our personal perceptions of the world—its beauties and its horrors—and to speak to others in non-conventional uses of those languages, thereby broadening and shaping our collective understanding of both the subject and the language itself.

Whether we're composing an informative technical manual (which I would equate with aspects of commercial photography), prose (photojournalism, documentary photography, or advertising), a personal journal (wedding photography or portraiture), or a collection of poems (fine art photography), the formal basis and structure of the language we use—its grammar—remain the same. The final form of a composed work is directly related to the fundamental principles upon which its language is based. Like written language, the basic rules of photographic grammar remain the same regardless of how or to what end we use them. To that end, when artists incorporate photographic imagery into a larger whole—a mixed media work of art or installation, or a photo essay accompanying text—these four grammatical elements must still be addressed in order to give the photographic aspect efficacy as a communicative tool. Sadly, and all too often, poor photographs are used as aspects of otherwise brilliant mixed media, multimedia, or installation works of art; the artists simply do not

understand the basics of photographic grammar, materials, and exposure. That said, this book pertains specifically to the process of making two-dimensional photographic images, although its concepts can and should be applied more broadly to address issues pertaining to photographs used in holography, multimedia, installation, and myriad other avant-garde and three-dimensional applications.

The nature of the photographic medium's communicative abilities (on all levels: descriptive, emotive, aesthetic, explanatory, expressive, and conceptual) lies in the fact that its technological underpinnings necessarily affect its visual outcomes. Very recently, the invention of digital media became the single largest technological change in photography since its invention more than 160 years ago. The focus since the inclusion and rapid spread of digital media throughout academic programs and the technical photography fields has led some to proclaim that "from this moment on, traditional analog photography is dead." In this book, I claim it is not; there simply is no reason for digital media to replace traditional media throughout the discipline insofar as choice of media should be subordinate to the photographer's ultimate goals for the image. Further, and perhaps more importantly, I propose

that the elements of photography's grammatical structure must be expertly addressed by the photographer, regardless of media choice and the end use of the images, and any use of photography that does not address the grammatical elements of photographic language fails to mine its potential. At a time when digital imaging technology threatens to completely replace wet darkroom traditions in college and university programs, it is imperative to recall the elements upon which the medium itself is based, and underscore the workings and outcomes of those elements to aspiring photographers.

This approach to teaching the elements of photography is geared to accomplish just that for intermediate-level practitioners across disciplines (fine art, documentary/photojournalism, and technical), and to eliminate the perceived barrier between traditional and digital media. It is based on the idea that it is more productive and expansive to study photography from a grammatical standpoint rather than from a "media" standpoint. In academia, once students have had practice in the range of available media (black and white, color, digital, traditional, alternative processes, etc.) it is most beneficial to teach the technical and aesthetic elements upon which photography is based and allow

specific media choices and techniques to be subordinate to the image itself—skilled process should follow concept in order to most effectively communicate meaning. At best, photography programs will continue to offer a range of traditional and digital facilities, expertise, equipment, and materials that would allow students to define their own media needs based on their goals.

ABOUT THE FORMAT AND USE OF THIS BOOK

As previously stated, this book outlines four key technical elements that comprise the grammar of photographic language and make it a unique form of visual expression. The four elements are: the photographic frame and its borders; quality of focus as determined by the aperture or lens; shutter speeds and their effects in relation to time and motion; and the physical media used to create the aggregate image.

I chose these four elements specifically because together they answer a three-part question aimed at defining the essence of photographic language: "What are the essential technical elements inherent to photographic image making, in what ways do those elements dictate discrete visual outcomes, and what meanings do those outcomes suggest in relation to the subject?" Since these elements are inherent to the camera and physical media, they provide an excellent framework for studying photography. In the end, photographers who study these elements can successfully distill images from ideas; photographers who control these elements, consciously putting them into practice in their work, can create images that accurately represent their vision.

Four key technical elements comprise the grammar of photographic language and make it a unique form of visual expression. The four elements are: the photographic frame and its borders; quality of focus as determined by the aperture or lens; shutter speeds and their effects in relation to time and motion; and the physical media used to create the aggregate image. Together, they answer a three-part question aimed at defining the essence of photographic language: What are the essential technical elements inherent to photographic imagery, in what ways do those elements dictate discrete visual outcomes, and what meanings do those outcomes suggest in relation to the subject?

I begin with the chapter entitled *Framing and Borders*, since the imposed frame of the camera's viewfinder is the first and most fundamental means through which "the world in front of the camera is transformed into the photograph" (Shore, 1998, p. 17). The frame encapsulates the image content, and the outermost boundaries of the frame—the borders of the media and print—contribute significant visual information relating to the image itself. Within this chapter, I discuss basic two-dimensional compositional principles such as juxtaposition and picture planes, which are a natural outcome of translating the three-dimensional world onto a two-dimensional picture plane (Shore, 1998, p. 18). This first chapter goes on to explore aspects of using multiple frames, expanding on the idea of the frame to include single images created through gestalt. Chapter 2, *Focus: Apertures, Lenses, and Depth of Field* centers on the aperture as a portal through which the image is transported, types of lenses, and the relationship between the lens plane and the media plane. This chapter examines a variety of non-traditional lenses, as well as several notions of clarity associated with focus and depth of field. Chapter 3, *Shutter Speeds: Time and Motion* discusses the world of motion as it appears when recorded onto static media (light-sensitive film, paper, or sensor). This chapter outlines numerous technical considerations in order to demystify the process of successfully recording frozen, blurred, or multiple-exposure images. Finally, Chapter 4, *Materials and Processes: The Aggregate Image* deals with the physical attributes of the printed image and the meanings suggested by media choices in both image capture and output.

The format of this book leads to greater understanding of how photographs communicate by progressing from theory to practice through each of the four elements in succession. Each chapter begins with a thorough discussion of the specific element at hand and continues in an exploration of technical considerations, outlining the equipment and materials used to control and manipulate the visual outcomes of those elements. The technical component of each chapter includes basic how-to information. The *Technical Tutorials Section* of the text is organized in order by chapter. It includes demonstration photographs and Adobe Photoshop step-by-step tutorials for several specific techniques, both traditional and digital, in-camera and in-darkroom. The technical explanations are intended to illuminate how specific visual effects are achieved. They are not intended as an exhaustive look at methods; rather, they explain some of the common processes photographers use

in order to encourage further exploration using the information as a springboard for experimentation.

Additionally, each chapter contains *Portfolio Pages* with selections from several outstanding contemporary photographers' work intended to enrich the chapter's theoretical and technical information. Alongside the work, the artist–photographers have provided personal and technical statements addressing their techniques and explaining how those techniques reinforce the creative and conceptual meanings of their work. The photographers' work is not *about* the elements of photography, but uses the elements expertly in a wide variety of ways in order to illuminate the viewer about the meaning of their work. The portfolio pages primarily represent fine art photography, but also include documentary and editorial photography in order to remind students of the possibilities that control of these elements offers all photographers.

Finally, each chapter ends with practical exercises designed to encourage photography practitioners to engage, experiment, and create using the theoretical and technical information provided. You are encouraged from the onset to choose a single topic, genre, or theme on which to concentrate throughout the exercises. In considering topics or "related themes," you should choose something that is interesting and engaging both visually and conceptually, since you will spend considerable time building a body of work around it (for excellent advice on this, see the discussion entitled, "Selecting a Subject" in *On Being a Photographer* by David Hurn and Bill Jay). *See Appendix A for more information concerning modes and constructs of image making.* By defining and adhering to a specific subject or genre and completing the chapter exercises in sequence, photographers gain considerable understanding of their chosen topic, achieve an advanced level of control over the aesthetic appearance and communicative effectiveness of their photographs, and create a portfolio of images that thoroughly explores a single subject. While the exercises provide a framework for approaching a subject methodically, concentrating on a specific subject allows photographers to dedicate energy usually spent "wondering what to shoot" on the more important task of making photographs. When you complete the exercises—I recommend proceeding from the first through the last chapters in succession—you have a body of work possessing a natural coherence. Once finished you may choose to repeat the exercises choosing a new topic.

I have taught photography for more than a decade using this approach and am consistently amazed at the power of imagery, both technically and creatively, that interested practitioners achieve once they begin to explore the grammar of photography. Using this approach, you will gain solid practice in the foundations of photographic technique, a more concrete understanding of photographic visual literacy, and a strong body of work with which to demonstrate to portfolio reviewers, employers, and image buyers your unique vision, knowledge, and talent. You will build self-confidence with the medium's technical principles and how those principles translate into visual images, and develop a working method that is proven to be engaging and successful when exploring a subject using the medium of photography. You will stop "taking pictures" and begin "making photographs" as you learn that while anyone can take pictures, photographers understand and utilize the medium's inherent grammar in order to make photographs. Through practice, you will begin to make photographs that accurately communicate your message whether it's political, personal, poetic, spiritual, aesthetic, or journalistic. Using the techniques outlined in this book, you will be well on your way to making the photographs you envision with success and a sense of personal style.

I would like to advocate to image makers the necessity of incorporating interdisciplinary studies into your practice. I cannot overemphasize the importance of carefully reading this and any book relevant to your field of study, and thoughtfully researching any work about the topic or genre you chose. Be inquisitive; have a curious mind; be willing to explore. Don't limit your search to direct information about your subject. Include research about how it influences or is influenced by broader cultural history, religion, philosophy, politics, sciences, social sciences, poetics, photography, and other arts. Seek out information shared by others throughout history who have been passionate about similar subjects to the point that they have researched and studied, written or made art about it. Using an interdisciplinary approach to understanding your subject is invaluable to you as artists; it informs your work in ways that visual exploration alone cannot.

EQUIPMENT AND EXPERIENCE

The information and techniques included here were developed for intermediate-level photographers possessing a solid foundation in the technical aspects of camera operation and exposure (i.e., metering the amount of light in the scene, controlling ISO, f-stops, and shutter speeds), as well

as a fundamental working knowledge of darkroom printing and/or Adobe Photoshop. *For a refresher in basic exposure, see Appendix B.* This text can also be used by beginning or advanced practitioners as a supplement to technical texts or to provide a broader theoretical and visual perspective. The techniques offered here are by no means exhaustive studies of the visual possibilities of photographic image making; rather, they are tools for developing a deeper understanding of the possibilities inherent to photographic practice. These techniques may be practiced with historical, traditional, digital, or a combination of media. Additional equipment such as tripods, filters, alternative lenses, and darkroom equipment are discussed, but are not required in order to practice and create a sound body of photographic work using this book.

ACKNOWLEDGMENTS

Several years of more and less tangible work go into writing a book, and many people played significant roles in this book's creation; I offer my sincere gratitude to them here. To my father James Michael Faris and to my mother Charlene Brown Faris, who taught me by example the importance of discipline and hard work, and who nurtured my dreams unconditionally. For your years of belief and encouragement and for sharing the gift of your lives with me, I acknowledge family, Jim Faris, Mary Stine, and Ahndrea Pett; the few I call friends, in particular Rachel Paul, Michél LeRoy, Greg Marion, and Shawn Curtis (for your wonderful illustrations); and professors Sean Wilkinson and Roger Crum from the University of Dayton, and Marianetta Porter, Joseph Grigely, and Peggy Kusnerz from the University of Michigan. To Randy Wolf, my dear friend (from our first conversation about cats and dogs), for reminding me to live in the moment. Heartfelt thanks to three wonderful spirits—Nancy Jowske, Kim Coughnour, and Anne Camm—for your wisdom, faith, and guidance while I located my true north.

Special thanks to my gracious friend and colleague Dennie Eagleson for your immense well of support, for being a finely tuned critical sounding board, and providing much needed content editing even into some mid-night hours. To Jon Lybrook, plate maker extraordinaire, for your dedication to solving the photography world's polymer photogravure problems. Thank you also to Joan Teemer and Tom Finke for making possible the publication of Jack Teemer's work in this book; in so doing you have allowed me to tangibly acknowledge his positive influence for so many students through his excellent teaching. Thank you to Dean Keesey for providing your mother Masumi Hayashi's images during a tremendously difficult time. Most humble thanks to all of the photographer–artists and photographic contributors to this book; your amazing works illustrate photography's depth and power more than my words ever could. Thanks to Frank Varney and to my students and colleagues at the Art Institute of Colorado for your patience while I diverted much time and energy to this project. Thank you also to two fantastic women, Valerie Geary and

Diane Heppner, and all involved at Focal Press for your dedication to quality photography publications and patient assistance in the difficult task of preparing them.

Most importantly, infinite love and gratitude to my husband, Dave Belt, the perfect partner in this life's physical, spiritual, and intellectual journey, for your boundless support and encouragement, for sharing with me the depth of your wisdom and being, and for your eagerness to explore, understand, and embrace with me the Universe from which we came and to which we will finally return.

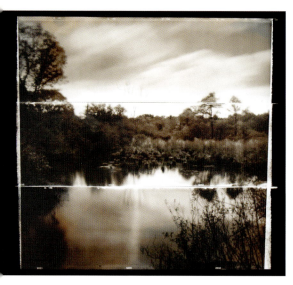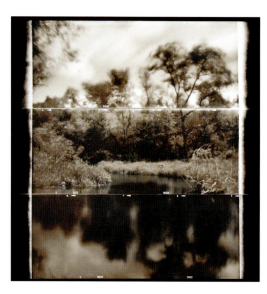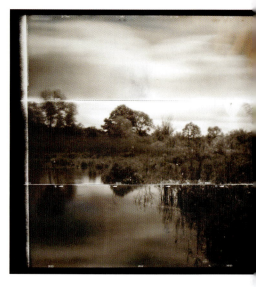

PART 1:
FRAMING AND
BORDERS

"PHOTOGRAPHY IS ABOUT FINDING OUT WHAT CAN HAPPEN IN THE FRAME. WHEN YOU PUT FOUR EDGES AROUND SOME FACTS, YOU CHANGE THOSE FACTS." —GARRY WINOGRAND

IMAGES
© MARK ESHBAUGH,
from his series
Day's End, Triptych
(Chelmsford, MA).

WHAT IS "THE PHOTOGRAPHIC IMAGE" EXACTLY?

Simply stated, the image is the product or confluence of three components as captured within a frame. The three components can be described as *subject, form, and content* (Ocvirk et al., 2002, pp. 12–15). In fact, every work of art, including images, sculpture, music, literature, and dance, is comprised of these three components. Although the naming conventions used to describe them vary, it is understood that these three primary components combine to create a complete image or work of art. The subject can be defined as what the image is about; it is the essence or meaning of the image, and may or may not be visibly present in the image. In literature, the subject is often referred to as the theme of the work. An interest in the subject is often the reason photographers make images to begin with; as Magnum photographer David Hurn explains, "... photography is only a tool, a vehicle, for expressing or transmitting a passion in something else" (1997, pp. 29–30). As good novels or poems operate for writers, good photographs are generally a means for an artist to convey some specific meaning (a point or message, a theme ... the reason behind the work's existence). The subject of a photograph may range from literal to abstract; however, an abstract subject

such as "hope" or "transcendence" (or anything else which is not a noun) can only be conveyed through skillful consideration of the other two components: content and form.

While the term "subject" refers to what the image is about, the term "content" refers literally to the image's contents. Image content (also referred to as *subject matter*) can be defined as those persons, places, or things that are visibly present and/or identifiable in the image. When the subject (or theme) and content (or subject matter) are understood as separate yet interdependent image components, photographers can combine them more accurately to convey meaning. The best photographers closely consider all image content as it relates to their chosen subject, and they do so for several reasons. First, all content, like all words, carries meaning that operates on connotative and denotative, subjective or objective, psychological, intellectual, spiritual, cultural, political, and many other levels. Therefore, the inclusion of content which is widely recognized to have specific meaning on one or more levels is more likely to communicate successfully to a wide audience. Second, each discrete piece of content in an image is like individual words in a sentence; each has the potential to either clarify or obscure meaning when juxtaposed. Additionally, like the subject of a work of art or literature, content can

be abstract or non-representational; in these cases the remaining component of the image—form itself—might literally be the subject, or might afford the viewer a great deal of insight about it.

To illustrate the difference between subject and content, I often ask students if they are familiar with the novel or film *The Shawshank Redemption*. Most of them are. Then I ask, "What is the subject of the work?" Invariably students reply that the subject is "an innocent man who is sent to prison and escapes through 'a river of shit.'" This interpretation by students proves that they confuse subject with content, and are thereby missing the real meaning of the work. I am familiar with the novel and the film, and I suggest to students that the *subject* of the work is *hope* or perhaps *the nature of redemption* itself. The innocent man imprisoned, all of his experiences, the experiences of all those around him, the "river of shit" and his unlikely path to freedom, all fall under the category of content—the concrete, identifiable aspects of the work that carry its subject or theme across. In order to use content to communicate about a subject, an artist needs to provide an organizational structure, and that organizational structure is called form.

The third component of the photographic image, its form, refers to all the means through which the subject and content are unified and presented. Form can be defined as the design elements that the artist combines to arrange a work compositionally, or the formal organization of elements that dictate the appearance of an image. Form, also called composition, in a photograph includes the traditional design elements (line, shape, value, texture, and color), to which I would add quality of light and framing. Mary Price, in her critical text *The Photograph: A Strange, Confined Space* suggests that what sets the work of more successful photographers above others is the photographer's "Visual recognition of meaning in form," and that it is precisely this recognition which "entails the ability to see a three-dimensional objective world in two-dimensional flat form . . . in instantaneous appreciation of what that segment about to become a separate whole will signify" (1994, p. 84).

It is the interrelationship between subject, form, and content that creates meaning in an image. Since form is the means through which an artist's chosen subject and content are linked together, it is important to understand the technical elements behind it for a given medium. Form, specific to photography, is in large part dictated by the four technical elements which comprise all photographic imagery. When constructing images, photographers who

consciously manipulate the formal arrangement of carefully selected content are able to accurately communicate their ideas about a subject. The manipulation of a photograph's formal arrangement is in large part a direct result of the technical elements that create camera-made images. That first element is framing.

FRAMING: THE FIRST PHOTOGRAPHIC ELEMENT

Photographers who have had some basic training and practice in photography should fully understand metering and exposure in ambient light situations, as well as the attributes of their particular traditional, digital, or hybrid (meaning a combination of the two) media. Beyond that, they are most interested in creating images that apply their technical knowledge in a meaningful way, and they do so by using the elements of design and composition. But even photographers who know the basic rules of two-dimensional composition don't necessarily understand how to apply those rules toward orchestrating content within a photographic frame. This chapter explores the principles underlying framing in the camera's viewfinder and addresses the borders of the resulting image.

If the principles governing proper metering and exposure are new to you, see Appendix B for more detailed explanation. As this is not a design text, if the elements of design and rules of basic composition are new to you, I recommend independent research using any of the excellent textbooks available on the topic.

AFFECTING VISUAL QUALITY AND PHOTOGRAPHIC MEANING THROUGH CONSCIOUS FRAMING

Photographic images—images made from the action of light—are contained within a frame. The frame can be defined as the outermost boundaries of the photograph, the structure which circumscribes the photographer's decisions regarding image content. Framing and borders combine as the first element of photography because they intersect as the transition point between the world and the image at every stage of the image-making process. Framing begins in-camera, continues through the cropping stages, and completes with borders created in the traditional or digital darkroom.

Every camera imposes a frame; it is a constant element of photographic images regardless of camera format or lens

choice, determining the specific segment of space and time that will exist within its borders. As soon as you place the imposed frame of a camera's viewfinder between the world and your eye, you actively engage the first unique technical element of photographic image making that directly affects the visual outcome of the image. You place the camera in front of your eye, and the world, which has no boundaries, is suddenly confined to the square or rectangle of the camera format's viewfinder. In the words of Stephen Shore, "The photograph has edges; the world does not. The edges separate what is in the picture from what is not … the frame corrals the content of the photograph all at once" (1998, p. 28). Here's the rub: the frame defines what viewers will see as the image content regardless of the attention paid to it by the photographer. Too often the transition from "seeing" to "seeing through the camera" is not present enough in the photographer's mind; therefore, thoughtful framing must be developed as a very conscious act.

A visually literate viewer assumes the entire content of the frame to be *intended* by the photographer; through framing the photographer tacitly states that all content should be addressed toward determining the meaning of the image. In this respect, framing the contents of a photograph is like composing a work of literature; conscientious authors don't add random words to sentences or unnecessary sentences to paragraphs. For instance, while reading a novel, how would you respond if there appeared non-sequiturs which only served to misdirect you with regard to the story line, and in the end the author notes that he or she didn't intend the extraneous sentences to be treated as part of the novel at all! Just as meticulous readers interpret each sentence (indeed each word) of a novel in order to derive meaning, meticulous viewers interpret every aspect of a photograph's content to derive meaning.

At some point in the process, photographers decide what to include and what to exclude from the final image. Framing refers to in-camera decision making, within the imposed frame the camera provides. Photographers make framing decisions based on what they determine to be the important aspects of the scene until the precise moment of exposure (or capture); once exposed, the captured image contains all the content that it will contain. For this reason (and for ethical reasons in fields such as photojournalism or forensic photography) the best time to make framing decisions is while the camera is in your hand and the scene unfolds in front of you.

When framing the content of an image, photographers should ask the following questions:

- Does all the content in the frame contribute to the meaning of my image and lead the viewer to understand what I am trying to communicate about my subject?

- Does any content in the frame distract from communicating about the subject or theme of my image? If so, how can I eliminate it?

- How can I organize the frame so that the appropriate content emphasizes the subject and all other content supports it?

The frame does more than include and exclude potential content; however, *it plays an indispensable role in organizing that content.* In *The Nature of Photographs*, Stephen Shore describes some of the visual outcomes of framing through an attribute he calls "flatness." He says, "When three-dimensional space is projected monocularly onto a plane, relationships are created that did not exist before the picture was taken. ... Any change in vantage point results in a change in these relationships" (18–19). In this concise quote, Shore touches on three important aspects of framing: *vantage point, juxtaposition, and picture planes.* What follows is a discussion of those three aspects of framing,

because they directly affect the visual organization and hierarchy of image content.

ORGANIZING THE FRAME: VANTAGE POINT, JUXTAPOSITION, AND PICTURE PLANES

When photographers capture an image they do so on the picture plane; that is, the flat, physical surface of the media on which the image is captured. By orchestrating the frame's contents through careful consideration of *vantage point*—the distance and position of the camera in relation to the subject—the photographer dictates the hierarchy of information and the visual flow of the image.

In choosing vantage point carefully, the photographer also changes the perceived spatial relationships among various content and dictates how three-dimensional space will be depicted in the two-dimensional image. Will the picture plane minimize the illusion of depth, or will it emphasize that illusion? The answer should depend on how the sense of depth (or lack thereof) in the pictorial space will affect the viewer's reading of the image. (We will take a closer look at this attribute in the section on picture planes.) In addition to creating spatial hierarchies, vantage point can assist you in communicating specific ideas about the subject or content

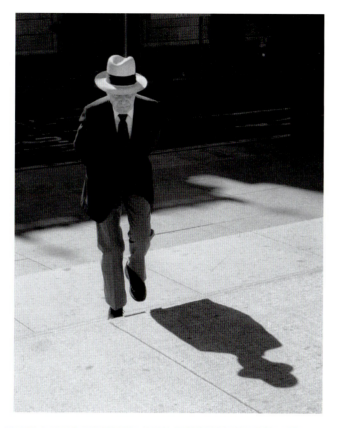

In this photograph, David Beckerman uses vantage point to great advantage in framing the man's light face and hat against the dark background, while including a secondary figure (the man's shadow) that mimics his subject's own form. Also, in pointing his camera downward to include the man's broken shadow, he balances the composition and leads the eye into the bottom of the frame. www.davebeckerman.com

in an image. For instance, if you were making a portrait of someone you admire, and whom you want the viewer to admire, you might adopt a lower vantage point and *literally look up* at the person when making the portrait, or place them above (from your vantage point) the other content in the frame; conversely, if your intent were to diminish or demean the subject of the portrait, you might literally adopt a vantage point which looks down at the person.

Additionally, by changing vantage point, the photographer organizes the way various aspects of the image content are *juxtaposed*—the relationship and interaction among discreet contents—and these changes alter the image structure and its subsequent meaning.

"In the field, outside the controlled confines of a studio, a photographer is confronted with a complex web of visual juxtapositions that realign themselves with each step the photographer takes. Take one step and something hidden comes into view; take another and an object in the front now presses up against one in the distance. Take one step and the description of deep space is clarified; take another and it is obscured. In bringing order to this situation, a photographer solves a picture more than composes one" (Shore, 1998, p. 23).

Juxtaposition is a key component in any language; just as words are juxtaposed with other words in order to create more complex and specific meaning, the contents of photographs are juxtaposed with other contents in order to add complexity and meaning. The work of Elliott Erwitt provides a classic example of the nature of juxtaposition; the contents within his carefully, albeit spontaneously, composed frames often reference one another in extreme or visually obvious ways in order to create the humor or irony he calls attention to. The work of Alexandre Orion uses juxtaposition as well and can be viewed in the Portfolio Pages of this chapter.

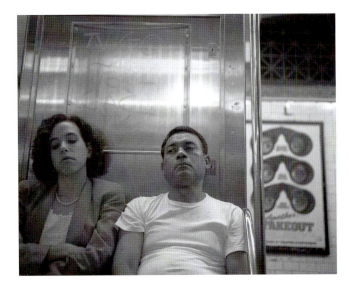

The third organizational aspect of the frame is the picture plane—the flat, physical surface on which the image is captured. When the binocular perspective of our vision is removed, one of the three primary types of spatial organization emerges onto a picture plane because of the way that three-dimensional space is ordered when flattened through a single lens perspective. The three types of picture planes are: *parallel*, *diagonal*, and *overlapping*. They delineate the way depth is organized in the pictorial space, and perhaps as important, they dictate the pace at which the viewer's eyes move into and through that space to read the image.

1. *Parallel picture planes* emphasize the two-dimensionality of the image; in them the image content is parallel to the picture plane, so there is no real sense of depth or receding space in these images. On the one hand they can be viewed as quiet and meditative, and on the other stagnant and boring. One common means of limiting or eliminating the sense of receding space in a photograph

PHOTO © DAVID BECKERMAN, *MAN AND WOMAN*, SUBWAY, NEW YORK, 1993.

This photograph illustrates one aspect of the nature of juxtaposition. By framing both the people whose attention is passively downward and the sign whose eyes intently peer back at us as, David Beckerman juxtaposes two contentual elements, which bring to the forefront the active nature of our own gaze upon others.

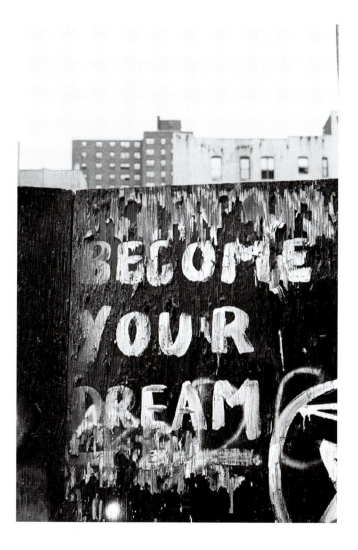

is to approach content straight on, such that from your vantage point three-dimensionality is minimized.

2. *Diagonal picture planes* provide the sense of receding space that is created when the photographer's vantage point is at an oblique angle to the content of the image. In this way the content forms a real or implied diagonal line through the image at an angle to the picture plane. Images framed in this way convey a sense of rapidly receding space, aided by the increased size of content in the foreground in relation to the diminishing sizes toward the background.

3. *Overlapping picture planes* contain a sense of depth due to image content overlapping from foreground to background. In these cases, the viewer perceives space as receding due to some content being in front of other content from the camera's point-of-view. Since overlapping occurs from the point of view of the camera, care should be taken to insure that the vantage point helps to clarify the image. Common problems

PHOTO © DAVID BECKERMAN, *BECOME YOUR DREAM*, NEW YORK, 2005.

This image uses a parallel picture plane by facing the content of the frame head-on. It creates a confrontational image, with unavoidable connections created between the background high-rise buildings and the hand-scrawled *Become Your Dream* graffiti in the foreground.

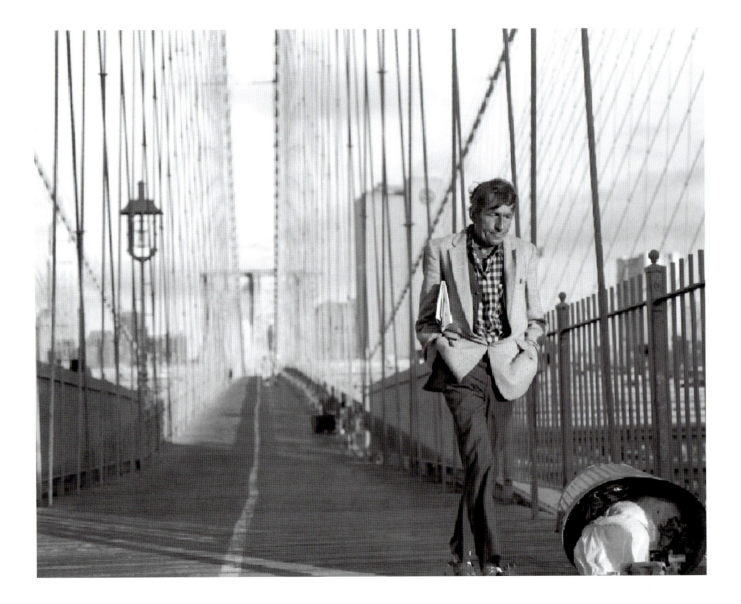

PHOTO © DAVID BECKERMAN, *CROSSING BROOKLYN BRIDGE*, 1993.

Diagonal picture plane: The image composition creates dramatic depth in receding space, since the frame's primary content is diagonal to the picture plane. The direction of the subject's movement toward the corner of the picture also activates the composition and leads the viewer's eye in that direction, where we view a significant piece of secondary content—an overturned trash can.

of inattention to vantage point when composing overlapping picture planes include tangents (when two elements barely touch and therefore create distracting visual tension) and tonal mergers (when using black and white media in particular, two independent objects that stand apart visually due to color contrast might blend together when reduced to grayscale tonal value … using contrast filters designed for shooting black and white film or adjusting the separate Channels in Adobe Photoshop help prevent tonal mergers from being a problem in the final image).

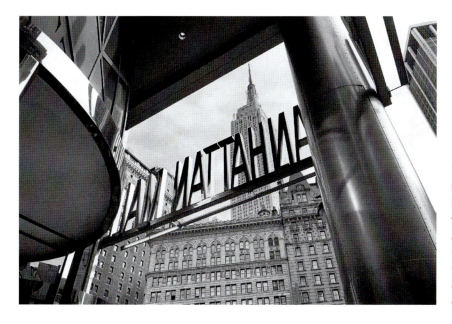

PHOTO © DAVID BECKERMAN, *MANHATTAN MALL*, NEW YORK, 2006.

This image uses overlapping planes at varying angles in order to juxtapose content in the frame. It well describes the crowded nature of the place, allows David Beckerman to incorporate the place name in relation to other contentual elements, and gives the viewer a definite sense of spatial relationships.

CONTACT SHEETS: KEY TO CHOOSING THE BEST FRAME

Once the images are captured and processed, the next step is to edit, and *contact sheets*—prints with several thumbnail sized images printed on them—are an indispensable tool for image editing. They allow photographers to look at the sum of images they have created in printed form and choose from the group one or several that most successfully represent their ideas. The most effective contact sheets provide images large enough to view and are of good density, contrast, and color. There are many methods of editing images from contact sheets. I recommend first editing for technical quality: any images that are poorly exposed, out of focus, or have camera shake due to slow shutter speeds should be immediately eliminated—don't try to "fix" these problems in the traditional or digital darkroom; instead, learn from your technical mistakes and don't make the same mistakes again. Next, edit for content and formal quality: ask yourself which of those technically sound frames best convey your meaning or express your ideas about your subject. I recommend enlarging these images into work prints, hang them up, and live with them in your office or studio for a while, so that only the best images emerge in your view as successful. Your contact sheets and work prints will also reveal that even the best attempts at in-camera framing sometimes fail to produce the desired result ... and it is then that a photographer might decide to crop.

There are great advantages to editing from high-quality printed versions of images (rather than from negatives or from digital files). It is easier to note subtle technical and formal differences from frame to frame—changes in exposure, focal length, distance, vantage point, shutter speed, and depth of field—which serve to significantly affect the image as the photographic process unfolds. In the contact sheets, the evidence of the photographer's growing awareness and sharpening of the composition of contents from frame to frame is apparent.

CROPPING: FRAMING AFTER THE FACT

While the ideal time to make framing decisions is with the camera in hand, it's not always practical. For example, in making images "from the hip" a photographer might know to some extent what will be captured in the frame, but cannot predict it with certainty; or when shooting quickly in rapidly changing circumstances as photojournalists often do it's important to capture the moment. In these cases the decision to eliminate extraneous elements initially captured near the frame edges in the traditional or digital darkroom might help to clarify meaning of the image for a viewer.

Conscious cropping is a valid, and valuable, means of defining the content of a photographic frame, although many photographers choose never to crop an image in the printing stage.

The decision to exclude aspects of the original frame's content is referred to as *cropping*. There are two times after image capture when photographers have the opportunity to re-define the boundaries of the image by excluding certain aspects of it. Cropping affords photographers a second chance to eliminate extraneous content from a frame prior to publication or exhibition. It can be done at either of two points after capture: during printing or during presentation. The latter, and perhaps the worst, time to crop is during presentation; that is, a photographer might choose to crop a part of an image during window matting or display if cropping decisions were neglected during the previous two opportunities.

In the traditional darkroom, the most indispensable tool for precision either in printing the full-frame or cropping is a four-bladed adjustable easel. There are many brands and types of easels on the market, but those with four independently adjustable blades are best designed to control sizing, framing, and borders of the print. In the technical section of this chapter you will see a variety of techniques used to control sizing, framing, and borders of the print, and a variety of effects achievable through careful use of a four-bladed easel.

BORDERS: THE EXTERIOR EDGE OF THE FRAME

Even photographers who posses a practiced sense of framing and composition in-camera might be delayed in the realization that the *image border*—the transitional space between the image content and its surroundings—has its own significance. Perhaps because it is a boundary space, the image area's border carries with it all the weight and connotations of any other, similar boundary. It is the space where a viewer enters, rather unconsciously most of the time, the pictorial space. In this way entering the frame is like opening a book; the quality and attention to the outside cover affect our ideas—whether consciously or unconsciously—about the book prior to our reading a word of it. As an undergraduate photography student I hadn't thought of "carrier edge" as being anything other than sloppy craftsmanship until my professor, Jack Teemer, explained it in reference to his color photographs of children at play. Of the colorful, jaggedly inconsistent border area he said, "I wanted to suggest that this environment continues beyond the frame." And it did! Where the image

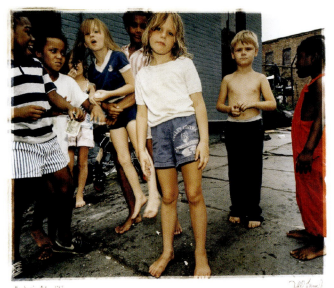

IMAGE © JACK TEEMER, FROM HIS SERIES *CHILDREN AT PLAY*.

Creating a carrier-edge border, the artist suggested to the viewer that the world captured inside the photograph extends beyond the frame. See how to create carrier-edge borders in the next section.

content ended, there were hints of color and detail extending beyond the interior of the frame, all visually related to the content at the edges all the way around the frame. At that moment I realized the importance of this boundary to the image, and I began to experiment with a variety of

border effects in the darkroom, and to consider as part of my printmaking decisions the type of border to create (if any) in order to best carry my message about my subject.

TRADITIONAL DARKROOM BORDER TECHNIQUES

In the traditional darkroom, the relationship between the inside edge of the negative carrier and the outside edge of the image area on the film determines the types of borders that are produced. The interior dimensions of standard negative carriers are made slightly smaller than the dimensions of the image area on film. Because of this, and with the help of easel blades, photographers making prints using standard negative carriers tend to produce prints with a "clean edge" almost by default; that is, assisted by the easel blades the print's image area ends where the white space of the paper begins. If you don't like that option for your images, some simple planning and engineering of the negative carrier can make a marked difference in the appearance of your printed image borders. See the Technical Tutorials Section for Chapter 1 for a detailed discussion of how to alter your negative carriers to produce specific effects.

In the following examples, prints made from traditional black and white negatives demonstrate several types of

border effects. These border effects are some that I refer to as "organic"; that is, the borders are a natural outcome (albeit nurtured) of the interrelationship among the tonal values at the edge of the negative, the edge of the carrier, and exposure to light. I recommend making work prints with several different types of borders in order to help you to determine how these effects reflect on the subject and content of your images.

- *Borderless*: In this example, fine art photographer Todd Dobbs created a traditional darkroom gelatin silver print using a long strip (multiple Holga camera exposures overlapped) of 120 film placed in a glass negative carrier. The carrier was masked at the image edges using rubylith tape, and the easel blades were adjusted to be just inside the image area to create a clean edge. The resulting clean, pristine border between the image area and the paper is a somewhat default method of printing standard negative sizes. Borderless prints suggest that the border itself is inconsequential to the meaning of the image.

- *Fine black border*: With the negative placed in a filed out negative carrier, the easel blades are adjusted to a

IMAGE © TODD DOBBS, *BUILDINGS NO. 12*, 2002.

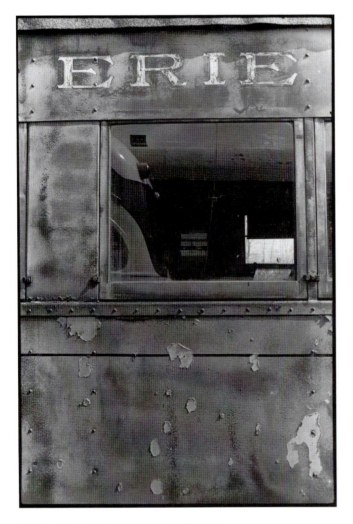

IMAGE © TODD DOBBS, *ERIE TRAIN CAR*, 1998.

position just outside image area to include the film base plus fog. The width of the black border can be adjusted to anywhere inside the projected negative carrier edge. By creating a black border around the image area, the photographer tacitly points to the boundary of the image, and the viewer more consciously enters the pictorial space.

- *Vignetted borders*: In addition to any of the borders that the carrier helps to create in the darkroom, you might choose to vignette the image—to darken or lighten gradually—toward its edges. To do this is simple in both the traditional and digital darkrooms, but it's also easy to go overboard and create a poorly made vignette, so practice and technique are essential. As a supplement to the print exposure, the photographer adds density to the outer edges of the image by *burning* them in, or reduces density from the outer edges of the image by *dodging* them. The degree of the vignette is determined by the duration of the burn or dodge as well as the contrast used. Whether a standard or filed out carrier is used, when the edges of the print are vignetted, the viewer's attention tends to remain more inside the frame.

Most often, vignetted-edge manipulations carry with them connotations of memory, traveling back in time, or projecting forward to the future. They can also allude to notions of ephemerality, ethereality, and other transitional states. The edges create a smooth visual transition into the pictorial space, allowing the viewer to enter the image and regard its contents gradually. Vignetting applied to the wrong image content can have an overly sentimental or cliché feeling, but a conscious photographer will avoid such cliché. One successful example demonstrating the visual and communicative power of vignetting is in a series entitled *At Rest* by fine art and portrait photographer Melissa Mercado. The images are presented as diptychs, and are the product of hybrid (combined traditional and digital) media.

A variation of these vignetting techniques is to vignette the border through burning, with the entire sheet of paper printed to black. To do this, an exposure set to maximum black is made to the area of photographic paper outside the image area, after the initial exposure is made. Simply place an opaque board of the size of the image on top of the image, lift the easel blades, and make the exposure to the remainder of the paper

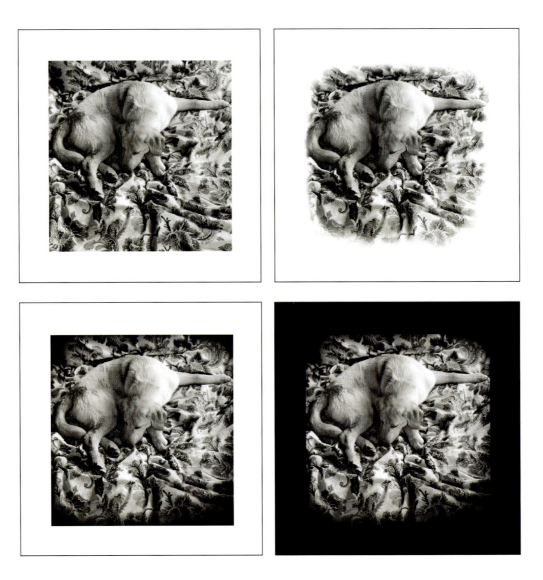

IMAGE © ANGELA FARIS BELT, *DHARMA IN A PAISLEY FIELD*, 2005.

Clockwise from upper left: plain border, fade to white border, vignetted border with paper printed to black, and vignetted border. The various methods used to print the borders of the final image change the feeling and intensity of the image, and affect how the viewer reads the image content.

surface. Techniques such as this are often used when the treatment of the entire sheet of photographic printing paper is considered a part of the work itself. Often, prints such as these are displayed "floating" in a frame using spacers (and no window mat) or are incorporated into a larger whole.

THE DIGITAL REALM: BORDERS WITHOUT FILM EDGES

With digital photographic capture, there is no physical media edge extending beyond the sensor, and so nothing extending beyond the image area with which to continue the frame's communicative effects. As a result, many photographers have gravitated toward borderless images or the use of template borders. Template borders are prefabricated borders that are often supplied with online Photoshop tutorials and are digitally loaded into the image document and set in place. Template borders are either scanned or digitally created and often appear similar to borders such as those created through use of Polaroid

Type-55 or Polaroid transfer images. While these borders are adequate for many commercial and graphic design applications, artists want to create and control the appearance of their image even to its borders.

The emphasis here is on hand-made (what I call "organic") borders, specific to the image content itself. While the appearance of traditional darkroom borders is dictated by the physical relationship among the film edge, carrier edge, and easel blades, the appearance of digital darkroom borders is dictated in Photoshop with the primary relationship among the image size and canvas size, and the effect of image layers and blending modes on the tones occurring at the image edge. In traditional darkroom images the carrier edge is unique to each image; the potential for that same unique-to-the-image character exists for digital darkroom images with some understanding of the tools, practice, and patience.

In the Chapter 1, Technical Tutorial Section called Digital Darkroom Borders, I will attempt to lure you away from the ease of canned effects, and toward more organic

and conceptually sound approaches. These are simple techniques designed to help you begin experimenting with the borders of your digital images. Once you begin to work with the tools, you'll find that there are myriad ways to affect the look of your image borders without using canned borders.

I'll outline creating fine black borders, and creating "painted borders" using the edge tones and colors of the image itself, and applying blending modes to create a seamless transition. These tutorials offer starting points, and unlimited results can be achieved if you are willing to experiment.

Before

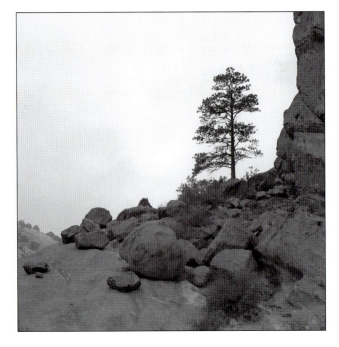

After

IMAGES © ANGELA FARIS BELT.
Fine Black Borders Technique

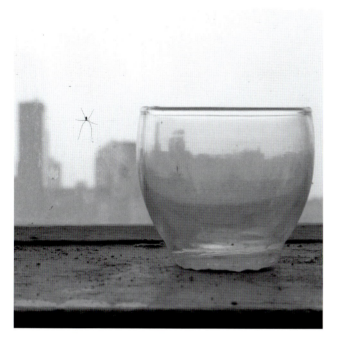

Before

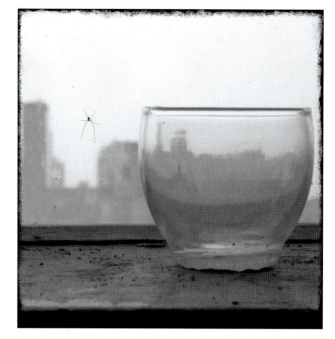

After

IMAGES © ANGELA FARIS BELT.
Painted Borders Technique

CHAPTER EXERCISES

In the Introduction to this text, I suggested that you choose a specific subject or genre, and to work with it throughout the chapter exercises. You should choose a subject that will be engaging to you visually and intellectually throughout the exercises; a subject that is of interest to you and that has the potential to be of interest to others. The reason for doing this is simple: it will enable you to approach

your subject in a more faceted way, guided by the grammatical elements of photography. Throughout the course of these exercises you will learn a great deal about both your subject and the elements that guide photographic language. Through critique you will begin to fully understand how the elements of photography can be manipulated to better communicate a visual message about your subject. Before commencing with the first exercise, clearly define your subject or concept and commit to conducting research about it. The more you know about your chosen subject, the more likely you are to make informed decisions about content, and the more able you are to use photography's technical elements to guide your creation of meaningful images.

For all of these exercises you may shoot traditional or digital media, color or black and white, or you might shoot an alternative media with an alternative camera. Media choice is up to you.

Exercise No. 1: Making Conscious Framing Decisions

This exercise should be used to define your subject both for yourself and for your viewers, and it should assist you in maintaining awareness of your in-camera framing decisions. Concentrate on using the imposed frame of the camera's viewfinder to define the content of your images. For each subject or scene, make two photographs:

1. Fill the frame with the subject matter. For this image, leave no area inside the frame untouched by the primary subject matter, and try your best not to abstract it. That is, frame the content such that the viewer still knows what he or she is viewing, but so that it encompasses the entire frame.

2. Photograph the same subject matter so that it fills only a small (perhaps 10%) portion of the frame. For this image, secondary image content is used to support the subject and lead the viewer to it.

Understand that it will likely take several images per scene in order to achieve the two successful images for each. Study your results, and edit several images to enlarge.

Exercise No. 2: Picture Planes

Conscious structuring of content within the picture plane allows the photographer to dictate the sense of space that the three-dimensional world takes within the two-dimensional picture plane. It also dictates pace at which viewers will read the image, and the viewer's sense of spatial relationships among various content within the image.

For this exercise, make three images of each scene you photograph. Remember that it will likely take several images per picture plane in order to achieve three successful images:

1. Structure the content using a parallel picture plane.

2. Structure the content using a diagonal picture plane.

3. Structure the content using overlapping planes.

Consider the placement of your subject matter and the way that the sense of depth (or lack thereof) through the picture plane affects your viewer's attention to it, their pace at reading the image, and sense of relationship between objects within the pictorial space. Remember to use a sufficiently small or large aperture to render the depth of field you need.

Exercise No. 3: Darkroom Borders Experimentation

Edit and print three identical copies of your four best images from the previous two exercises. These should be your best four images from the exercises, not comparison images from a single exercise. Using the media of your choice, create 2–3 different border effects for each image. Critique these images and determine which border effects work best with your subject and what you were trying to say about it. Determine whether this border effect might be used throughout the series of images.

PORTFOLIO PAGES

The artists represented in the *Framing and Borders* portfolio pages engage in a wide range of photographic practices. To create their work they use traditional, digital, and hybrid media, and they consciously (visually as well as conceptually) address the framing and borders of the photographic image. The work in these pages is not about framing and borders; rather, it uses them as visual strategies to support or address the subject of their images.

These images are intended to inspire creative thinking and critical debate about the content and subject of the work, as well as the use of framing and borders in relation to that content. Additionally, what other artists do you know whose work uses the frame consciously, or refers to it in the work literally in order to comment on their subject? How might a more conscious use of the imposed photographic frame and created borders of the print add dimension and meaning to your images?

ALEXANDRE ORION

Metabiotics

ARTIST STATEMENT

Alexandre Orion grew up in some of the busiest streets in Brazil. As a child in São Paulo, he became accustomed to sidewalks thronged all day, and the din of traffic at night. Orion was quick to respond to the appeal of the streets and his first graffiti was done at the age of 14. While adolescent instinct drove him, the hard reality of the streets called for new ideals. Now he draws inspiration from multitudes; silence and thought; experiences and memories; happiness and suffering. An artist amid the crowd, the many found within him. Humanity lives in Orion: his time unique, his universe collective space.

Discovering photography in 2000 coincided with an interest in the theory of image in Barthes, Dubois, and Aumont. A year later, his *Metabiotics* project involved finding a place in the city where he would paint the wall and with his camera at the ready, await the decisive instant when people interacted spontaneously with his paintings. Framing the precise situation promoted a joining of painting and real life, encouraging an encounter (or confrontation) between reality and fiction within the field of photography.

This decisive moment of interaction between people and painted image led to *Metabiotics*, as opposed to traditional photography's conveying the false idea of all that is photographic being real. *Metabiotics* questions truthfulness: the paintings were actually done in the walls, people really did pass by and act spontaneously, but what we see suggests a type of montage that did not exist. Everything is both true and false.

METABIOTICS CONCEPT

Origin:

Metabiosis, female noun. Intermediate symbiosis; a state in which an organism only survives after another organism has prepared a favorable environment and died. *Portuguese*

Language Student Dictionary, Brazilian Ministry of Culture, 1976.

Definition:

Meta—Greek prefix meaning objective, target, limit, or transposition.

Bi—Latin prefix meaning duplication or repetition.

Otics or optics—part of physics that studies the phenomena of light and vision.

Explanation:

Painting and photography share the same environment like two inseparable yet incompatible organisms. Photography as purpose is an environment in which there is no distinctive boundary between attachment and detachment between languages. There is something beyond the two viewpoints: a tenuous and infinite gap that leads us to non-existence.

Alexandre Orion, visual artist

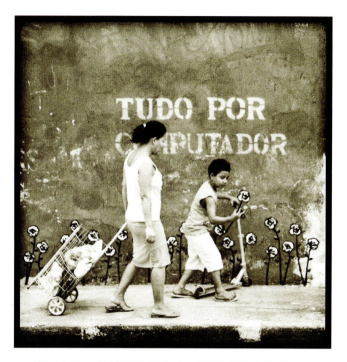

IMAGES © ALEXANDRE ORION, FROM HIS SERIES *METABIOTICS*.

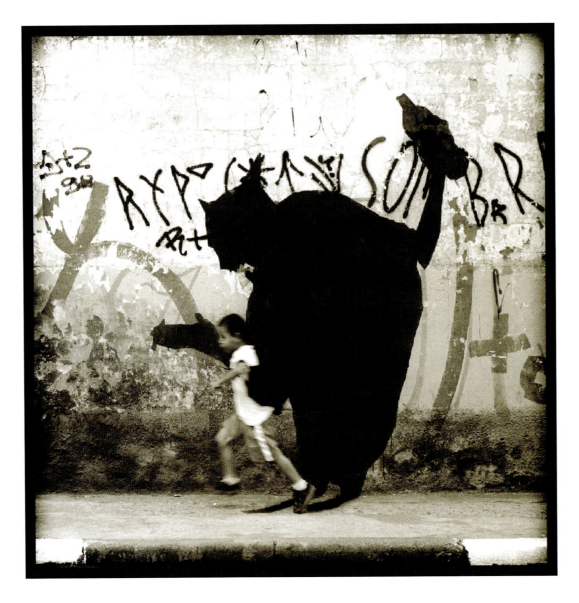

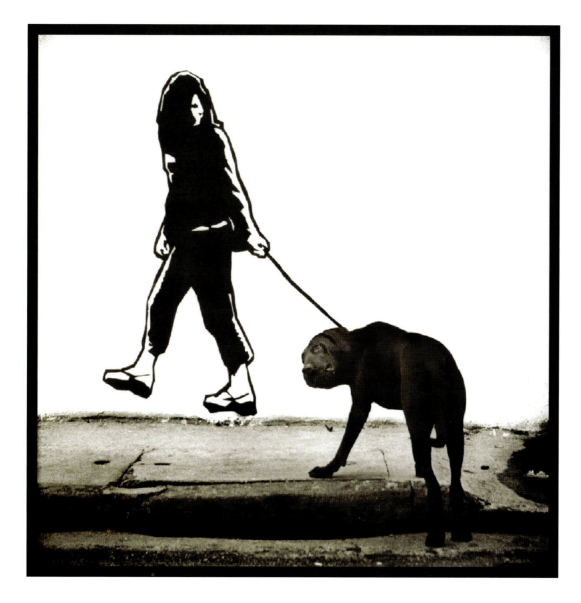

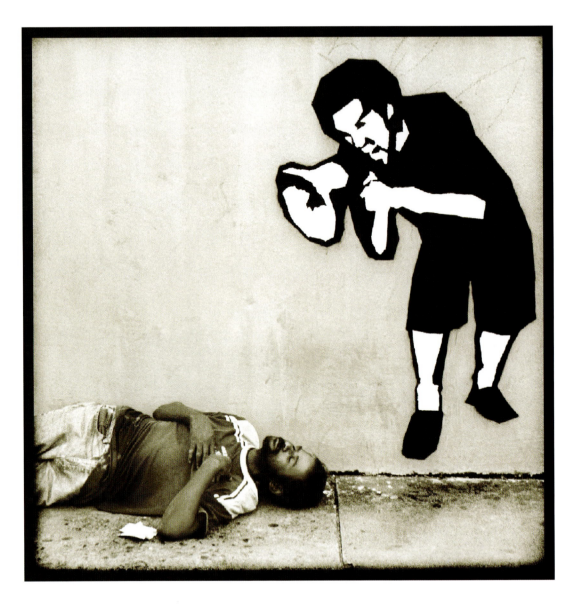

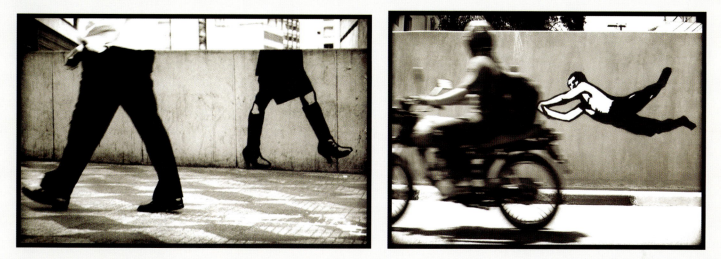

IMAGES © ALEXANDRE ORION, FROM HIS SERIES *METABIOTICS.*

ANGIE BUCKLEY

"THE IN-BETWEEN"

ARTIST STATEMENT

Personality is continuously shaped through associations with people in our immediate environment and our perceptions of the world. In a nation established on immigration many of us are products of cross-pollination and are caught among several cultures. Habits, stories, and traditions from various groups are passed from one generation to the next and most of these things transform over time through a subtle metamorphosis. One of the results is a magnitude of assumptions made about others based on a pre-constructed interpretation. My artwork is driven by a fascination with the invisibility of such transmutations and its effect on our society as a whole. Overall, exploring heritage is a rich journey, particularly in a time when social equality and ethnic recognition are prominent political topics.

The dreamy quality of the pinhole camera distorts the sense of scale of the landscape and the dioramas. Likewise, the primitive quality of the camera contrasts a current obsession with technical advancement. Cutting out various shapes of figures or objects and placing them in front of the photograph from which they came makes it seem as if they have stepped out of time to confront the viewer. The duplication of characters is similar to the retelling of the stories and the open silhouette holes are analogous to the vacant cultural histories of the displaced. Subsequent generations, such as my own, find themselves in-between imagination and the real world in order to put pieces together to build understanding and define distinction.

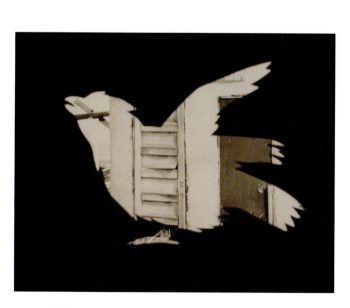

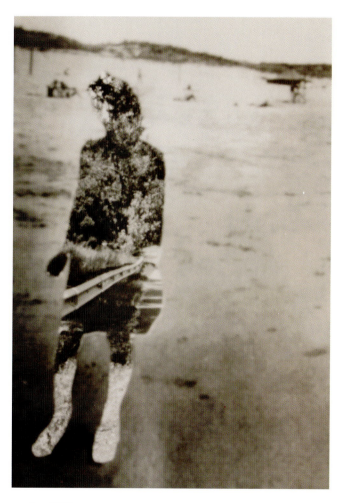

convene, 2006.

convince, 2006.

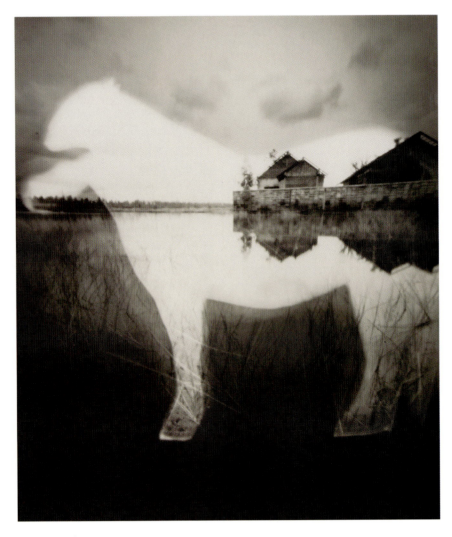

buoyant, 2005.

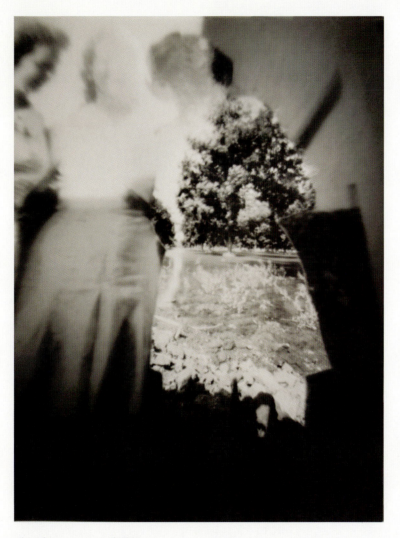

when things are tranquil, 2001.

JANE ALDEN STEVENS

TEARS OF STONE: WORLD WAR I REMEMBERED

ARTIST STATEMENT

While on a research trip to France, I was deeply moved by the sheer number of monuments created in honor of those who died in World War I. The unprecedented number of wartime casualties introduced the concept that when a country loses a huge portion of its population in wartime, it has a need to acknowledge and defend the sacrifice in a public manner. In Western Front countries, the thousands of national, local, and private memorials that were built became, and continue to be, places of pilgrimage and remembrance, along with the hundreds of military cemeteries where soldiers lie buried.

A desire to examine the manner in which these men are still memorialized today became the catalyst for the body of work titled *Tears of Stone: World War I Remembered*.

Undertaking acts of remembrance to lost loved ones can be a profound experience, regardless of culture or era. As long as the objects of remembrance that came to be built after the Great War continue to exist, it is my belief that the memory of those who fell will continue to be honored. In that sense, these photographs act both as a reminder of the ongoing cost of historical events and as a mirror to the human heart.

Process Information

Two medium format panoramic cameras, a Pinoramic 120, and a Noblex Pro 6/150 U, were used to photograph *Tears of Stone: World War I Remembered*. Working in a panoramic format allowed me to make pictures that did justice to the

nature of my subject. I chose to include a black border around each photograph in part to lend visual gravity to their content. However, it is customary in many European countries to include a black border around obituary notices and photographs of the deceased. Including a black border around photographs of European war cemeteries and monuments was consistent with that custom.

After editing from contact prints, the negatives of the chosen images were drum scanned and retouched in PhotoShop®. The exhibition prints were made on Epson® printers with Piezography™ BW software and quad black inks, on Wells River digital watercolor paper.

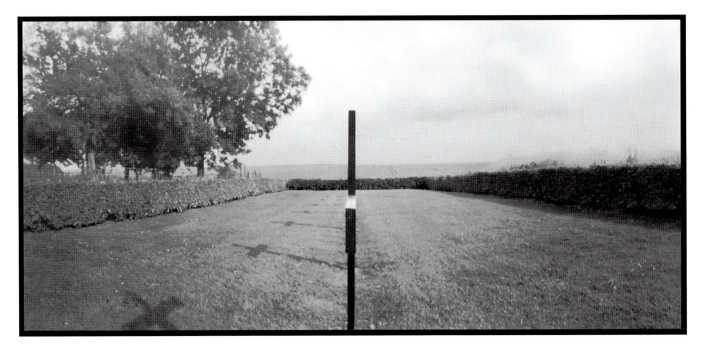

Achiet-le-Petit German Military Cemetery, France.

Fort Douaumont, France.

Chatham Naval Memorial, England.

Voormezeele Enclosures No. 1 and 2 (British), Belgium.

T. JOHN HUGHES

CITYSCAPE PANORAMA PROJECT

ARTIST STATEMENT

The *Cityscape Panorama Project* is a manifestation of my interests in the built environment, change, downtown Denver, panoramic viewing, light, and the preservation of memory.

In 1992 I walked throughout Denver, taking 160 snapshots with the intention of deciding on a certain number of views that would define the city, and set the stage to record its fabric and pace of change. These were edited to 40 views that I believed accurately represented the various looks of downtown from attractive to ugly, from humorous to sad, from boring to stimulating. I stepped away from my commercial sensibilities of making everything look glamorously lit and planned to shoot at all times during the day.

I also planned to keep careful records of each shot, its location and the weather conditions, so that I could return in 5 years, repeat the shot under similar conditions and allow for an "apples and apples" comparison.

I have now shot each of the views three times, with a fourth planned for August and September of 2007. I have to say that the results have been highly rewarding on many levels, and eye openers as well.

This project has many facets and implications. Some are about form: lighting, composition, and timing. But the most significant aspects are definitely about content.

Watching the city change tells us about what works and what does not. It makes us think about what should remain, and what could change. It is a visual record in a society that has so many organized written records and so few organized visual records. On this topic, I have become a bit of an evangelist, encouraging communities of any kind to *visually* record their environments.

Showing this work has made me realize something important which is that I enjoy projects that appeal to my fellow artists as well as people completely removed from the art world. Both seem to be engaged by the photos, spending long periods examining the prints.

Finally, I would like my viewers to think about the value of the "preservation of memory." It is so easy for us to forget what was on a corner a short while after it has been replaced with something else. The Cityscape Panorama Project helps us retrieve those memories as individuals and as a society.

Process Statement

The *Cityscape Panorama Project* is shot on medium format color negative film, using an Art Pan camera with a ground glass back that yields a negative of 2¼" by 9½" with a field of view of approximately 90°.

During the first year of the project, I shot transparencies, and in ensuing years I have been able to reproduce the exact same compositions by taping outtake transparencies to the ground glass and using them to align the views. I scan the film and make digital prints.

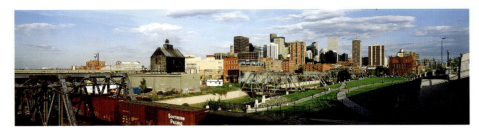

1992

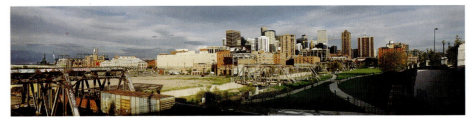

1997

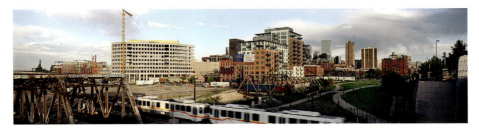

2002

Rail Yards, 1992, 1997, 2002.

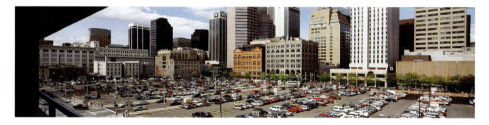

1992

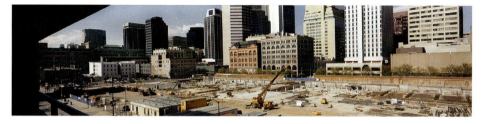

1997

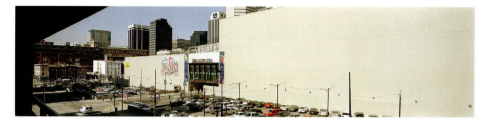

2002

Pavilions, 1992, 1997, 2002.

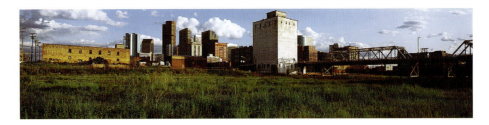

1992

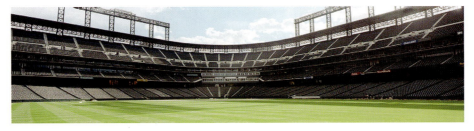

1997

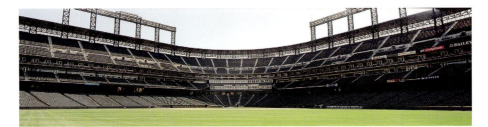

2002

Ball Field, 1992, 1997, 2002.

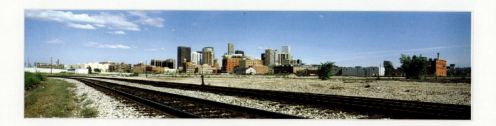

1992

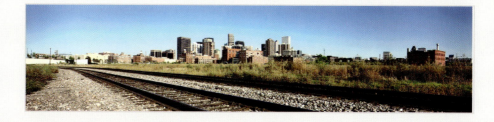

1997

2002

Arena, 1992, 1997, 2002

TONY MENDOZA

BOB

ARTIST STATEMENT

I've done art projects before (*Ernie: A Photographer's Memoir,* Capra Press, 1985) where I've focused on an animal for an extended period of time (2–3 years). *Ernie* was my first book, and my most successful book as far as sales, but since then I hadn't done an animal project. I figured, I've done that.

But then, Bob came along. Bob is my first dog, and I'm fascinated by him. I've been photographing him and his friends for the past 2 years. All the pictures are done with flash, and especially, from the eye-level of the dog. Animal pictures are usually done by photographers standing up and aiming down. The low vantage point captures their world from their perspective. Having the sky in every picture also provides a cool tone to balance the warm colors of the dogs.

Process Statement

I shoot all the pictures with a Nikon 10 megapixel digital SLR. All the pictures are shot with flash, which allows me to stop motion, use a large depth of field, and provide terrific sharpness. I usually take a lot of pictures of every situation and always check the camera's display after every picture, to see if the exposure and the frame are working for me, and if they are off, I adjust for the next shot. I print them at home with an Epson wide printer, to a size of 24″ × 36″, on Epson ultra smooth fine art paper.

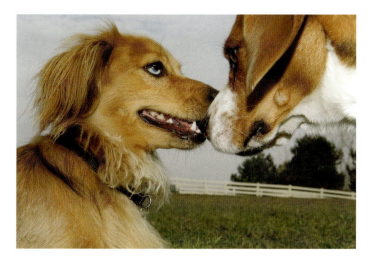

Untitled, from Bob.

Untitled, from Bob.

Untitled, from Bob.

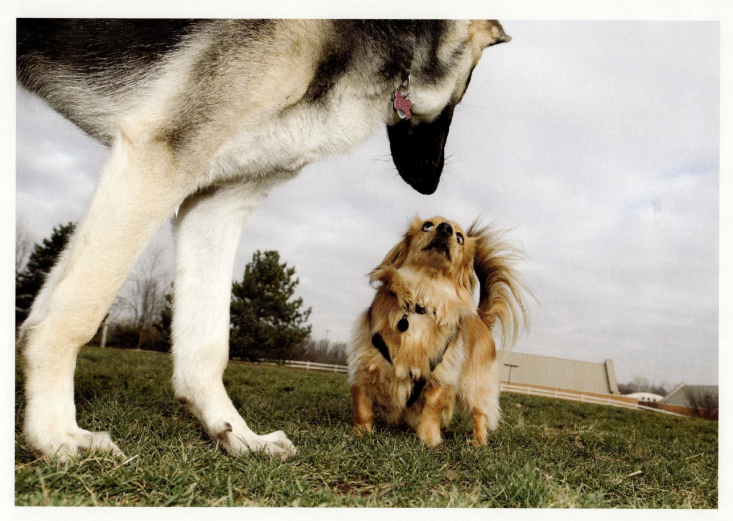

Untitled, from Bob.

TOM COAKER

LIVING ON BENSON HIGHWAY

ARTIST STATEMENT

My work explores ideas of representation, and I often attempt to simultaneously engage realistic and idealized reads of my work. By instilling some measure of doubt or uncertainty concerning the images, I endeavor to explore the representative nature of images on what and how we think. It can be through association, questioning ideas already formed, or bringing about new ones by prompting the viewer into interpretive dialog. This allows a kind of semiotic approach to the work: studying signs and symbols, what they mean, and how they relate to the things or ideas they refer to or represent. This work focuses on a short stretch of county highway that was once a major business thoroughfare and has since been severely impacted by the adjacent construction of a newer interstate highway. Now lined with defunct shops, bars, restaurants, derelict motels, and homeless encampments, the numerous dislocated shopping carts found in the area became acutely symbolic of how the landscape and its inhabitants had been transformed as a result.

A unique characteristic of any work of art is its capacity to provoke a viewer's imagination based on representation. Interpretation of a subject's meaning is dependent on both the objects represented and the setting of representation. In photography, every time you compose an image you make choices about *framing*. It's important to have the final image in mind, so as to arrange things in order to achieve the desired effect. Framing provides the general background or context within which something takes place. To allow for a contextual read, it's essential to look for compositional devices that add meaning to the subject matter. Working with the premise that "meanings are contextual" or rather that something, in particular an object, does not inherently have meaning suggests the *meaning*

is dependent on the setting in which the representation occurs. Thus *juxtaposition* comes into play, and placing two or more things together suggests a link between them or emphasizes the contrast between them. Successful framing will ultimately allow the meaning of the image to effectively begin revealing itself.

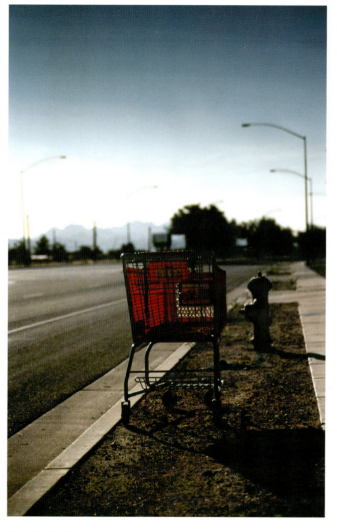

Roadside #1, 2004.

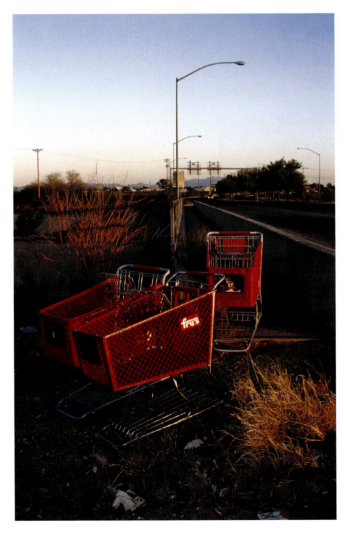

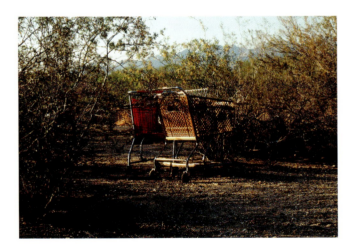

Homeless Camp #1, 2004.

Highway Ramp #1, 2004.

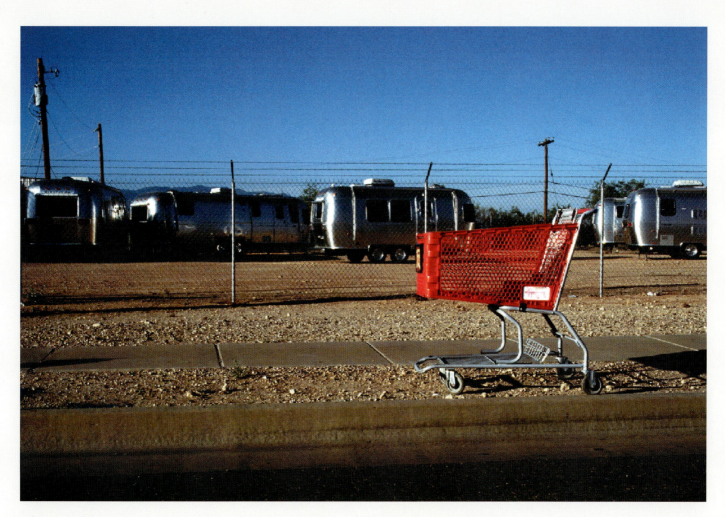

Airstreams, 2004.

PHOTOGRAPHS © TOM COAKER, FROM HIS SERIES *LIVING ON BENSON HIGHWAY*; 13″ × 19″ INKJET PRINTS.

SYLVIA DE SWAAN

SUB-VERSION SERIES

ARTIST STATEMENT

I'm a Romanian-born photographer who has lived and worked in Mexico, Europe, and the United States. Since 1990 my work has been involved with ideas about transience, loss, identity, memory, and war. I'm interested in the lines of destiny that shape our lives and the tidal waves of history that can sweep those lines away.

My current project, *Sub-version* was begun in the aftermath of 9/11 as an effort to conjoin the scenes of violence emanating from my television with the eerily quotidian view of life outside my window. I combine documentary and staged photographs to explore interconnections between truth and fiction and to portray how politics and world events increasingly enter our daily domestic sphere.

Sub-version is about terror, mass media, post-millennial anxiety, dual realities, shadowy threats, and ominous rumors.

Regarding Framing and Borders

I work mainly with 35-mm film cameras and wide-angle lenses for maximum portability, spontaneity, and engagement. My hands are so familiar with the equipment that I don't have to think about mechanics and can direct my full attention on the formal aspects of the picture and the mood and meaning I'm seeking to create. I compose with an awareness of the edge of the frame, allowing reality to play itself out before me—until that crucial moment of tension and rightness when I choose to release the shutter.

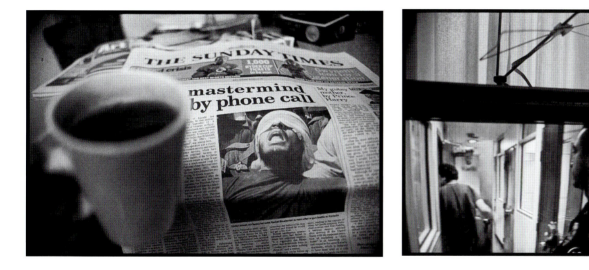

The Times, London, September 18, 2002.

Intrusion, Utica, NY, September 15, 2001.

Arrivals, Austin, TX, March 19, 2003.

Inflight Fiction, Gatwick to Newark, September 23, 2005.

MISHA GORDIN

CONCEPTUAL PHOTOGRAPHY

ARTIST STATEMENT

The greatest power of the photograph, our belief in its straight-forward truthfulness, has been lost forever. We place our confidence in what accurately represents reality, and photography, with its realistic accuracy and exactitude, has long been aligned with "truth" and its etymological relative, "trust." Its undeniable advantage to painting and other mediums is that we subconsciously believe that what is photographed has to exist.

In the digital era, however, truth can be conjured and changes made quickly, with no chemicals, no darkness, and no mistakes.

My first introduction to digital photography demonstrated how similar it is to analog techniques and I believe that a soul of a photograph, its magnetic language of feeling, can be achieved both ways. At this moment, however, I do not see any reason to switch to digital manipulation. I still prefer the glowing quality of the original print and the laborious process to achieve it.

Process Statement

All my images are assembled in a traditional darkroom under one enlarger using a masking technique developed and perfected over the years.

The process is always the same. Once I have determined my concept, I work out my compositions in sketches. Using my sketch as a guide I photograph components of a future image. Before I print the original, I make tests and adjustments for every negative to be printed. I write the tables where I indicate the proper exposure and all sequences of manipulations for every negative used. Next is the stage of "dry" printing. This part is the most unforgiving. I meticulously project one negative after another, constantly changing precise masks until the last negative is used. One mistake and lots of time is wasted.

The next step is the most exciting part of the process— developing the print of the first edition. I usually print editions of seven plus three artist's proofs.

After the first print is developed and closely inspected, the tension disappears. It feels like returning home safely after a long, long drive.

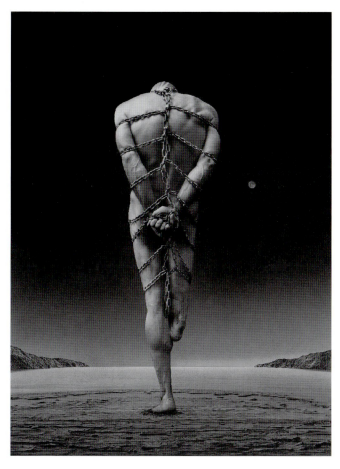

Doubt #11.

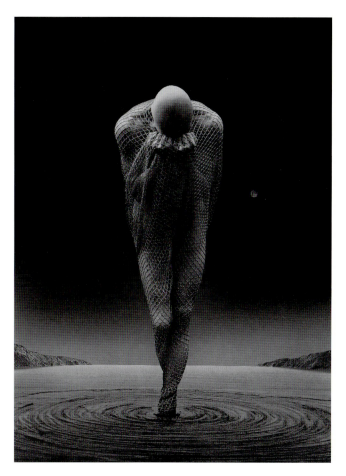

Doubt #12.

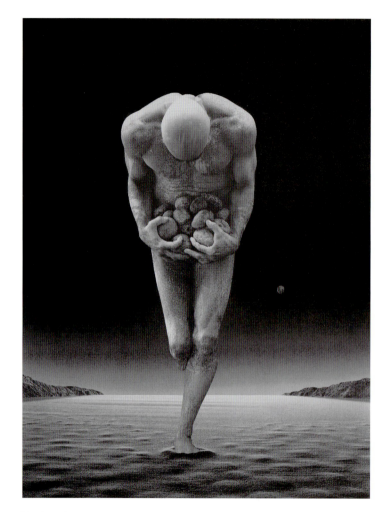

Doubt #15.

PHOTOGRAPHS © MISHA GORDIN, FROM HIS SERIES *DOUBT*, 2004; 18″ × 22″
GELATIN SILVER PRINTS.

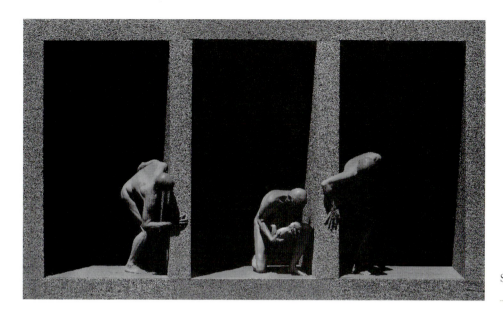

Sheptun #4.

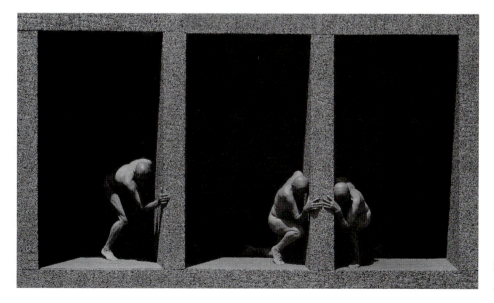

Sheptun #1.

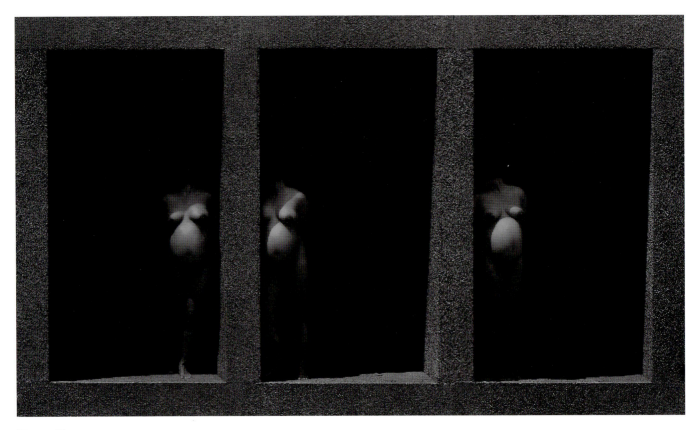

Sheptun #5v.

PHOTOGRAPHS © MISHA GORDIN, FROM HIS SERIES *SHEPTUN*, 2004; 18″ × 22″ GELATIN SILVER PRINTS.

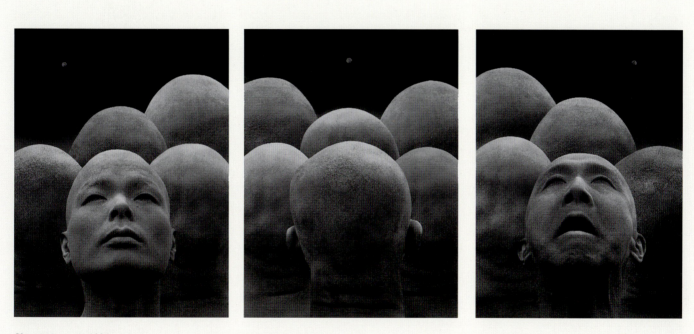

Shout #13, 14, 15, 1986.

PHOTOGRAPHS © MISHA GORDIN, *TRIPTYCH* FROM HIS SERIES *SHOUT*, TRIPTYCH SANKAI JUKU; 19″ × 22″ GELATIN SILVER PRINTS.

PART 2: USING MULTIPLE FRAMES

The frame is the most basic element of photographic image making since it is the first element you encounter—before apertures and shutter speeds, and more immediately than media choices—when you pick up a camera. The most straightforward way to use the frame is to simply make photographs—take single slices out of time and space—and print them. But many photographers choose to represent their subjects through the use of two, three, or multiple frames configured as diptychs, triptychs, panoramic, or montage images, and they do so for several reasons.

First, the use of multiple frames allows artists to create images that cohere through *gestalt*; that is, several images are combined to be interpreted as a unified whole. Images such as these force the photographer (and the viewer) to consider the multiple frame edges—their relationship and proximity to one another—and their relationship to the subject and content of the image. In this way the interrelationship of frames has a direct bearing on the meaning and interpretation of the image.

Second, using multiple frames allows photographers to create panoramic images and multi-panel pieces. In making these images, photographers can capture physical space outside the camera frame's format; it allows photographers to create images that include a wider angle of view than the camera's format could otherwise capture. Some of these types of images are seamlessly "stitched together" in the

traditional or digital darkroom, but in the end those can be considered in the same way as a panoramic image made with a panoramic camera—as a single frame. What concerns us here is the creation of images that maintain the multiple-frame character of the image.

A third reason to use multiple frames is that it allows the artist to represent the passing of time without blurring, and as such is a conceptual means of breaking out of the single frame = single image mentality, as artists such as David Hockney so famously put to use. This is not the same as using a sequence of images, as, say artist–photographer

Duane Michals does; it instead uses several images read as a single image to illustrate the passing of time.

Finally, using multiple frames in the form of collage or montage allows artists to incorporate historical and other images in order to make statements which expand on the subject of the image, as in the recent works by Mark Klett and Byron Wolfe (see the Portfolio Pages of this chapter for examples of their work).

This part of Chapter 1 is not about multiple exposures or multiple printing techniques (those are more closely related to the element of time which will be covered in Chapter 3);

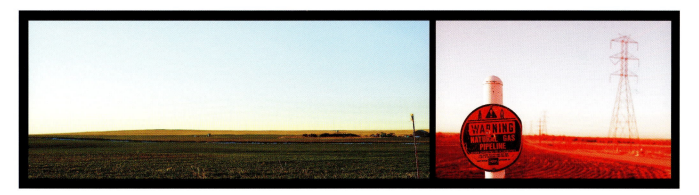

IMAGE © JOE LAVINE, 2007.

This dual-panel panoramic image allows photographer Joe Lavine to work with the relationship of the color in the landscapes individually; the effect makes the message of the scene more visceral.

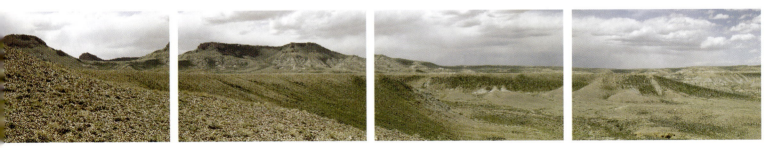

IMAGE © ANGELA FARIS BELT, *WYOMING LANDSCAPE,* **JUNE, 2006.**

This seven-panel panoramic image was made on my first expedition to Wyoming. The view was so wide and expansive, and so foreign to me, that I wanted to make a panoramic image of it. I placed my camera on a tripod, only generally leveled it for each frame using the circular bubble level on the tripod head. I paid attention to content in the far right edge of each frame, being careful to repeat that content slightly in the far left side of the next frame as I panned to the right. The slight repetition serves to elongate the image and contributes visual continuity from frame to frame so that the seven frames are more easily perceived as a single image.

it is about using multiple frames to create a single image, used to extend and add complexity to the way you would approach single frame images of the same subject. Think of using multiple frames as similar to individual stanzas in a poem: their proximity to one another within a single poem defines each as part of the larger whole; they may be interpreted individually, but in order to gain the complete meaning of the poem one must consider all of the stanzas together. In multi-frame images, each individual frame, like each stanza, has its own self-contained (framed) content, and as such is somehow divided from the larger whole, but only in relation to the other frames in the

piece (other stanzas in the poem) is the image considered whole in its ability to fully communicate meaning. Like stanzas, multi-frame images tend to have components of equal or measured size for the purpose of structural unity, but this is by no means the rule.

Following is a discussion of some common types of multiple frame image techniques.

MULTI-PANEL PANORAMAS

You see them quite often: the scene that has too wide an angle of view to capture in a single frame. So you proceed to make several exposures in a row from left to right and

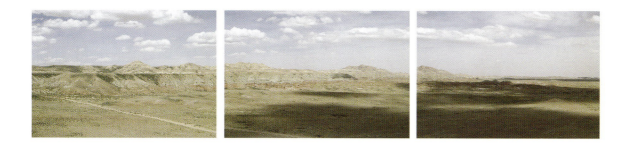

put them together later. The process can be either simple or complex, depending on whether it's important for the images to align perfectly. To clarify, although the general process is similar, we are not talking about shooting several digital frames in order to make a seamlessly stitched panorama in Adobe Photoshop; that would defeat the point of bringing multiple fames into the discussion. We are talking about using several, clearly distinguishable frames placed together to make a single image.

The easiest way to make a multi-panel panorama is to simply make a sequence of images which, when printed together or placed next to one another in order, are read as a single image. You do not need a tripod to create these types of images; you only need to pay attention to the contents at the frame edges where the images will "adjoin." You can make successful multi-panel panoramic images this way, but you should know that the results will be very

different from those achieved though use of a tripod and a bubble level.

Making Multi-frame Panoramas

If you are making panoramic exposures, whether to stitch seamlessly or not, there are several technical considerations to be aware of. The Technical Tutorials Section for Chapter 1 provides more information about how to successfully create images such as these.

Dividing the Single Frame

In order to use multiple frames or create an image which relies on gestalt, you don't necessarily have to capture several frames; you can also divide a single capture into multiple ones. In the following image, I saw hundreds of birds flocking, preparing for their winter migration. The scene looked like utter chaos from the outside. I made some

photographs, which I immediately cropped into a wide horizontal to follow the density of the trees surrounding the bright cornfield. After evaluating this image, I chose a different edit and decided to conscientiously crop it into four separate panels, aligning the content between frames. The multiple panel image is the one I chose to represent the scene, since it added to the feeling of rhythm and frantic energy of the scene.

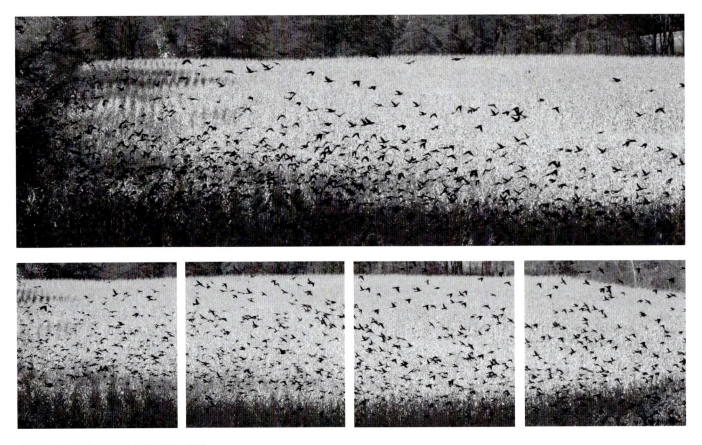

IMAGES © ANGELA FARIS BELT, 2006–2007.

MAKING CONTACT SHEET IMAGES

Images that use the structure of the contact sheet itself can be an interesting way to combine a direct reference to the medium with the subject to a viewer. Making successful contact sheet images can be extremely difficult, and it takes a good deal of planning prior to shooting. The following tips will help you along:

1. If you are using traditional film, be sure to understand the orientation of the film and the direction it advances inside the camera. Also, determine how the film fits into its designated sleeves, or plan to hand-place your negatives under glass in a pre-considered configuration for printing.

2. If using digital media, pre-determine how many rows and columns of frames you will want in the final piece, and match that configuration when you go to File > Automate > Contact Sheet II. You will have to be sure to name your files in such a way that they are placed in order when the automated function runs. You could also place the images by hand using layers.

3. Sketch out your ideas beforehand, using a template that has the correct number of frames you will use in the final piece in the order you will organize them. Also

make sure that the template has individual frames that are to the proper size and orientation.

4. Decide beforehand if you want a fixed perspective; if you do, then you want to use a tripod.

5. Before you begin, determine proper exposure by metering an average (middle-gray) part of the scene or using an incident-light meter, and keep your exposure the same throughout the contact sheet regardless of your camera meter's changes from frame to frame, otherwise your image will not have consistent density.

6. Keep your focus point where you want it. If you want to create a contact sheet that is visually similar to a single capture, zone focus and keep your focus point at the same distance by turning off any auto-focus capability that the camera has. If you want to use selective focus as part of the image, you can re-focus to different distances throughout the process, and you can mimic shallow depth-of-field to isolate your primary subject frames by capturing the surrounding frames intentionally out of focus.

7. Once you choose your subject and camera position, do a "dry run" by moving the camera from position to position in order using the focal length you intend to use, and considering your distance from your subject

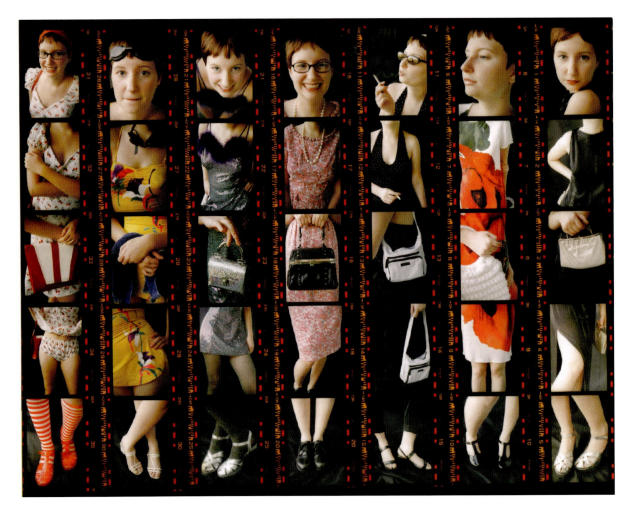

© **JASON LAVERIS**, *STACEY PLOTT CONTACT SHEET IMAGE*, 2000.

This contact sheet image was made by one of my students. His whimsical approach of dividing the image into seven scenes based on the structure of the contact sheet was inventive, and allowed his friend and collaborator Stacey to show off her extensive wardrobe. Jason is currently working as a freelance photographer in Los Angeles.

(the most common problem with failed contact sheet images is that the photographer was too far away from the subject matter).

Thomas Kellner's work provides an excellent example of what can be done using the contact sheet or any other grid-type configuration to make a multi-panel image. See examples of his work in the portfolio pages of this chapter.

There are innumerable ways to combine several images into a single piece; the idea is to think about how multiple images might communicate about your subject, and what using multiple frames will allow you to accomplish that using a single frame could not. Experiment, practice, be open to conceptual implications, and notice all of the multiple frames around you.

CHAPTER EXERCISES

In these exercises you will take framing one step further, and use multiple frames in order to help you communicate about your chosen subject or concept. Take a "no-holds-barred" approach to conceptualizing and creating your images, in particular when it comes to thinking of ways to place several frames together in order to make your images. Problem-solve to overcome any technical or equipment

hurdles so that you can make your images exactly as you want them.

Exercise No. 1: Multi-Panel Panoramic Images

Make a series of photographs in a row with the intention of printing them as a multi-panel panorama. You may use a tripod or not for this exercise, but know that your results will be very different depending on which way you choose. Be sure to keep your exposure the same throughout each series of images that you intend to print together. If you intend to enlarge negatives in a traditional darkroom, remember to consider the size constraint of the enlarger you're using; a 4×5 enlarger can print a panoramic image using three 35-mm frames across using a handmade or glass carrier. Alternatively, you could print each image separately and determine the best way to physically arrange them after printing, using window mat to separate them, or dry mount them flush with one another overlapping in the appropriate places.

Exercise No. 2: Contact Sheet as Image

In this exercise you will use the format of the contact sheet to create an image. Consider what the format—the space between frames and the use of so many frames—of a contact sheet has to add to a viewer's perception of your subject.

Shoot each frame deliberately, so that when they are printed together as a contact sheet, the image revealed in the frames represents the unified whole that you had envisioned. The contact sheet will be your final piece, so there is not much post-shooting work to speak of; most of the work is up front. Making a successful contact sheet image can be easier said than done, because the image must be successfully planned and executed; one incorrect frame and the entire piece could be compromised. See the tips included earlier in this chapter for help. Remember that in the digital world a "contact sheet" can have a variable number of frames per column and row, and that the background color as well as the space between the images may be controlled by hand-placing and aligning the images onto a single canvas.

Exercise No. 3: Incorporating Other Images

In this exercise, you will use images that you have previously made, found imagery, or old family photographs, and build on them to create a larger whole.

Concentrate on building imagery that incorporates already existing imagery, in order to expand the viewer's understanding of your subject. You might decide to demonstrate the passing of time or a panoramic view (such as Mark Klett and Byron Wolfe do with the images in the Portfolio Pages of this chapter). Consider the dimension you can add to your statement about your chosen subject through thoughtful juxtaposition of multiple frames.

You may do this in the traditional darkroom by re-photographing old photographs, or digitally through scanning. You may choose to use collage, montage … anything goes, really. Push your ideas about your subject, continue conducting independent research about it, and expand the interpretive value of the images you use and create.

PORTFOLIO PAGES

The photographer–artists represented in the *Multiple Frames* portfolio pages all use more than one image to piece together a more faceted view of their subjects than the single image could provide, to defy the hold of time over the single capture, and to create significant visual and conceptual ties to their subjects. Their work is not about multiple frames; however, the meanings that these images communicate would not be possible without the use of multiple frames. Their meaning is intrinsic to the physical interrelationship and/or interconnectedness of the frames. Conceptually the images depend on this interrelationship; photography theorist Terry Barrett might refer to them as "theoretical" on that level in that the use of multiple

frames is often used to comment on "modes of representation" (1990, p. 68), and included in these modes is the widespread and historic use of multiple frames. In creating their images these photographers use film, digital, and combined media to suit their specific needs. The following Artist Portfolio Pages should inspire ideas and discussion about these notions and more regarding the use of multiple frames.

THOMAS KELLNER

ARTIST STATEMENT

My work has been titled in very different ways in the past years. Usually I go back to its basic technical description: contact sheets.

Some have called my work deconstructive, others collage, de-collage, or montage, some say it is architectural photography—no and yes; only the subject is architecture. In a time where everyone turns to digital photography (some have not even used film in their life at all), "indexprints" might be the more contemporary description, I still use film and I use every image on the roll. If I shoot on one frame the final size of the print is 20 × 24 cm, if I use 36 frames, the print is 100 × 120 cm. And because the single frames are all shot in sequence I simply cut the strips, mount them together, and make a contact print.

It all started in pinhole photography using an 11-pinhole camera and also one with 19 pinholes made for the whole length of a 35-mm roll of film. That was when I started to create multiple image reconstructions. I learned to collage on the negatives by shooting different objects or moving the camera in between each shot. This I do still today when I shoot architecture, each frame is a single shot and for each shot I tilt the camera differently.

But it all starts with choosing the object and finding the right time of day and weather (everything is shot with the same exposure time and aperture). Then I decide the final size of the image through the number of frames I am going to use. I already know how many frames there will be and I have to divide the images into this number of frames by finding the right focal length. I use a scale on my tripod to match all the vertical lines as they must line up precisely. Shooting can take anywhere between 30 minutes to 5 hours, depending on the size of the image.

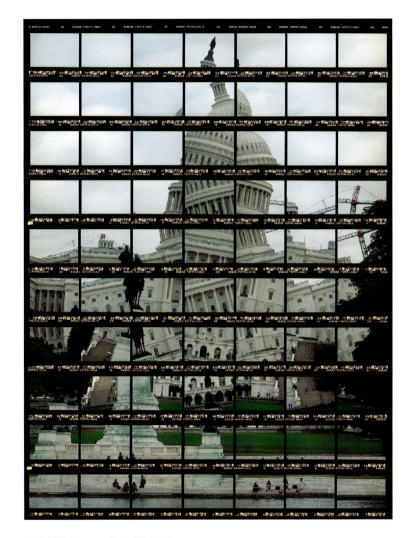

41#01 Washington, Capitol I, 2004.

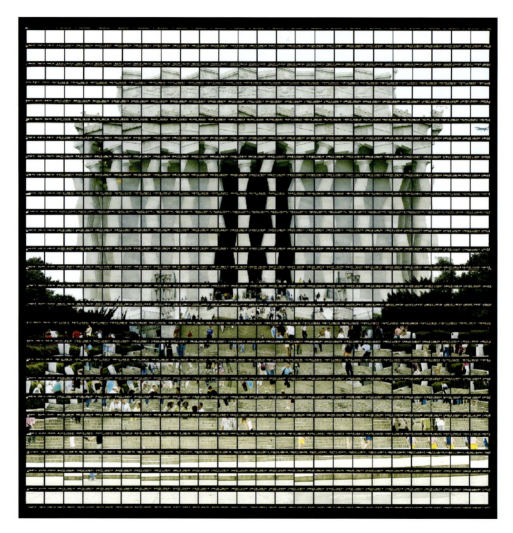

41#05 Washington, Lincoln Memorial, 2004.

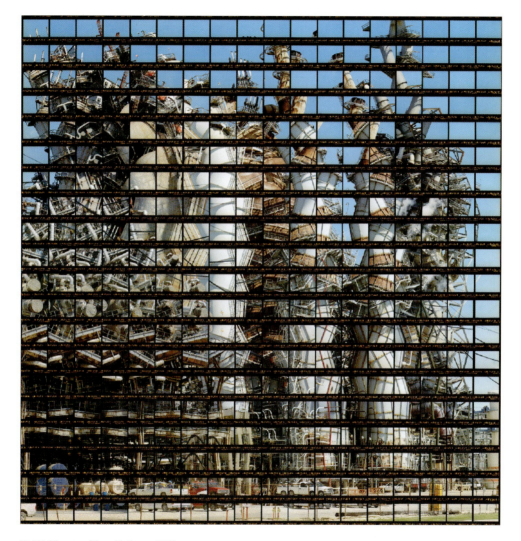

51#01 Houston, Texas Refinery, 2006.

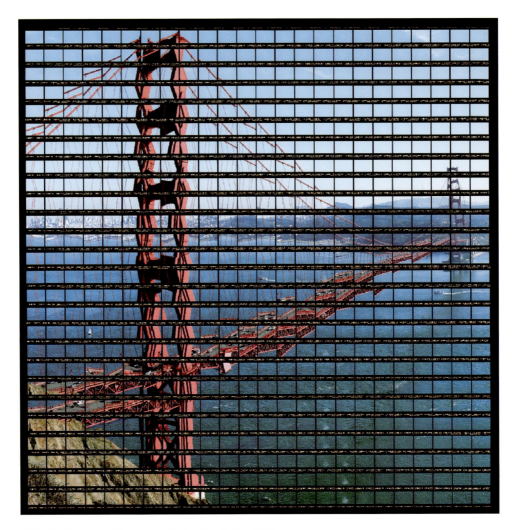

42#16 San Francisco, Afternoon at Golden Gate Bridge, 2004.

IMAGES © THOMAS KELLNER. LIMITED EDITION C-PRINTS, DIMENSIONS VARY.

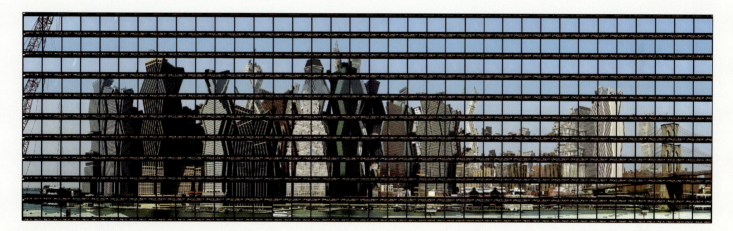

40#11 New York, Lower Manhattan Skyline, 2003.

MASUMI HAYASHI (1945–2006)

AMERICAN CONCENTRATION CAMPS

A note from the author: Masumi Hayashi is best known for her striking panoramic collages of Abandoned Prisons, E.P.A. Superfund Sites, Cityscapes, and Japanese Internment Camp Sites. The following artist statement was published alongside an exhibition of her series, American Concentration Camps, while it was on view at the Cleveland Center for Contemporary Art in 1997. These panoramic photo-collages document the remnants of World War II Japanese American Internment camp sites; in addition to the photo-collages, Hayashi interviewed camp survivors from the United States and Canada, and she collected personal photographs taken during their internment.

ARTIST STATEMENT

The Landscape of Place and Memory: American Concentration Camps

In February 1942, 3 months after the Pearl Harbor attack, the United States took unprecedented action directed at its own population. Executive Order 9066 and Civilian Exclusion Order 5 decreed that over 120,000 Japanese Americans be removed from their homes in the "western defense zone" of the United States and incarcerated in ten "internment" camps, which were located in isolated areas of Utah, Montana, Arkansas, Arizona, California, Colorado, and Idaho. These ten camps functioned as prison cities, with populations of 10,000 to 18,000 people in each camp.

With the bombing of Pearl Harbor, the Japanese Americans in America were no longer seen by other Americans as industrious, immigrant neighbors but were transformed

into enemy aliens overnight. There were no trials, no hearings to prove innocence or guilt. They were assumed to be the enemy and made prisoners, indefinitely incarcerated because of their race. Successful Japanese Americans were informed that, according to Civilian Exclusion Order 5, they were required to liquidate all property, including homes, real estate, business holdings, and anything else that they could not carry themselves into the prison camps.

They lost their homes, property, and communities. Families were separated. After the war there was a long silence because of their shame and guilt, not unlike the victims of the holocaust.

The work *American Concentration Camps* is about a collective memory of the camps that "interned" 120,000 Japanese Americans during World War II without trial. Its memories are about the reconstruction of that time and space 50 years later. It is about the transition of the immigrant Japanese American people caught between two countries at war; people caught without a country that would claim them as their own. It is about the their collective voices and memories of that displacement, and it is about the quiet silence that surrounds the land, those prison cities, and that time.

Almost 50 years later, Presidents Clinton and Reagan issued letters of apology to the camp survivors that are still living. Collective voices now reach beneath the surface of the stereotypical Japanese American image of passive acceptance, "gamman" ("endurance"), "shikata ga nai" ("it cannot be helped"), and survival. Their voices call out beyond anger and memory.

THE PANOPTICAN

The French theorist Michel Foucault noted that nineteenth century prison architectural plans were often based on the panoptican, where one prison guard can see all of the prisoners in their separate cells. Such a space exudes hierarchy and control. These photographs of the concentration camps are about a mapping of space. The viewer can instantly see a 360° panoramic view which would otherwise circle around her, thus the viewer becomes both prisoner and guard within the photograph's memory. The camera's eye records a panoptic space, an impossible two-dimensional space composed of overlapping cubist images. From over 100 images, sequential fragments make up one panoramic photo-collage, extended and stretched like a warped shoji screen. They present the gestalt of looking at many fractured images and seeing a unified whole. These photographs confront the viewer with the beauty of the natural landscape and ironically with the history and memory of the land.

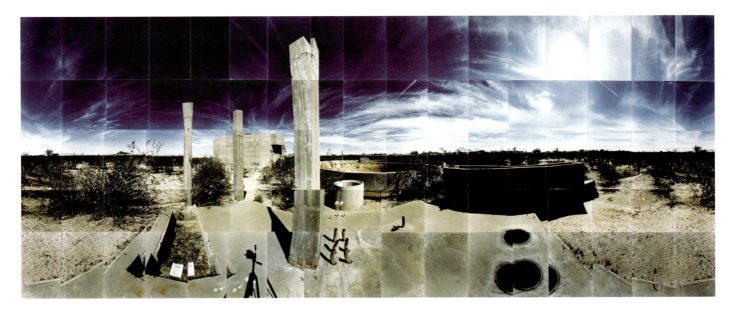

Gila River Relocation Camp, Foundations, Gila River, Arizona, 1990; 22″ × 56″.

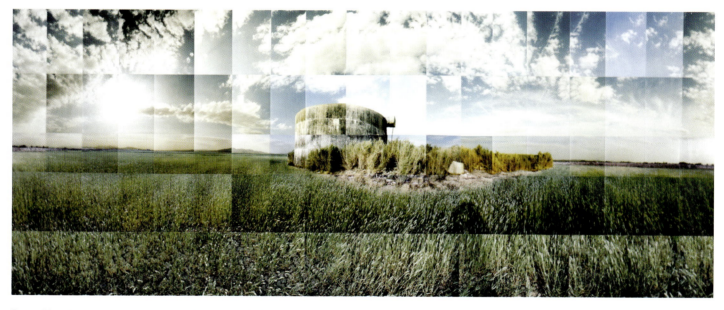

Poston III Relocation Camp, Sewer, Yuma, Arizona, 1997; 26″ × 63″.

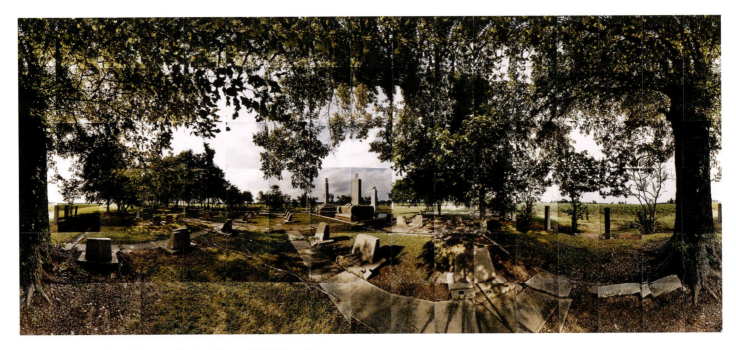

Rowher Relocation Camp, Cemetery, Desha, Arkansas, 1995; 33″ × 65″.

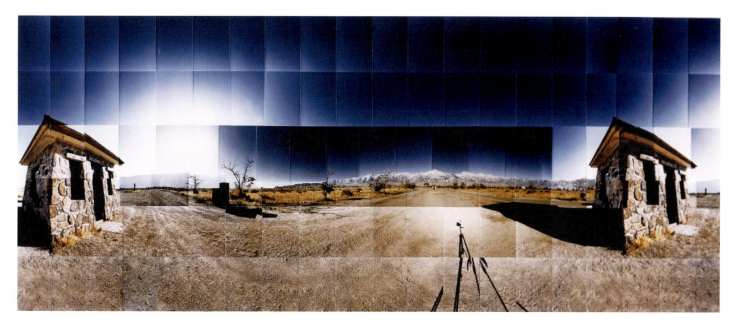

Manzanar Relocation Camp, Guard Gates, Inyo, California, 1995.

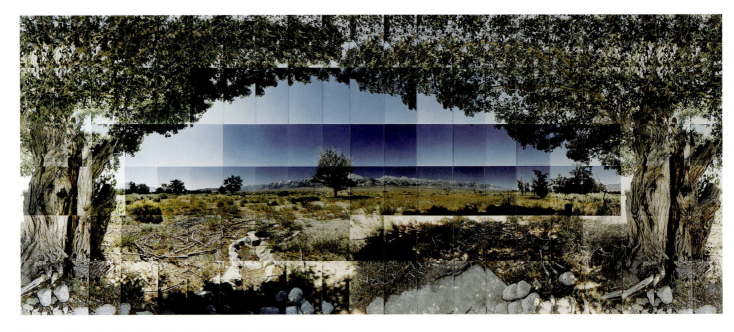

Manzanar Relocation Camp, Tree View, Inyo California, 1995; 22″ × 63″.

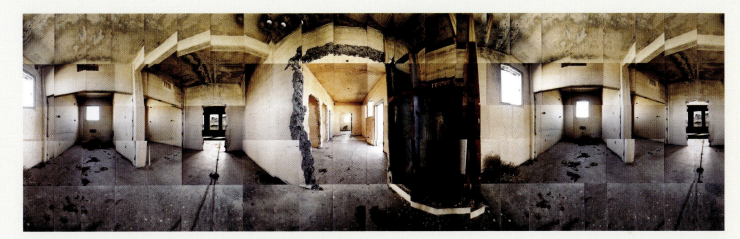

Tule Lake Relocation Camp, Tree View, Inyo California, 1995; 27″ × 79″.

MARK KLETT AND BYRON WOLFE

YOSEMITE IN TIME

ARTIST STATEMENT

We began our collaboration as a way of sharing ideas about time and change, and to examine the ways we had developed personal relationships with places. Working together we began with 19th century landscape photographs of the American West and made re-photographs from the same locations as the initial starting point for what became an extended form of visual research that combined historical images with scenes from the same location. By relocating the vantage points of historic photographs and embedding them into contemporary panoramas made of the contemporary view, the composite images revealed aesthetic decisions of photographers in both centuries. The pictures also clarified how the basic physical reality of the world is often quite different from what is suggested within the borders of an original photograph. Such comparative techniques are especially complex in Yosemite National Park—a landscape filled with many iconic photographs that helped define photography as an art form. Assembled as single, all-encompassing views that contain multiple historic images by photographers such as Carleton Watkins, Eadweard Muybridge, Edward Weston, and Ansel Adams, these multi-dimensional composites led us to consider a form of stratigraphic layering of physical and cultural changes across time and space.

Process Statement

Much of our collaboration takes place electronically through e-mail and digital file exchanges (Mark lives in Arizona and Byron is in California). Initially we gather and collect electronic versions of source pictures through online research or by scanning reproductions in books. In the field, we work together with printed copies of the pictures to pinpoint the vantage point of the initial photograph. We use a large format camera with Polaroid film to make test

pictures that we compare to the original view using visual cues and comparative measurements. We also sketch onto the Polaroid prints the projected frames of the original photographs. When making complicated panoramas, we trim and tape the Polaroids together to evaluate the visual continuity of the panels. As we establish the location for each panel, we record the image on large format color negative film. Back in our studios, we scan the film with a drum scanner and then begin the digital production, performing image correction, interpretation, and assembly in Adobe Photoshop. Once all the elements of a panorama have been assembled, we send the digital file back and forth for comments and revisions until we make a completed image that meets with our approval. The resulting images are printed using large format roll paper digital printers.

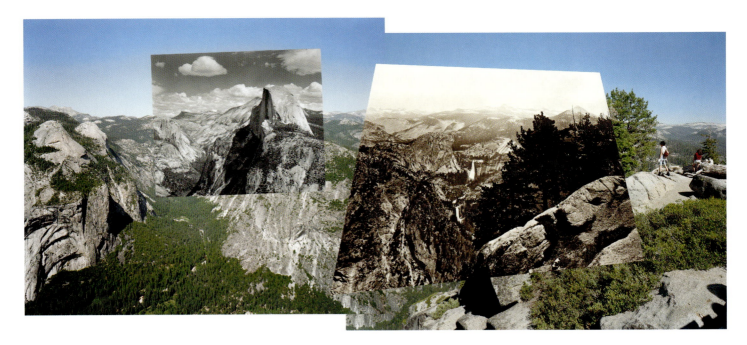

View from the handrail at Glacier Point overlook, connecting views from Ansel Adams to Carleton Watkins, 2003 (Watkins's photograph shows the distorting effects of his camera's movements as he focused the scene); inkjet print, 24″ × 54″
Left Insert: Ansel Adams, *c.* 1935 (*Courtesy*: The Center for Creative Photography, University of Arizona)
Right Insert: Carleton E. Watkins, 1861 (*Courtesy*: The Center for Creative Photography, University of Arizona).

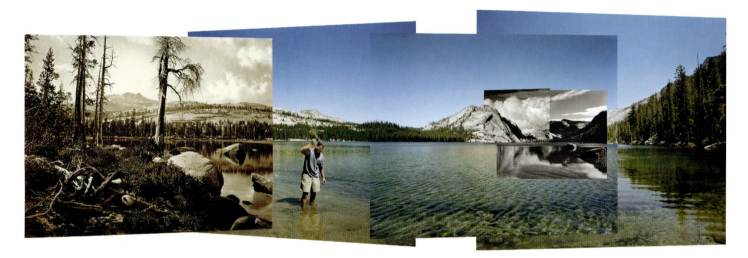

Four views from four times and one shoreline, Lake Tenaya, 2002; inkjet print, 24″ × 66″

Left to Right: Eadweard Muybridge, 1872 (*Courtesy*: The Bancroft Library, University of California, Berkeley)

Ansel Adams, *c.* 1942 (*Courtesy*: The Center for Creative Photography, University of Arizona)

Edward Weston, 1937 (*Courtesy*: The Center for Creative Photography, University of Arizona)

Back panels: Swatting high-country mosquitoes, 2002.

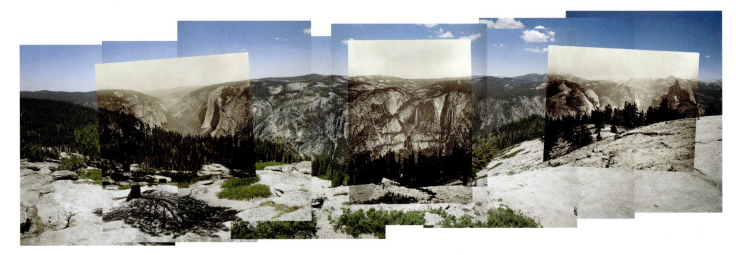

Panorama from Sentinel Dome connecting three views by Carleton Watkins, 2003; inkjet print, 24″ × 70″
Left Insert: From the Sentinel Dome, Down the Valley, Yosemite, 1865–1866 (*Courtesy*: Fraenkel Gallery)
Center Insert: Yosemite Falls from the Sentinel Dome, 1865–1866 (*Courtesy*: http://www.artnet.com/magazine_pre2000/reviews/fineman/fineman7-10-96.asp: Fraenkel Gallery)
Right Insert: The Domes, from the Sentinel Dome, 1865–1866 (*Courtesy*: Fraenkel Gallery).

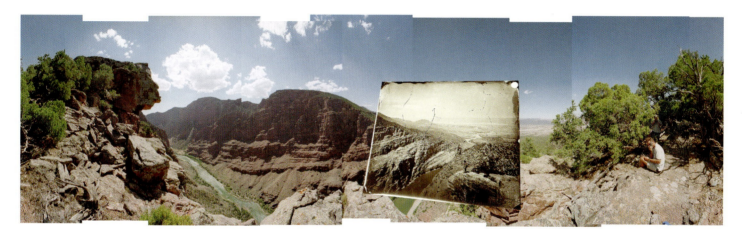

Panorama from Timothy O'Sullivan's 1872 *Canyons of Lodore*, Dinosaur National Monument, Colorado, 2000
Inset: Timothy O'Sullivan, 1868 (*Courtesy*: US Geological Survey).

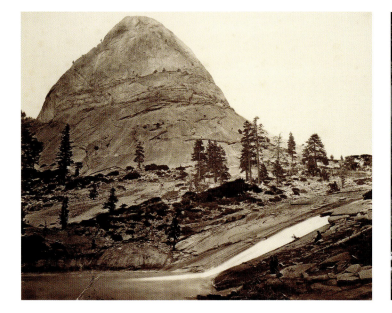

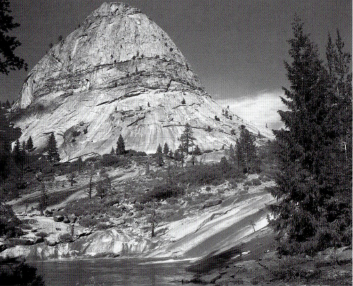

A: Eadweard Muybridge, Helmet Dome and Little Grizzly Fall. No. 42, 1872.

B: Mark Klett and Byron Wolfe, Sugar Loaf and Bunnell Cascade, Little Yosemite Valley, 2003.

C: Mark Klett and Byron Wolfe, Eighteen trees as clocks above Bunnell Cascade: the same trees 1872 and 2003.

MARK ESHBAUGH

DAY'S END

ARTIST STATEMENT

My continual experimentation with different cameras and different film formats has eventually led to the creation of my own unique camera that I use today. Through dedication to experimentation my images are works of art that incorporate the medium they're composed in.

The fractured imagery reminds us of the limitations of the medium and the limitations of our own memories. We cannot capture a complete moment of time with a photograph, just as we can never remember a complete moment of time accurately. Humans can only remember bits and pieces of a moment, and as time moves on biases and changed perspectives cloud that vision. Each fractured pane exists in a paradox of harmony and conflict. One moment the pieces are working together to create a whole image; the next moment the pieces are fighting one another, trying to capture your full attention.

Process Statement

Using both modified and cameras of my own design and construction, all images are shot on multiple rolls of film simultaneously. While many of the images are lens-based, some photographs are pinhole images. All images are silver gelatin prints made from the unaffected negatives straight from the camera exposure. The edge markings are from tape used to hold the negatives in place in the enlarger framing each image within the print itself. The coloration is made through the multiple and selective use of archival toners that change the silver halides in the paper base. The chemical reactions result in a more stable compound, increasing the longevity of the print and creating the colors perceived. No color photographic materials are used. As a result of the extensive toning each print is unique in tonality.

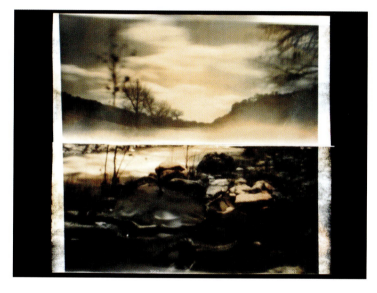

Untitled #289 (Austin, TX); 12″ × 18″.

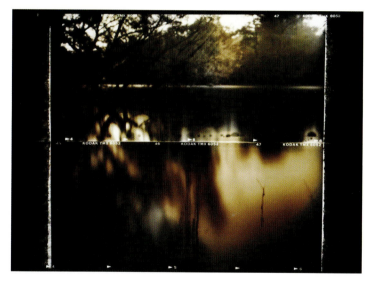

Untitled #169 (Ogeechee River, Savannah, GA); 12″ × 18″.

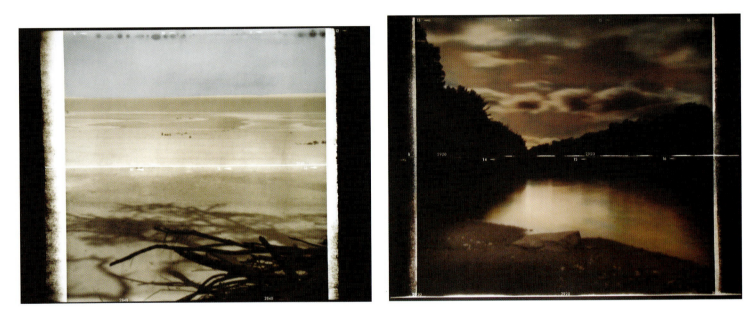

Untitled #265 (Hunting Island, SC); 10″ × 14″. Untitled #276 (Westford, MA); 12″ × 18″.

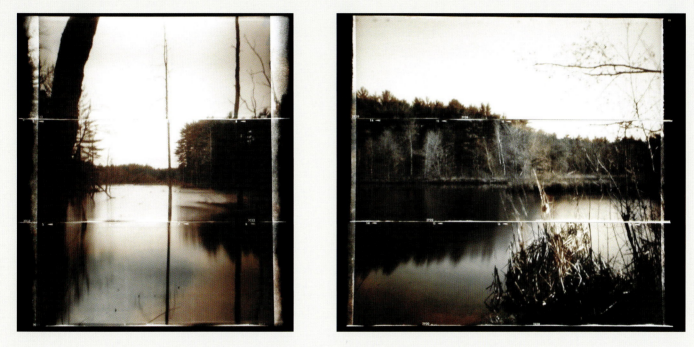

Diptych (Left: Savannah, GA; Right: Carlisle, MA) from the series *Day's End; Image size*: Left: 9.5″ × 9″; Right: 9.5″ × 11″.

KATHARINE KREISHER

CONTEMPLATING PEACE

ARTIST STATEMENT

All my images begin with photography. Over several decades of art-making, I have altered photographs of myself and my personal environment by employing the distorting effects of handmade cameras, linking pictures through direct collage, painting on the surface of finished photographs, transforming them as photo-etchings, and eventually feeding them to the computer.

Current images about one's unstable sense of self in an unpredictable world are driven by archetypal images derived from dreams. I begin with pinhole photographs, because they extend the serendipitous nature of the photographic medium, supplying me with pictures that seem to come directly from the unconscious, the source of dreams. The process is enhanced by the re-interpretation of everyday experience through meditation and disciplined yoga practice. For me, the images reflect our anxious experience of ongoing metamorphosis as elusive, fragile constructed identities shift throughout life. The contemplation of images emerging from the unconscious supports a search for peace, both an individual peace of mind and a shared universal peace.

Process Statement

The original pictures for the *Contemplating Peace* diptychs are made outdoors through very long exposures (more than half an hour) in a large corrugated cardboard pinhole camera that holds 11″ × 14″ fiber-base photographic paper. I participate in the extended exposure time by holding quiet yoga poses or meditating or simply watching leaf shadows shift on the lawn. The time becomes a slow and fruitful contemplation of peace. After development, I generously (or subtly) alter some of the paper negatives by drawing with Prismacolor pencils or painting with Marshal's photo oils. Then I scan the painted pinhole

photographs to my computer for further manipulation in Photoshop where the files are stacked in a tight diptych format creating tall extended frame digital prints. This vertical extension enhances meaning by referencing dualities and hierarchies, and by suggesting either progressions or simultaneous events. Between frames comparisons can be made, narratives invented, real and imagined worlds linked. In some images the device works to extend the observable visual space, while in others quite separate spaces (perhaps internal and external states of being) are implied.

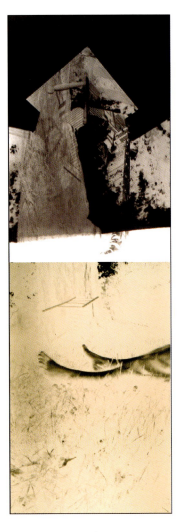

Contemplating Peace: Corpse Pose, 2006.

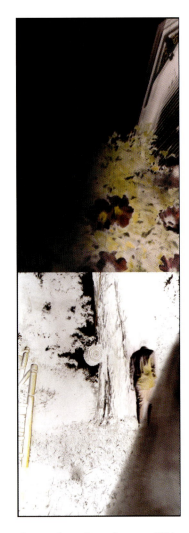

Contemplating Peace: Sunspots, 2006.

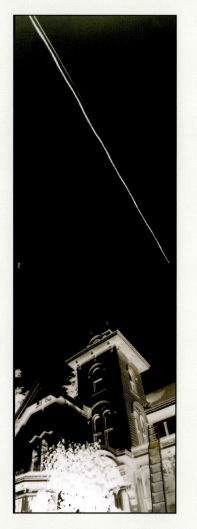

Contemplating Peace: Tower, 2006.

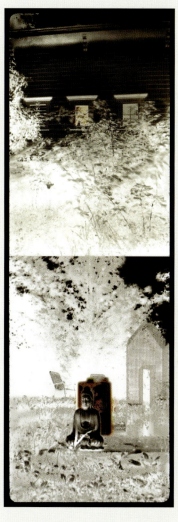

Contemplating Peace: Two Buddhas, 2006.

FOCUS: APERTURES, LENSES, AND DEPTH OF FIELD

"My primary project has always been in finding ways to make the viewer aware of their own activity of looking at something."—Uta Barth

FOCUS: THE SECOND PHOTOGRAPHIC ELEMENT

Have you ever seen a painting you identified as "Photorealistic?" What was the primary quality of that painting that made it most like a photograph? The answer: the *quality of focus* it depicts. What sets Photorealistic paintings apart is that they depict a scene *the way a camera would see it*, and photographs, no matter how closely they seem to approximate human sight, never depict the world *as we see it*. Photorealism *looks* photographic primarily because it reproduces a sense of the camera's monocular vision, which, as discussed in Chapter 1, differs from our binocular vision in the way it flattens depth perspective onto a two-dimensional plane. The physical characteristics of the camera's aperture and lens, that camera vision allows variable depth of focus, along with the ways in which framing operates, create an image that is altogether different than the one our eyes and brain create. It is those physical characteristics that impose themselves upon the focus (or sharpness) of the images they apprehend, and it is those characteristics that Photorealism explicitly acknowledges in its creations. Our visual memory enables us as viewers to recognize the differences in quality of focus as uniquely photographic, and in so doing requires us to relate to the subject and content of Photorealistic paintings in a specific way. I use the example of Photorealism to begin this discussion because through painting, quality of focus is called to our attention in a way that is so implicit, so transparent, that it is often lost when we view photographs.

Since the invention of photography, the disparity between the appearance of images captured by the camera and those apprehended by human vision has been of primary importance to its practitioners and viewers. The relevance of this disparity deals with the quality and depth of focus. Images captured by the action of light (through an aperture or lens) exist on a sort of continuum with a familiar center: the quality and depth of focus produced by human, binocular vision. On one end of the focus continuum are images that are somehow "clearer and more descriptive" than our own eyes can see, and on the opposite end are images that are somehow "hazy and less specific" than human vision generally affords. Precisely where the focus in an image is fixed on the continuum greatly impacts how it communicates about a subject, as well as the way it is interpreted by viewers.

The ways in which photographers and artists have represented quality of focus has had an extreme range since the conception and use of the earliest camera, the camera obscura. Scientists were inspired by the ability of the device to render the visible universe more objectively and more

accurately than the mind's eye tethered to the hand could render. By 1850, only a few short years after photography could record the ephemeral image, daguerreotypes began a precedent of photographic processes replacing traditional forms of manual reproduction for any purpose that relied on fidelity and descriptive quality. Conversely and almost immediately, the Pictorialists became photography's first practitioners to successfully embrace the value of the specific *lack of sharpness* that the camera-made image could deliver. This began several waves of practitioners using it as a form of art for rendering expressive rather than descriptive images. Around the same time, the still point of the focus continuum was located with P.H. Emerson and the Naturalists, many of whom consciously manipulated the monocular vision of the camera in such ways as to attempt to approximate human vision's quality of focus.

Throughout its history, the camera's unique quality of focus has offered photographers control over the appearance and meaning of images; today, visually literate photographers have even more tools at their disposal that allow the controlled manipulation of focus if they understand how to use it. At the one side, sharply focused photographs carry connotations of specificity, and by extension, truth and reality. Viewers more readily equate sharp focus with what was present in front of the camera, and the more descriptive it is, the greater our degree of trust in the accuracy and factualness of image. Documentary, photojournalistic, and evidentiary images rely on sharp focus for this very reason. Photographs on the opposite end, those that use soft or distorted focus, remove this relationship between the contents of the image and the seen world. They connote a vague essence of things, and an atmospheric or more overtly filtered image of reality. In addition, the softly focused image guides the viewer's attention more consciously to the act of seeing.

APERTURES: A BRIEF TECHNICAL BACKGROUND

It is usually assumed that this element of photography is comprised of two parts: the aperture and the lens that houses it. However, a lens is not needed in order to create images from light. Apertures and lenses have distinct technical attributes that contribute to the visual outcome, and therefore the meaning of photographic images; so, discrete but interrelated study of each provides more thorough understanding of how they combine to affect the quality of focus in photographic images.

An aperture of any kind is simply an opening. As it relates to the camera, the aperture (also called the f-stop) literally

refers to the opening through which light enters the camera to produce an exposure. This mechanism, normally located within the camera lens, controls the amount or quantity of light that will strike the photographic media upon releasing the shutter mechanism. Aperture numbers correspond to a range of fixed diameters in full-stop increments. These full stops allow in exactly ½ or 2 times the amount of light allowed by the number directly before or after it, and it is important to understand their interrelationship. Some lenses allow you to adjust the aperture in fluid, step-less increments, or in ½ or ⅓ stop increments, which offers

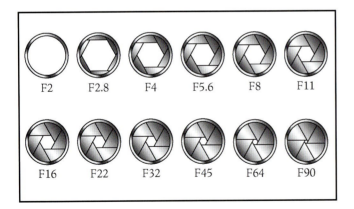

ILLUSTRATION © TOBY COCHRAN, 2007.

These are the common, whole-stop aperture numbers. They are referred to as being "1 stop" apart; that is, each whole aperture number doubles or cuts in half the exposure to light that the adjacent number provides.

finer control over exposure but makes the mathematics of it much more complicated.

DEPTH OF FIELD: A BRIEF TECHNICAL BACKGROUND

An image projected through a camera aperture is "in focus" at a specific distance from the aperture, and it gradually becomes less focused the further you get from that specific distance. The fall-off of focus occurs both in front of and behind the focus distance, and has a relatively predictable pattern. This is an important technical and visual attribute of the aperture and lens, and it is referred to as *depth of field*. Depth of field describes the ratio from foreground to background that an image will be in focus from its focus point. The ratio of depth of field is always on the order of ⅓ in front of the focus point and ⅔ behind it.

Since the chapter discussion will include depth of field at several points, it is important to first understand what it is and how it is influenced.

The three controllers of depth of field are as follows:

1. *Aperture*: The size of the aperture controls the depth of field in that the smaller the aperture is, the greater

the depth of field (the other two factors remaining the same).

2. *Lens focal length*: The focal length of the lens controls the depth of field in that the shorter (or wider angle) the focal length, the greater the depth of field (the other two factors remaining the same).

3. *Camera to subject distance*: The distance between the camera and the subject controls the depth of field in that the further from the focus distance the camera is, the greater the depth of field (the other two factors remaining the same).

Technically speaking, if you want a wide range of depth of field from foreground to background, select an adequately small aperture, focus ⅓ of the way into the scene, and shoot. In this way you can better maximize depth of field when you need it. Conversely, if you want to maintain narrow depth of field, use a larger aperture and focus on the precise distance of the subject or primary content. This range and control over depth of field offers a way of seeing that human vision cannot afford, since our plane of focus is fixed at the distance at which we are focused and falls off rapidly on either end, and we can do little to alter it. Using the camera's focus and depth of field controls, we can focus on aspects of the visible world that are imperceptibly small

and bring them into clear view, or we can image a scene whereby the entire picture plane, from its nearest point to infinity, is rendered in sharp focus.

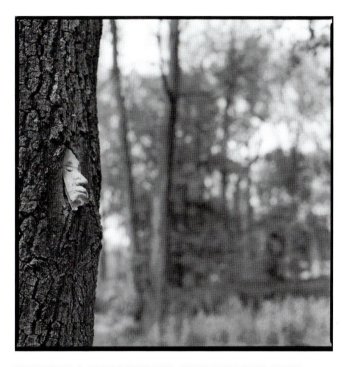

PHOTOGRAPH © ANGELA FARIS BELT, *UNTITLED* FROM THE SERIES *SPACES*, 1999.

Using shallow depth of field directs the viewer's attention to the primary content in the image; the lack of sharp focus on other areas in the frame indicate to the viewer that these are areas of secondary or supporting content. The fine black borders (created by using a filed-out negative carrier) are an explicit barrier underscoring what is in the frame versus what is not.

CAMERAS WITHOUT LENSES

As stated in the chapter introduction, the aperture's size, composition, and orientation determine important aspects about the visual outcome of the image. No lens is required to capture an image. The aperture size determines the intensity of light entering the camera and also the optimal sharpness at the plane of focus. Light entering an aperture is focused at a specific point in space; if you place light-sensitive media at that precise distance a more clearly focused image is rendered; any other distance will render a less clearly focused image.

Photographers choose to make images with lensless cameras for a variety of reasons. First, many photographers prefer to make their cameras rather than buy them; that is, they prefer images that are captured through a device created by their own hands, or designed in a non-traditional format according to their own specifications. Second, the image projected through an aperture and without a lens has its own characteristics (which we will discuss more in depth in a moment). In many ways those characteristics communicate more specific messages to a viewer about the photographer's impressions of a subject than a lens-made image could. Still other photographers like the experimental nature of alternative cameras or are interested only in the ephemeral image inside the camera obscura rather than in capturing it.

Camera Obscuras

The first apparatus to use an aperture to transfer an image made from light was the *Camera Obscura* (Latin for *Dark Room*). Essentially, a camera obscura is a dark room, which can be large enough for a person to be inside, with a very small hole in one side which, if sized properly, allows light to project the outside scene onto the interior opposite wall of the camera. Although the technology to record images onto light-sensitive media did not exist until the 19th century, the camera obscura's optics were recognized by Arabian scientist Abu Ali al-Hassan Ibn al Haitham in the 10th century B.C., who described it as his tool for studying a solar eclipse. The camera obscura was also referenced in China as early as the 5th century B.C. and by the Greek philosopher Aristotle in the 4th century B.C. It was not until the 15th century that artists throughout Europe used camera obscuras and then camera lucidas to assist them in drawing from nature, though many would not admit to doing so. Recently, the camera obscura has made a comeback, notably by photographer–artist Abelardo Morell, who has created iconic documentary images of the camera obscuras he creates in hotels, museums, and other interiors throughout the world.

Although the camera obscura does not have a lens, the hole through which the image is transported must be of a particular diameter, and the distance from the hole to the far side of the "dark room" must be of a particular distance, in order for the image to be rendered as sharply focused as possible. Here is a simplified way of calculating both:

- Focal length = Distance from the aperture to the far wall of the camera obscura. This distance will dictate the precise aperture diameter that will render the image sharpest at the plane of focus.

- Aperture size (f-stop) = Focal length/Diameter of aperture.

- Aperture diameter determines the sharpness and brightness of the projected image. The formula for determining the best aperture diameter for a given focal length is complex, involving physics of light wavelengths and some more advanced mathematical calculations. Several reliable charts are available on the topic, so through research you should find the aperture diameter that works best for your needs.

Pinhole Cameras

The pinhole camera is based on the same premise as the camera obscura, but inside the dark room is added a piece of light-sensitive media placed at the image plane so that the image projected through the pinhole may be recorded and preserved. As stated in the camera obscura section, for every focal length there is an "optimal" aperture diameter, that is, a diameter which produces the sharpest possible image. Given that pinhole photographers and artists may not desire the greatest possible sharpness, the aperture size is a general guide.

There are many excellent resources for information about making pinhole cameras, beginning with www.pinhole-resource.com. There are many places that sell custom pinholes in body caps to fit nearly any camera, but if you enjoy experimentation and making things from scratch, one very simple method follows. Begin with an extra body cap for your SLR camera, and drill about a 1-inch diameter hole in the center of it. Then determine the proper size pinhole for the focal length of the camera's inside dimension by measuring the distance from the pinhole to the media plane. Buy or create the pinhole using needles with known diameters; insert the appropriate needle into the center of the body cap, and use its corresponding f-stop to determine proper exposure. This method of pinhole camera experimentation combines the quality of focus of a pinhole camera with the convenience of accurate, adjustable shutter

speeds, a ready-made tripod mount, and the comfort of familiarity with the equipment.

Beyond the basic calculations and information provided above, there are a few technical considerations that pinhole or lensless photographic image makers need to understand:

1. Because of their minute apertures (for example, f 295); pinhole cameras capture infinite depth of field. A given camera structure has a corresponding, optimum aperture (pinhole) size that will produce the sharpest image quality. The same formulas for focal length (the measurement from the pinhole to the media plane),

aperture size (f-stop), and aperture diameter used for camera obscura apply to the pinhole camera.

2. Pinhole apertures can vary considerably in diameter depending on the camera's focal length; generally, a smaller pinhole will result in better image resolution (a sharper picture) because the projected circle of confusion is smaller. Depending on the distance from the aperture to the film plane, the infinite depth of field means that the fall-off in focus in front of and beyond the focus point has little visible effect on overall focus. Any softness produced by the aperture is far less a factor of "lenslessness" than it is of light diffraction due to the minute aperture size (or rough-edged pinholes).

A PINHOLE CAMERA MADE FROM A YIP YAP DOG
BREATH FRESHENER TIN BY DENNIE EAGLESON.

3. The rounder and smoother the pinhole, the sharper the image; distorting (deviating from a round pinhole) the shape of the pinhole distorts the image, and can be used as a creative or communicative tool. Industrially produced pinholes are generally laser-etched and are more "perfect" than handmade pinholes.

4. The thinner the material from which the pinhole is made, the sharper the image. This is because as the diameter of the aperture approaches the thickness of the material in which it is made, a greater degree of edge vignetting occurs due to light entering at other than a 90° angle. Materials too thin to remain rigid are not useful. Materials such as brass shim stock or metallic shim stock (painted black) work quite well.

5. The smaller the pinhole, the longer exposure time is required.

6. A shorter focal length (distance from the pinhole to the media plane) decreases the exposure time required and results in a more wide-angle image; a longer focal length increases the exposure time required and results in a more telephoto image.

IMAGE © DENNIE EAGLESON, *SPRAY BOOTH.*

This image was made on 35-mm film in a Yip Yap Dog Breath Freshener tin that is 2″ × 3″ × ¾″ in dimension, converted to a pinhole camera. The camera has an attached 35-mm film feeder cassette, a light-tight take-up cassette, and an aperture of f/62. See more of Dennie Eagleson's work in the Portfolio Pages of this chapter.

AFFECTING VISUAL QUALITY AND PHOTOGRAPHIC MEANING WITH APERTURES AND LENSES

The element of photography that allows light to enter the camera and form the image is the aperture. The addition of a lens dramatically affects the light entering the aperture and its transportation onto the media, and the effects are significant as they relate to the resulting image. There are also technical and communicative advantages to using a lens. The first advantage to using a lens is that the photographer can vary and make precise the point of focus. Second, most lenses allow the photographer to vary the aperture size, which is a benefit in terms of *exposure* and *depth of field*. Third, some lenses (called zoom lenses) provide a range of focal lengths in a single lens, so that photographers do not have to frame images within a fixed focal length. Fourth, the vast majority of lenses offer optical advantages: they provide a more even field of sharpness, reduce distortion and vignetting, and have coatings that reduce chromatic aberrations to transmit more accurate color hue and saturation while reducing flare and reflections.

It is not necessary for the purpose of this discussion to understand the inner workings of camera lenses. It is important to recognize the three combined attributes of lens-made images that significantly affect the visual character of the image: they are the *lens focal length, plane of focus,* and *lens quality.*

Lens Focal Length

There are three basic categories of lenses: normal, wide angle, and telephoto lenses. These have different effects on the angle of view and visual quality of the image, as outlined below.

NORMAL FOCAL LENGTH LENSES

The normal focal length for any given media format is the same as the diagonal measurement of the media plane. For instance, if you measure the image size of a 35-mm SLR camera, you arrive at a normal focal length of approximately 50 mm.

ILLUSTRATION © SHAWN MARIE CURTIS, 2007.

The normal focal length lens provides photographers with particular visual advantages. The normal focal length for a given format most closely approximates human sight, and projects an image with the least distortion and compression of space from foreground to background.

The approximate normal focal length size for the common film formats are as follows:

35-mm format = 50-mm normal lens

645 format = 75-mm normal lens

6 × 6 format = 80-mm normal lens

6 × 7 format = 90-mm normal lens

6 × 9 format = 105-mm normal lens

4 × 5 format = 150-mm normal lens

Note: As of this printing, common digital SLR sensor sizes, although many of them use the same lenses, are generally a bit smaller than the 35-mm film camera image area; therefore, the normal focal length is a bit shorter than 50 mm. Consult your DSLR manual for specific sensor measurements.

For darkroom practitioners, these are also the minimum focal length lenses required for making enlargements that provide an even spread of light across the picture plane, as well as the largest projection possible. Using a shorter focal length than that required for the negative size vignettes the image to white; using a longer focal length than that required for the negative projects a smaller image.

Normal focal length lenses are the standard when you wish to represent a subject in a relatively non-inflected way, by maintaining normal perspective within the visual field

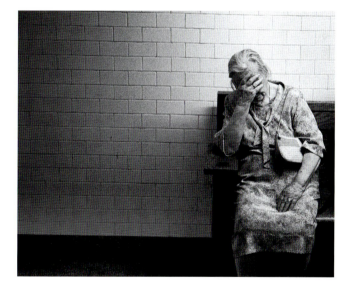

PHOTO © DAVID BECKERMAN, *HEAD IN HANDS*, SUBWAY, NEW YORK, 2005.

Using a normal focal length lens brings to this documentary-style photograph a balance of intimacy and distance. It creates an image that feels more like natural human vision, and in doing so places the viewer easily into the scene, allowing them to empathize with the subject more intimately.

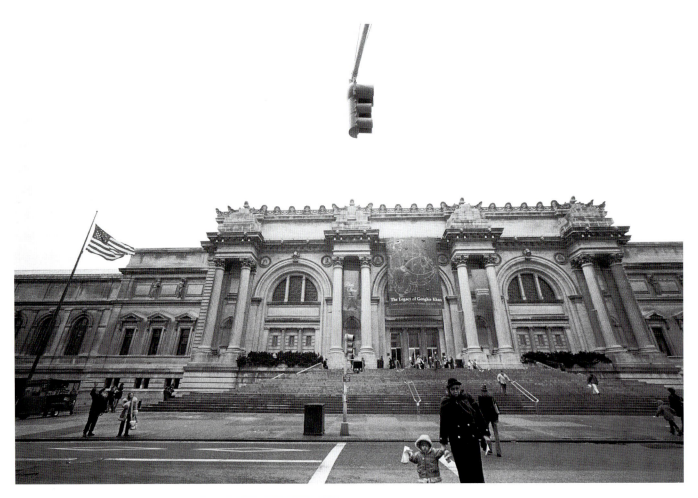

PHOTO © DAVID BECKERMAN, *METROPOLITAN MUSEUM*, NEW YORK, 1999.

Using a 16-mm wide angle lens on a 35-mm SLR camera allows a wider than normal angle of view for this scene. The distortion and inclusion of the traffic light dangling from the top of the frame act as compositional elements that occur as a direct result of the wide angle of view. www.davebeckerman.com

and keeping the distance and size relationships from foreground to background relatively unchanged. Although their visual advantages are often underrated, normal lenses are excellent general purpose lenses.

WIDE ANGLE LENSES

Also called *short lenses*, the wide angle lens for a given format is described as any lens that is literally shorter than the normal focal length. For a 35-mm film SLR camera, this would be any lens shorter than 50-mm. Wide angle lenses provide a wider than normal angle of view than the format's normal focal length lens does, which means that wide angle lenses include more of the scene than their longer counterparts. In addition to providing a wider angle of view, wide angle lenses exaggerate size relationships by making foreground elements larger than they would appear naturally in relation to background elements. At the extreme, such as fish-eye lenses, wide angle lenses distort the angle of view into a circular form, and make elements in the background minute in size.

TELEPHOTO LENSES

Also called *long lenses*, the telephoto lens for a given format is described as any lens that is literally longer than the

PHOTO © DAVID BECKERMAN, *WALL STREET SHAPES*, NEW YORK, 2000.

A long telephoto lens (200mm on a 35-mm SLR) was used to create the drastic compression of space and merge the buildings and the light post into a single almost abstract composition.

normal focal length. Long lenses provide a narrower than normal angle of view than the format's normal focal length lens does, which means that telephoto lenses include less of the scene than their shorter counterparts. In addition to providing a narrower angle of view, telephoto lenses compress perceived space between foreground and background in the scene, bringing objects in the background more fully into juxtaposition with objects in the foreground.

Plane of Focus

As light enters the aperture or lens, it projects an image of the outside world linearly through the camera body. The image is focused at only one precise distance, one place in space—the *plane of focus*. The optimized plane of focus is determined by the confluence of aperture size, distance from camera to subject, and focal length, and it is generally positioned precisely at the *media plane*, so the projected image is in focus. Because most cameras are designed such that the lens plane bears a fixed, parallel relationship to the media plane, plane of focus of the projected image always bears a direct relationship to the focus point, rendering everything at the focus distance in the same degree of sharp focus. But this is not always the case; some cameras and accessories allow the photographer to have creative control over the plane of focus (read on).

Bellows Options

One exception occurs in direct view cameras where a flexible bellows is placed between the lens and the media plane, allowing each plane to be manipulated independently. View cameras locate the lens on what is called the "front standard" and the media plane is located in the "rear standard." View cameras allow two movements that alter the lens plane to media plane relationship; they are tilt (in which the front or rear standard is tilted downward or upward) and swing (in which the front or rear standard is pivoted horizontally). Tilt allows you to confine the plane of focus to a horizontal strip across the media plane, and swing allows you to confine the plane of focus to a strip vertically through the film plane. In addition to view cameras, certain medium format camera systems, such as the Hasselblad ArcBody, offer a lens mount that will allow similar, yet more limited, plane of focus adjustment. These cameras are smaller and less bulky than view cameras, and offer the added benefit of being able to look through the viewfinder while making the photograph.

In the following images, fine art photographer Lincoln Phillips uses a 4 × 5 view camera to direct the plane of focus. He states, "In these images I am concerned with the simultaneous specificity and generality of 'place' as

PHOTOGRAPH © LINCOLN PHILLIPS, *RED ROCKS CRUX*, 2003.

PHOTOGRAPH © LINCOLN PHILLIPS, *DOD SIGN*, FROM BELOW LOS ALAMOS, 2004.

experienced both by me as I photograph, and by the viewer as she or he sees. To manifest this concern visually, optical manipulation becomes my experimental tool kit. When selecting sites to photograph, decisions are often based

more on sensation than mechanics. In each image juxtapositions arise from the process of manipulating the focal plane and defocus field to create visual interest and the potential for conceptual relationships. Focus initially directs sight to

forms and objects rendered crisply, lending identifiable context for the viewer." Additionally, Philips uses Polaroid Type 55 positive/negative film and includes the masking marks around the edge, "both as a direct reference to process and for the visual symbol of frame as context and concept."

Both adjustable bellows options, the view camera and the adjustable prime lenses for medium format cameras, are cost-prohibitive for many photographers who wish to experiment with controlling plane of focus. Fortunately, a solution came in the form of an inexpensive attachment designed for most common SLR and DSLR camera bodies: the Lensbaby™.

Lensbabies are selective focus SLR camera lenses made with flexible tubing. The lenses are made from multi-coated optical glass, so the optical quality is maintained. Using the Lensbaby, the photographer can capture photographs with one area or plane in sharp focus. Photographers can adjust the area of sharp focus anywhere in the image area by bending the flexible lens tubing. There are several versions of the Lensbaby, each with different advantages, and there are Lensbabies made for Medium Format cameras. With the Original Lensbaby™ and the Lensbaby 2.0™ the photographer manually holds the lens in a bent position while pressing the shutter release; the Lensbaby 3G™ adds

Top view of Lensbaby.

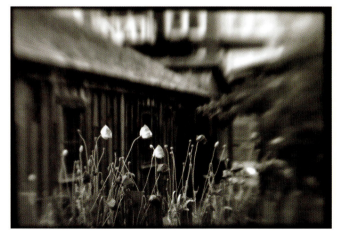

IMAGE © DARKO JUVAN. *COURTESY*: LENSBABIES, LLC.

three focusing rails that allow the photographer to lock the plane of focus in a desired bent position.

Bellows cameras, adjustable plane prime lenses, and attachments like the Lensbaby all offer plane of focus manipulation allowing photographers the ability to direct the viewer's attention in a non-traditional way. Altering the plane of focus outside of the parallel position removes the viewer's sense of "the way we see," that is, with the single plane of focus afforded by human vision, and replaces it with a conscious feeling of seeing the way that only the camera can. The value in offering this opportunity to viewers is that their innate familiarity forces them to literally see the contents of the image in a new and different way, opening their mind's eye to clues about the meaning of the image.

Using a flexible bellows is the most common way to break free of the rigid relationship between lens plane and media plane, but ingenuity and experimentation also afford ideas. Think about the relationship of the lens plane to the media plane, and how and when you might adjust it. You cannot very well "bend" a digital sensor, but you can bend, bow, or otherwise alter the flat plane of traditional media, both film and paper, in the camera and in the darkroom. You can alter the flat plane of the negative in the enlarger housing, or you can print onto paper that is not parallel to the negative

carrier. The communicative and visual potential for manipulation of plane of focus are not limited to those practices that have been widely experimented with and publicized. The idea is to understand the characteristics of the medium and begin to utilize them to your specific advantage.

Out-of-Focus or Soft-Focus SLR

While the bellows option allows the lens plane and media plane to be manipulated independently, SLR cameras with a fixed lens to media plane relationship also offer their own unique opportunities for focus control. While the plane of focus is parallel to the media plane with most cameras, in most instances the photographer determines where to place the plane of focus. If you are using a manual-focus camera, you may simply *choose* to capture the image out of focus by placing the plane of focus in front of or behind the media plane. The idea to capture images in sharp focus happens nearly by default, but choosing not to can lend a great deal of feeling and meaning to your images.

In order to control the results of out-of-focus shooting, here are a couple of tips: first, use the widest aperture on the lens. When you view through the lens, as you do with SLR cameras, you are viewing the image at its widest aperture, since the aperture only closes down to record the

image. This gives you a more accurate feel for what the final image will look like when shot at that aperture. Second, use your depth of field preview. Most SLR cameras have this option; it closes the aperture to the corresponding number you choose; the image in the viewfinder becomes darker

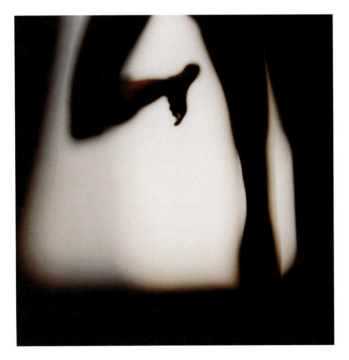

PHOTOGRAPH © SEAN WILKINSON, *UNTITLED*, FROM HIS SERIES *TRACES*, 1999, LONDON.

Sean Wilkinson uses a medium format SLR camera, carefully regarding the degree of focus through the lens.

but the depth of field becomes visible. If you don't want the aperture wide open, experiment with the aperture range by activating your camera's depth of field preview and looking at the image appearance through the viewfinder.

Out-of-focus imagery made by photographers such as Uta Barth, Robert Stivers, and Sean Wilkinson (see his work in the Portfolio Pages of this chapter) demonstrate a range of conceptual and visual potential that can be mined through this kind of image making. Research and look at a lot of out-of-focus imagery, and consider what "lack of focus" might indicate about your particular subject.

Lens Quality

The quality of the lens used—its optics, the quality of its glass and coatings, etc.—is the third significant factor in the *clarity* or *perceived sharpness* of the image. Image clarity includes things such as the sharpness of focus, resolution, and acutance. Resolution is defined as the ability of the lens to render fine detail, the lack thereof creates an image that feels *soft*. Acutance is the ability of the lens to render fine edge sharpness and sharp transitions between contrasty tonal differences. Sharpness, resolution, and acutance are also defined by media and materials, but lens quality significantly impacts image clarity. In short, the better the

lens construction, higher quality the glass and coatings, the clearer and sharper your images will be.

But not all photographers wish to produce images that are perfectly, or even reasonably clear. Many photographers recognize the value in lack of clarity for its unique relationship pertaining to the contents and information in the frame. In effect, decreasing lens quality can increase expressive potential.

One way of producing images that lack clarity is to use a plastic lens camera, and another is to alter your crisp-lens SLR camera.

PLASTIC LENS CAMERAS

There are many types of plastic lens cameras, but the two most common are the Diana, originally introduced in the 1960s and no longer in production, and the Holga, introduced in the 1980s and still in production. Both cameras capture images that are highly regarded by some for their low-fidelity aesthetic; they maximize the serendipity of light, producing images with light leaks, vignetted at the edges, and a reduced degree of clarity. These are all positive aesthetic advantages for practitioners who wish to use the camera's ability to record a less accurate reproduction of the subject. See *Plastic Cameras: Toying with Creativity*

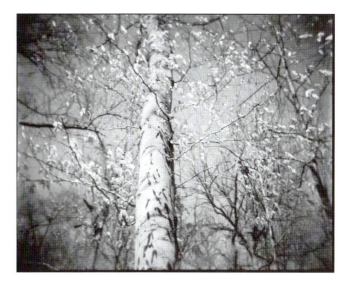

PHOTOGRAPHS © ANGELA FARIS BELT, *RAIN LEAVES*, 2007.
This plastic camera image was made with a Holga camera with the insert in place. The camera was held horizontally to make a horizontal frame.

by Michelle Bates for more detailed history and technical information about plastic cameras. (See Michelle Bates' images in the Portfolio Pages of this chapter.)

DIFFUSION

Diffusion is another aspect of lens quality that should be discussed independently because of its specific, unique attributes. Diffusion should not be confused with either lack of focus or lack of sharpness. Diffusion filters soften specular light without reducing sharpness or contrast.

Essentially, diffusion filters affect bright light the most by flaring it out, creating a "halo" around the bright area. When using diffusion filters in shooting, the highlight areas are affected most. When using diffusion filtration in the darkroom, however, the effect is just the opposite because the shadow areas in the negative are the brightest part of the image (the thinnest part of the film). Therefore, diffusion used in the darkroom creates halos around shadow areas of the image.

There are spot diffusion filters as well, which have strongest diffusion at the edges and less toward the filter's center. You can also make your own diffusion filters out of materials such as acetate (that you can scratch), petroleum jelly on an inexpensive UV haze or skylight filter (a bit messy), cellophane, waxed paper, or thin nylon stockings.

Making Your SLR Camera Behave Like a Plastic-lens Camera and Alternatives to Using Diffusion Filters

If you like the low-fidelity appearance of plastic camera images and of diffusion filters, but want exposure control and the comfort of using your familiar camera body, as well as the ability to be more creative with diffusion, you could alter your SLR camera. To reproduce both of the primary attributes of most plastic-lens cameras (lack of clarity and vignetting), you'll need to alter two aspects of the lens: its optics and its edges. To alter its optics, experiment with a number of materials that will soften the view slightly. You can use materials such as nylons stretched tightly over the lens, plastic wrap, or other clear(ish) translucent material. In order to both create the vignetting and hold the materials in place, use a lens shade intended for a focal length longer than the one you're using (for instance, if you're using a 28-mm lens, place a lens shade intended for an 80-mm lens).

You can do this for both traditional and digital image capture, in color or black and white. The idea is to capture the look of the image you want in camera using the tools necessary to make that happen.

DIGITAL DARKROOM FOCUS EFFECTS

In the digital darkroom, focus is not a real factor, and so in the digital realm any notion of focus which is to be affected after capture must be artificially created. There are several ways of altering the sense of focus in the digital darkroom, including fuzzy filters and plug-ins that mimic plastic cameras, but those are not "organic"; that is, they do not use the image content as a springboard for creating a specific

sense of focus, depth of field, or clarity that relates sensitively to the image subject. What interests us here is how to use the digital darkroom and the tools of Adobe Photoshop to regain a sense of focus control which would usually be captured in-camera or could be affected in the traditional darkroom.

Digital Plastic Camera Effect

The Plastic Camera Effect Tutorial found in the Technical Tutorials Section for Chapter 2 can be easily modified for producing a range of plastic camera effects in Adobe Photoshop; I developed it through research and some simple trial and error. You can begin with step-by-step, and develop more individualized techniques based on your needs.

The effect of plastic cameras varies, but two of the more telltale signs are a slight softness and intensified color and contrast, in particular near the vignetted edges of the image.

Original capture.

IMAGE © ANGELA FARIS BELT, 2006.

Plastic camera effect applied.

Digital Diffusion Effects

The Digital Diffusion Effects found in the Technical Tutorials Section for Chapter 2 were originally created in camera and in the traditional darkroom (and still are); they often have subtle and beautiful visual consequences for images. This tutorial provides information commonly known to many digital darkroom practitioners and is a terrific starting point for anyone interested in adding diffusion to their digital images. Remember that these techniques can be combined with others to make the outcome more

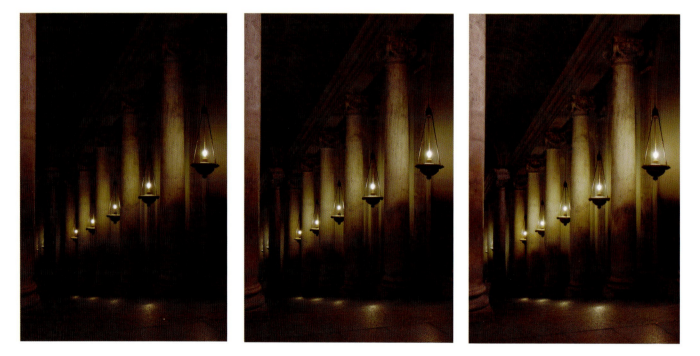

Enlarger Diffusion Effect. Original Effect. In-Camera Diffusion Effect.

IMAGE © LINDSAY GENRY, 2007.

unique and relevant to your subject. The diffusion effect images illustrate the technique and were created by one of my students, Lindsay Genry, from images she made during a trip to Italy.

Once you understand the nature of diffusion, its effects can be beneficial whether created in camera or in darkroom (traditional or digital). You can add visual weight to the image by diffusing the shadow areas of an image into the highlight areas, or conversely, you can create a more ephemeral feeling by diffusing the highlights into the shadows.

As an element of photographic grammar, the range of focus from the clarity of hyper-sharp, deep focus to the haziness of soft focus or diffusion influences and is influenced by other forms of reproduction (particularly painting) and by the needs of a marketplace of end users. Radical manipulation of lens attributes such as diffusion and plane of focus are prevalent in contemporary fine art and advertising photography, pointing to the significance of this element as a sophisticated tool for communicating diverse meanings to a wide range of viewers. Conscious use of this element of photography allows practitioners to utilize focus on a continuum ranging from concrete imagery that feels indisputable in its authority and specificity, to seductive imagery that only hints at its content, as it capitalizes on form and color. Focus leads the viewer's eye purposefully throughout the frame in a controlled and meaningful path, and places visual emphasis on the aspects of the frame that are central to communicating the meaning of the image.

CHAPTER EXERCISES

These exercises will help you to learn about camera's focusing abilities and how to manipulate them. It will also help you to question the notion of clarity, focus, depth of field, etc., that are part and parcel of photographic image making. Does an out-of-focus image have anything to tell us about a subject? Can a pinhole camera image, with its lack of sharpness but infinite depth of field shed understanding about a specific topic? Remember to stick with your chosen subject or concept that you've been concentrating on for the previous exercises, but for these, consider what the notion of "focus" has to say about your subject or what your subject has to say about focus.

Exercise No. 1: Limited Depth of Field Image Series

Make *a series* of photographs with your camera set at its closest focusing distance. Look through the lens and compose your images based only on the sharply focused aspects of the frame in relation to light and shadow rendered in

the rapidly diminishing depth of field that you see. *Use close to the widest aperture* (f/2, 2.8, 4) available on your lens in order to limit your depth of field to what you see through the lens. You will be printing a *series* (4–6) of them, so be sure to consider how the subject matter and content of these images will relate as a group.

For added complexity, you could create limited depth of field images to be printed as diptychs, triptychs, or multi-panel panoramas. As in the exercises in Chapter 1, plan the images in advance so that the results are more predictable. Still, work in a series, and edit 4–6 successful multi-panel images to print.

Exercise No. 2: Series of Out-of-focus Images

For this exercise make *a series* of photographs with your camera set to a focusing distance that renders the scene out of focus. Do not simply change your distance from your subject until it is in focus. Look through the lens and compose based only on the light and shadow that you see. *Use close to the widest aperture* (f/2, 2.8) available on your lens in order to limit your depth of field to what you see through the lens. You will be printing a *series* (2–5) of them, so be sure to consider how the subject matter and content of these images will relate as a group.

Exercise No. 3: Plane of Focus Manipulation

In this exercise you'll need access to a Hasselblad Arc Body or Flex Body, a Lensbaby, a large-format view camera, or even a vintage camera with an adjustable bellows.

View the scene through the lens, and begin to adjust your bellows or lens plane until the plane of focus looks interesting to you. Don't over-analyze it … make intuitive decisions based on the appearance of the image in the viewfinder or ground glass.

Approach this exercise as a series, and try to produce 4–6 images where the plane of focus manipulation adds to the meaning of the image.

Exercise No. 4: Convert Your SLR Camera into a Pinhole Camera

For this exercise, you'll want to do some independent research beginning with Pinhole Resource (www.pinholeresource.com). Purchase an extra camera body cap, and drill a smooth hole about 1″ in diameter into the center of it. Secure a handmade or purchased pinhole of the proper aperture size for the camera body's depth to the inside of the body cap using black tape, and use it to make photographs of your chosen subject, topic, or genre. Think conceptually about how the extremely wide depth of field

against the softness of the image can affect your viewer's perception of your subject.

PORTFOLIO PAGES

The artists represented in this chapter's portfolio pages engage in a wide range of photographic practices. To create their work they use traditional, digital, and hybrid media, and they consciously (visually as well as conceptually) address how the depth and clarity of focus affect the appearance and meaning of their photographic images. The work in these pages is not *about* apertures or lenses perse; rather, it uses the guiding principles of these technical devices as visual strategies to support or address the subject of their images. These photographer–artists use pinhole and plastic lens cameras, non-traditional and inventive focusing techniques, as well as specific attention to depth of field and framing to create images that communicate uniquely and beautifully.

These images are intended to inspire creative thinking and critical debate about the content and subject of the work, as well as the use of apertures and lenses in relation to that content. Additionally, think of other instances where still images use the depth and clarity of focus consciously, or reference them in the work in order to comment on their

subject. How might a more conscious use of the attributes of apertures and lenses add dimension and meaning to your images?

SEAN WILKINSON

TRACES

ARTIST STATEMENT

In making these pictures, I was interested in the suggestion of a thing rather than its description. Objects merge with their backgrounds, and light dissolves edges. I have deliberately sacrificed precision and detail in order to emphasize allusion and evocation. At the same time, I want the viewer to identify the subject matter sufficiently to discern, simultaneously, both its substance and its essence.

Process Statement

Clear focus is one of the most compelling virtues of photography. People once used a magnifying glass and a pin to count the bricks in buildings recorded in daguerreotypes. The seemingly infinite detail of a large format contact print can astonish us still today. To throw a picture deliberately out of focus seems almost perverse, a violation of what is "right." On the other hand, because of the relative novelty, almost anything looks temporarily interesting when seen this way. But although everything looked promising in the camera, the pictures were never the same as what I saw there. They never are.

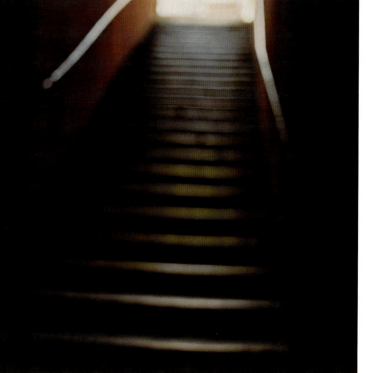

Untitled, 1999, Boston.

Untitled, 1999, Lyon.

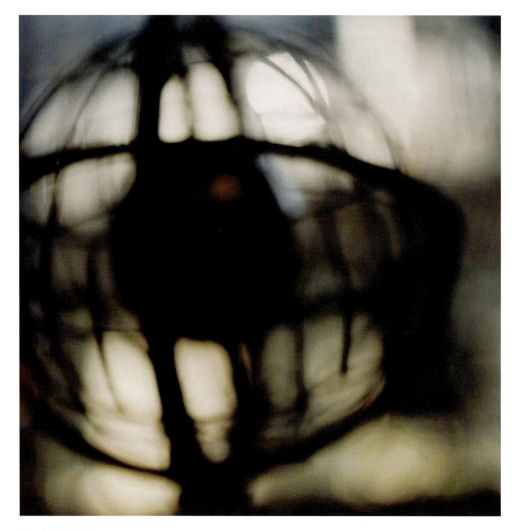

Untitled 1999, Florence.

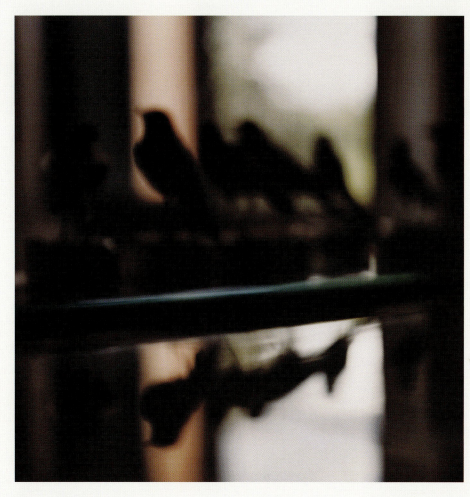

Untitled, 1999, Rome.

DENNIE EAGLESON

ARCHEOLOGY OF A LIFE

ARTIST STATEMENT

Interior spaces speak to me. I am curious about the way human presence imprints and leaves residues of its history. The house pictured in this exhibition was left empty in 2000 after the death of a 92-year-old woman, the last member of a family that had lived in the house for over a century. These images, taken with permission of the surviving relatives, are documents of the artifacts of a life that had few contemporary elements. The framed family portraits, drawers with *Harriet Hubbard Ayer's Beautifying Face Powder* and a button jar, an old edition of *The Tales of Peter Rabbit* tied with twine, saved ribbons and receipts, parts of a scrabble game exist in a space in which time is suspended. The house itself is a time capsule, with strange and anachronistic pairings of objects: a 1962 *New Yorker* magazine occupies a drawer with a more contemporary article from a local paper. I wondered about the personal value attached to what was saved and whether there was some mysterious order or meaning to the collections. The experience caused me to reflect on my own collection of treasures, and on who might sort through them after my passing, getting to know me, and my history through my artifacts.

Process Statement

I used pinhole cameras to make these pictures. The required exposure of the objects and spaces took long minutes to accomplish. I chose to work with pinhole cameras because the distortion and shifting colors inherent in the process resemble the evocation of dream or memory. The camera's extreme depth of field challenges normal perception of scale, and objects appear iconic and monumental, as with the image of the 1950s style radio, with its now obsolete radio tubes. The images were photographed with Fuji 400ASA color film and printed digitally on Legion Matt paper on an Epson 2200 printer. I appreciate the subtlety of control made possible with digital printing, and the ability to print on fine-art papers, creating an image that looks like an artifact in its own right.

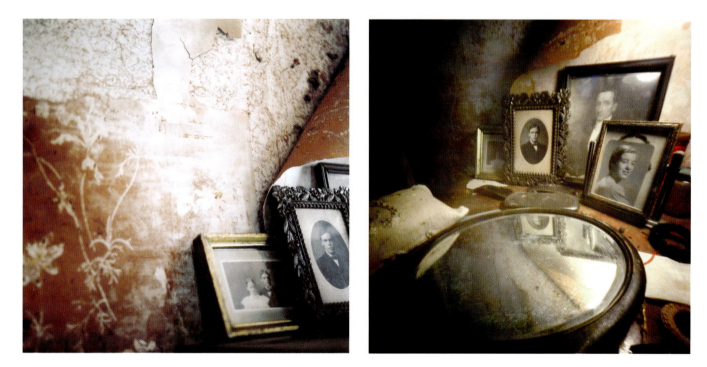

Pictures (diptych: left and right panels), 2004.

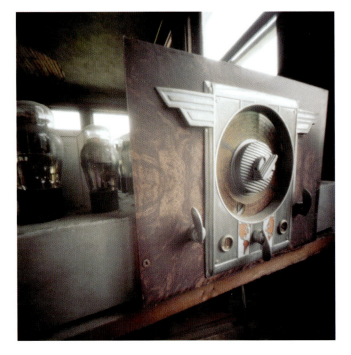

Radio, 2004.

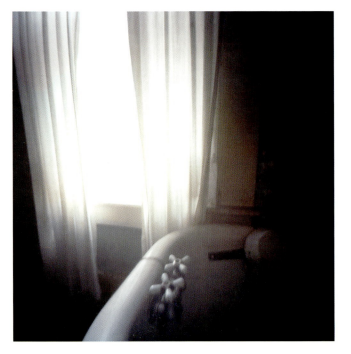

Bathroom Window, 2004.

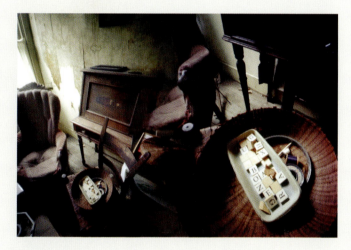

Scrabble Set, 2004.

Bathroom, 2004.

MICHELLE BATES

PLASTIC CAMERA IMAGES

ARTIST STATEMENT

The Holga is my camera of choice. It's a super-simple plastic box with a spring shutter and almost no way to adjust your exposure. It doesn't roll the film on tightly, sometimes the back falls off, and the negatives are usually way over- or under-exposed. On the plus side, they're cheap and light, and the images they make have a look and feel wonderfully different from what you get with a "normal" camera.

With my first successful Holga image made in 1991, I discovered that the square-ish negative was a bit bigger than the standard size for its format (6 cm × 6 cm on a medium format 120 film). In response, I cut a negative carrier out of cardboard that follows the Holga negative's natural edges, and I've been using that carrier ever since.

I've always loved the inherent characteristics of Holga images. They bulge outward like an old TV screen, leaving straight lines out of the picture completely. They vignette, drawing the eye into the center of the frame. The focus likewise falls off toward the edges, mimicking how we see the world through our eyes.

The themes I've made the subjects of my Holga images have changed over the years, but my Holgas always seem to like photographing quirky subjects. I have many images of carnivals rides, animals, fake animals, sculptures, parades, and other funky subjects that make people smile. Over time, though, I've pulled the Holga away from its traditional milieu to try to tease great photographs out of other subjects. These series include many city and nature photos, both scenic and abstract, and photos that focus on graphic qualities in structures.

The hit-or-miss aspect of this type of shooting keeps the intrigue in the act of photographing, breaking the expectation of predictability, and leaving room for unanticipated surprises.

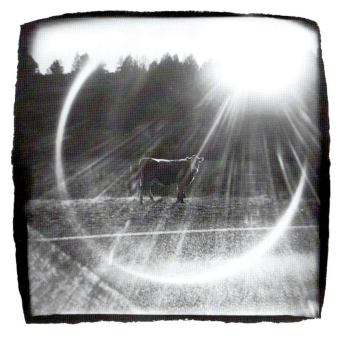

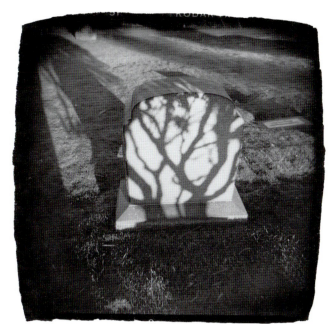

Holy Cow, Eastern Washington.

Lakeview Cemetery, Seattle.

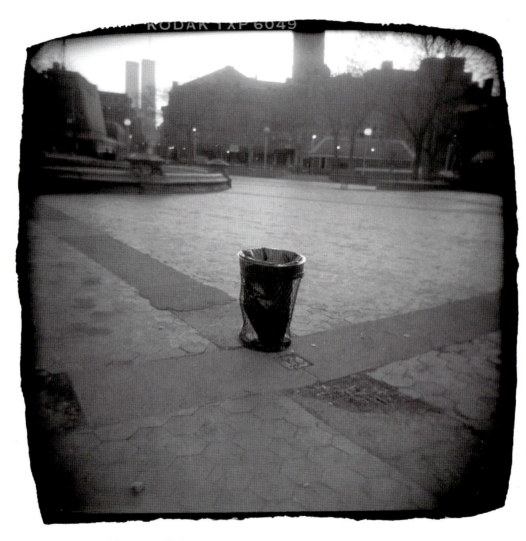

Garbage Pail and Twin Towers, New York.

Wax Orchards Tree, Vashon Island, WA.

CHIP SIMONS

ARTIST AND PROCESS STATEMENT

I love to run around with a shift/tilt lens adapter on my Mamiya RZ 67, especially with a 75-mm lens and 85b filter, and the auto prism. Though it is the world's heaviest point and shoot camera, it frees me to be spontaneous with both exposure and focus. This led to a "shoot before I think" way of shooting; I let my body and my stomach feel what to do … then I snap the shutter before I let my brain compose or focus. This is how the bunny series came about. It is a bit macabre and melancholy, but it is also playful, innocent, and fantastical. The soft focus, the vignette, and tonality add to their nostalgic and timeless impressionism. I think that selective focus is a bit like selective attention spans; sometimes my mind and I just like to wander and not focus on details … but rather take in the whole image and feel. Through these images, the viewer can do the same.

Clock Bunny.

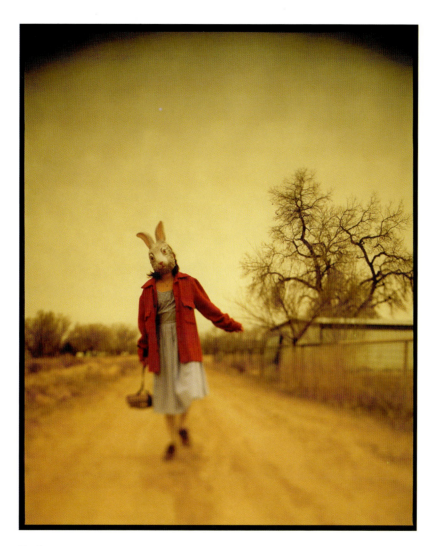

Penelope.

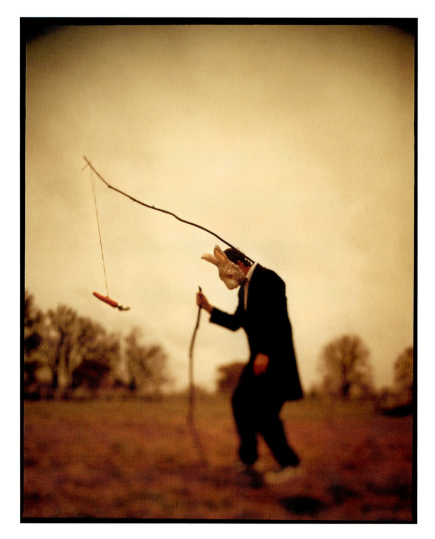

Follow the Carrot.

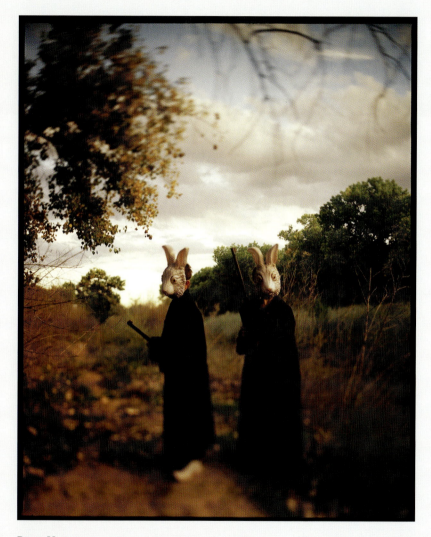

Bunny Hunters.

PHYLLIS CROWLEY

OFF-PEAK

ARTIST STATEMENT

There is a certain excitement about a train ride. It's a journey to somewhere else. That somewhere can be new or it can be familiar, but if you are, like me, a person who is drawn by an invisible force toward the nearest window, the experience of riding the train and window watching is always fresh. From the moving train, fleeting images of the landscape are perceived and held for a fraction of a second and then dissolve into memory. Familiar objects are transformed by the camera lens which produces blurs, movement lines, and records the marks and stains on the windows as impartially as what lies beyond. With speed, clear outlines dissolve, and sides of buildings become washes of color; grass and trees turn into green brushstrokes. Chance plays a role. Nothing can be planned; decisions have to be made in an instant. Every picture represents Yes! I like that! Click. After many such clicks, patterns emerge that help the photographer anticipate certain effects.

Process Statement

In this series, the lens and shutter were manipulated to evoke the experience of riding the train. Putting distant objects out of focus recalls landscapes glimpsed fleetingly, and remembered imperfectly. Memories have soft edges. When the focus is on the window, rather than a distant object, all the rain, dirt, or other marks record clearly, and the landscape appears to have the dirt and smears directly imprinted upon it. This awareness of the window is important to the meaning of the work. Obtaining the optimum range of apertures for sufficient depth of field was a consideration, as the shutter speed had to be at least 160 and often higher to eliminate camera shake and unintended blurs on a moving train. This limited the depth of field. The camera used is a Canon EOS Digital Rebel with a Canon EF-S 17–85-mm 5.6 IS USM lens.

Gritty City, 2006.

Painted Blocks, 2006.

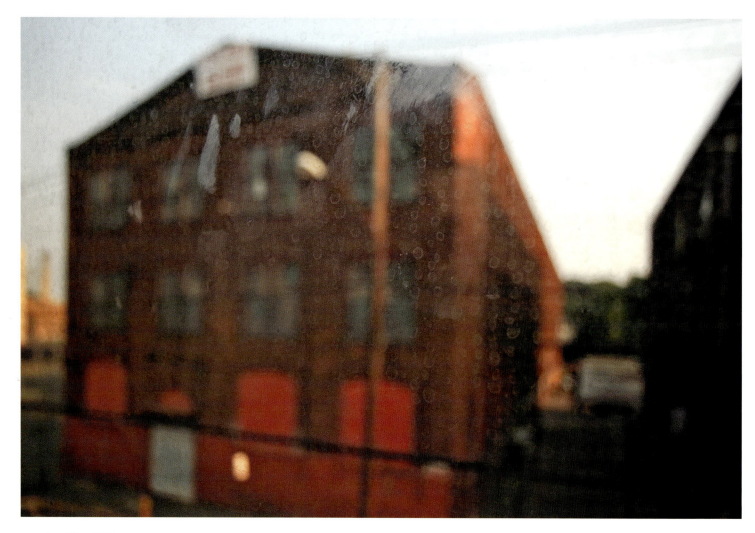

Jewel Box, 2007.

Passenger, 2006.

CYNTHIA GREIG

LIFE-SIZE

ARTIST STATEMENT

I'm fascinated by the fact that almost anything—whether sunglasses, a hypodermic needle, or condom—can be found in miniature. I'm equally intrigued by the desire to collect such tiny replicas of normal-size objects. As a smaller scale surrogate of the original, the miniature implies the existence of some kind of alternative universe where we—as larger bodies—are like gods, omnipotent, and in control. For my series, *Life-Size*, I use a 35-mm SLR camera with a macro lens to photograph my friends and family interacting with miniature dollhouse objects in their own homes and backyards. By exploiting extremely shallow depth of field, I make the surrounding environment fall out of focus, drawing attention to the surface details of the tiny objects as well as the wrinkles, scars, and pores of my larger human subjects. In the darkroom I enlarge the negative so that the previously small appears to approximate the "life-size" in the final photograph. This dramatic shift in scale and narrow range of focus emphasize the resemblance of the miniature to its larger-size referent, and at the same time upset our usual sense of order and proportion.

The resulting photographs show gigantic adult figures invading a claustrophobic world of Lilliputian proportions, awkwardly attempting to make these under-sized objects function as if they were actual working possessions or tools. This intersection of scales disturbs the imagined perfection of a mini-sized fantasy world, eliciting humorous and absurd narratives that explore our desire to control and contain the unpredictable and sometimes overwhelming circumstances of life. By inviting the viewer to look beyond the surface and confront the betrayal of appearances, the photographs explore the relationship between how we see, interpret, and experience the world we live in. By making images that challenge our expectations, I'm exploring how perceptual experience shapes our understanding of the world around us, and our concepts of what is real and/or an illusion.

Sunglasses, 2001.

Video Camera, 2003.

Life Preserver, 2003.

Gun (evidence), 2003.

SHUTTER SPEEDS: TIME AND MOTION

"BECAUSE PHOTOGRAPHY IS TECHNICALLY ... SUCH A PRECISE MEDIUM, ABERRANT EFFECTS, WHICH ONCE OCCURRED QUITE UNPREDICTABLY, CAN BE CONTROLLED AND SKILLFULLY EXPLOITED IN SERVICE OF GREATER EXPRESSION."—MARTIN FREEMAN

SHUTTER SPEEDS: THE THIRD PHOTOGRAPHIC ELEMENT

Since the first photographs, images recording motion-blur have both vexed and fascinated photographers and viewers alike. Blurring motion was not a creative discovery—throughout the medium's early years, photographers (and their subjects) had to go to great lengths to avoid it because of the extremely slow light sensitivity of available media—but it was to many an interesting occurrence, ripe with visual potential. Once media sensitivity increased to allow blur to be avoided, the degree of freezing or blurring motion could also be controlled, and photographers began to consciously utilize shutter speeds as an aesthetic and communicative tool. As they did, they and visually literate viewers began to realize the myriad levels on which the degree of freezing or blurring time could affect the visual character of their subject matter and infuse potential meaning into images. Indeed, like focus, motion in a photograph, can

PHOTO © NICOLE KULINSKI, 2006.

In this photograph of a traditional Mexican dancer, Denver-based editorial photographer Nicole Kulinski used a shutter speed of $1/4$ second at f/4 with a 170-mm lens. These factors, combined with her distance from the subject and the speed at which the dancer was moving, provided the perfect combination of factors to capture simultaneously the grace of the frozen moment with the fluidity of slightly blurred movement.

be recorded on a continuum of nearly innumerable points ranging from completely frozen to unrecognizable blur; for photographers it is important to understand that where you place your image content on that continuum creates specific, unique photographic meaning (Shore, 1998, p. 35).

SHUTTER SPEEDS: A BRIEF TECHNICAL BACKGROUND

The shutter speed controls the length of time that the media receives exposure to light, or how long the passage through the aperture is open. When you activate the shutter release mechanism, a curtain within the camera opens, leaving nothing between the open lens aperture and the media (the sensor or film) so that light may enter to create the exposure. There are two basic types of shutter mechanisms: leaf and focal-plane (also called *curtain*) shutters. Leaf shutter mechanisms are located within the camera's lens (usually in medium and large format cameras) and focal-plane (curtain) shutters are located inside the camera body just behind the lens in front of the film or sensor plane. Focal-plane shutters are most commonly found in SLR cameras. The two kinds of shutters have several different attributes that are most significant when using flash or strobe. Focal-plane shutters are limited to the flash synch

speed or slower in order to record information to the entire picture plane, because this is the fastest speed at which the entire image area (media plane) is open to light simultaneously. Leaf shutters, on the other hand, can be used with a flash or strobe at any speed, since the aperture opens from the center outward; however, because of this, leaf shutters also have a slower minimum shutter speed than do focal-plane shutters. While focal-plane shutters commonly offer a shutter speed as fast as 1/4000th of a second, leaf shutter mechanisms offer about 1/500th of a second at their fastest.

The common whole-stop shutter speeds are: 8 seconds 4′ 2′ 1′ $^1/_2$ $^1/_4$ 8 15 30 60 125 250 500 1000 2000 4000 8000

Understanding shutter speeds and their relationship to several other factors enables photographers to control the representation of time and motion in their images. Only practice and experimentation provide enough guidance to control this element of photography to make it effective as a communicative tool.

Students often question why they should learn these techniques when it's easy enough to create blur effects in Photoshop. My response is as usual—as photographers we are responsible for understanding and utilizing the

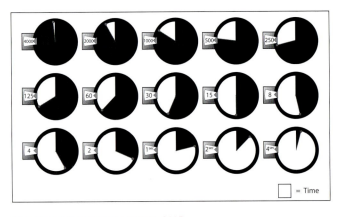

relationship between the world of motion and the static nature of our medium. You might decide to alter the freezing or blurring effects in the digital darkroom, but in order to do so with credence you must first understand how movement, suspended or drawn out against static media, actually appears. This enables you to create images in which movement is wholly believable, or incredible or fantastic by drawing upon the viewer's suspension of disbelief.

AFFECTING VISUAL QUALITY AND PHOTOGRAPHIC MEANING USING SHUTTER SPEEDS

Technically, the movement recorded in a photograph is dictated by the interrelationship of three factors: the shutter speed (duration of the exposure); the static nature of the media (the flat, stationary, light-sensitive material in the camera); and the movement in front of the camera or of the camera itself (including its speed and direction, camera to content distance, and magnification/focal length). Photographers use shutter speeds for communicative effect by controlling the interrelationship between these three factors.

Explained another way, while photographic media is static, the world flows in time (Shore, 1998, p. 35). Movement captured onto static media for a particular duration of time—30 seconds, or 3 hours, or 1/250th of a second, or 1/8000th of a second (what John Szarkowski calls "a discreet parcel of time")—creates a range of meanings completely different from those derived by watching the event unfold. These meanings are controlled in part by framing (our first photographic element) in which the photographer determines the specific aspects of the motion in front of them to be recorded onto the photographic image (knowing that viewers see only the motion occurring within the confines of the frame and have no visual reference to anything beyond it), but the meaning of motion in an image is primarily controlled by the three factors mentioned above.

Just as shutter speeds create a broad range of visual effects from freezing to blurring motion, the range of meanings created by those shutter speeds is so great that at polar ends they might have the effect of contradicting one another (depending on the subject matter and the movement as recorded onto the static media). While freezing motion in the creation of a sharp, crisp image carries with it connotations of truth, accuracy, and clarity (rightly or not), blurring motion necessarily calls into question the relationship between clarity and truth, and forces the viewer to confront the indistinct nature of the thing blurred as well as its place in time and space.

A photograph containing an adequately frozen moment creates concrete juxtapositions among clearly seen subject matter, allowing viewers to contemplate the moment in time as they imagine it took place. The clarity of the frozen-moment image often offers viewers the borrowed confidence of one who sees a thing first-hand, a great service to credence for photojournalists and documentary photographers. Conversely, a photograph containing blurred motion allows a viewer to contemplate a less usual reality, one which is difficult to place in an imagined context because our eyes do not transfer such images to the brain; in so doing blurred images offer the possibility of understanding truth of a different order than a frozen moment can reveal. For instance, the use of slow shutter speeds in relation to particular subject matter can infer the transience of a state of being—youth, aspects of the natural world, time, or life itself—it can literally record the passing of time in relation to a subject's processes, "discreet parcel of time" on earth, and the very traces left by its movement through time and space. Imagine you are making photographs whose subject is "time" and you decide to use a metronome as your primary content. The object itself is used as an indicator of time or rhythm, which is what the image is about. You could simply make a photograph of the metronome, with everything in the frame crisply frozen. Or you could place the camera on a tripod, set the metronome into motion, and using a slow shutter speed you could capture the device and its surroundings in a static state while blurring the rhythm of the clicking pendulum such that the viewer actually sees the motion itself extruded into the image. This type of comparison can be applied to a vast range of subjects, and makes a significant difference in both the appearance of the image and in the meaning it conveys to viewers.

One of the most significant attributes of the intersection of shutter speed, motion, and static media relates to *how* this intersection is framed. The intersection of photography's

temporal element as captured in the frame was referred to by photographer Henri Cartier-Bresson as "the decisive moment." Cartier-Bresson described that there is a certain way of making photographs in which there is "an interrelationship of eye, body, and mind that intuitively recognizes the moment in time when the formal and psychological elements within the visual field take on enriched meanings" (Rosenblum, 1984, p. 483). Cartier-Bresson believed photography's strength to be "The simultaneous recognition, in a fraction of a second, of the significance of an event as

well as of a precise organization of forms which give the event its proper expression" (Newhall, 1955, p. 485).

To this day, this "decisive moment" is the very thing that draws countless individuals to the practice of photography. It epitomizes the significance of photographic image making for countless photographers; among them is Alexis Abrams. Abrams' training is in photojournalism and documentary photography, apparent even in her personal work. Of it she says, "Capturing the decisive moment is

PHOTOGRAPH © ALEXIS ABRAMS, *LOOKING FOR THE QUETZAL*, SANTA ELENA, COSTA RICA, 2005.

the ultimate ambition for a documentary photographer, the conjunction of content ("the significance of an event"), composition ("the precise organization of forms"), and concept ("its proper expression")." She goes on to say that, "With an attitude of humility and a spirit of openness," she tries to "extract transcendent instants that reveal the beauty and humanity of her subjects out of the onslaught of ordinary moments."

Another photographer whose street photography relies on the principles of the decisive moment is photographer Tom Finke. Trained in fine art photography, Finke has spent many years developing two ongoing series of photographs entitled *Celebrations and Competitions* in both the United States and Japan. His images embrace the street photography tradition, and as such they employ the theory behind Cartier-Bresson's decisive moment. Of his work he says, "Like expressions of the face, the attitudes of the body are full of meaning. Some of our gestures and poses are contrived for an audience; some are unconscious and involuntary, or nearly so. All of them send messages about who we think we are, or how we feel, or what we mean—messages we might prefer to disguise, as well as,

PHOTOGRAPH © ALEXIS ABRAMS, *CARNEVALE*, LUCCA, ITALIA, 2000.

Abrams states that she uses, "minimal equipment and available light, so I can respond, unencumbered, to the moments unfolding before me. I have no desire to direct the action in front of my camera. My greatest pleasure, in photographing, is to coordinate my breath, eye, and movement with the chaotic rhythms and unpredictable intersections that occur naturally in the world, without mediation."

PHOTOGRAPH © TOM FINKE, *UNTITLED*, FROM THE SERIES *CELEBRATIONS AND COMPETITIONS*.

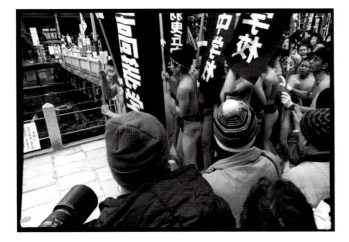

PHOTOGRAPH © TOM FINKE, *UNTITLED*, FROM HIS SERIES *CELEBRATIONS AND COMPETITIONS*.

those we intend to project. The present sample readily suggests the unsurprising conclusion that, we have become less inhibited about expressing ourselves."

THE DELINEATION OF TIME IN A PHOTOGRAPH

Based on the three factors that control motion–capture (shutter speed, static media, and movement), there are four ways in which the world of time can be translated onto a photograph. There are innumerable degrees to which time may be arrested or extruded, and some images can contain both simultaneously; however, all photographic images delineate time in the following ways. They are: frozen, blurred, static, or overlapping. What follows is a discussion of these four manifestations of time and motion in photographs.

1. Frozen Time

Time can be frozen in a photographic image; photographers from Jacques Henri Lartigue (1894–1986) to Lois Greenfield (contemporary) have done so to their advantage. When time is frozen in a photograph, two criteria are present: movement is occurring (in front of the camera, the camera itself, or both) and that movement is arrested. Here, a "discreet parcel" of fluid time is stopped because the exposure was of a brief enough duration to do so. Frozen

time often brings to mind the mid-air fast action captured by sports photographers, but this is not usually the case. In fact, to some degree or another, the majority of photographs capture frozen time, since cameras are most often handheld and their own motion during exposure must be arrested. Frozen time allows us to view aspects of the world of motion that would not be visible to our eye, and allows us to pause and consider the moment arrested in time.

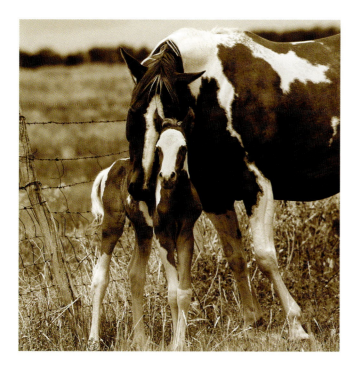

Frozen time is used in scientific photography as well as any photographs in which the significance of the image relies on a moving subject suspended in time.

There are technical factors to consider when attempting to freeze time successfully, and only practice will enable you to accurately determine how to proceed in order to achieve your desired result.

FIVE FACTORS THAT DETERMINE THE DEGREE OF FROZEN TIME IN A PHOTOGRAPH

1. *Shutter speed*: The other four factors being equal, the faster the shutter speed, the more frozen the motion will be rendered.

 Technical Note: In order to freeze the motion of the camera itself if you are hand-holding it, the shutter speed must be equal to or faster than the numerical equivalent to 1/focal length of the lens you are using.

PHOTO © NICOLE KULINSKI, 2006.

This photograph of a mother and foal was made in the San Luis Valley. It was made with a 300-mm lens; f/8 @ 1/500-second shutter speed. This image illustrates a perfectly represented moment of tenderness that existed only for the fraction of a second that the image was made. The shutter speed that Kulinski used was fast enough to freeze both the movement of the subject and the camera shake that exists with a telephoto lens.

Example: While using a 200-mm lens, you would need to use a shutter speed of 1/250 of a second.

2. *Speed of motion*: The other four factors being equal, the faster the subject or camera itself is moving, the faster the shutter speed must be in order to freeze the movement.

3. *Direction of motion*: The other four factors being equal, the more parallel to the lens axis the motion, the more frozen it will be. In other words, a subject moving toward or away from the camera will be rendered frozen

at a slower shutter speed than a subject moving across (perpendicular to) the camera's field of vision.

4. *Distance from subject*: The other four factors being equal, the further the camera to subject distance, the more frozen the motion will be.

5. *Focal length/magnification*: The other four factors being equal, the shorter the focal length of the lens, the more frozen the motion will be. This is because shorter focal lengths (wider angle lenses) provide less magnification. Conversely, when a macro or close-up lens is used the movement of the subject and camera are magnified, so a faster shutter speed is needed to freeze motion.

2. Blurred Time

Time can be blurred in a photographic image. Photographers such as Ralph Eugene Meatyard (1925–1972) and Francesca Woodman (1958–1981) have blurred time. With blurred time, the movement in front of the camera or the movement of the camera itself is extruded, drawn out across the picture plane. In these instances, the content of the image is moving, the camera is moving, or both are moving and blur is created because the exposure time is long enough to record the movement across the picture plane. There are nearly unlimited ways in which blurred time

ILLUSTRATION © SHAWN MARIE CURTIS, 2007.

If movement is perpendicular to the lens axis (across your field of view) a faster shutter speed is required to freeze it.

If movement is parallel to the lens axis (directly toward or away from the camera) a slower shutter speed can be used to freeze it.

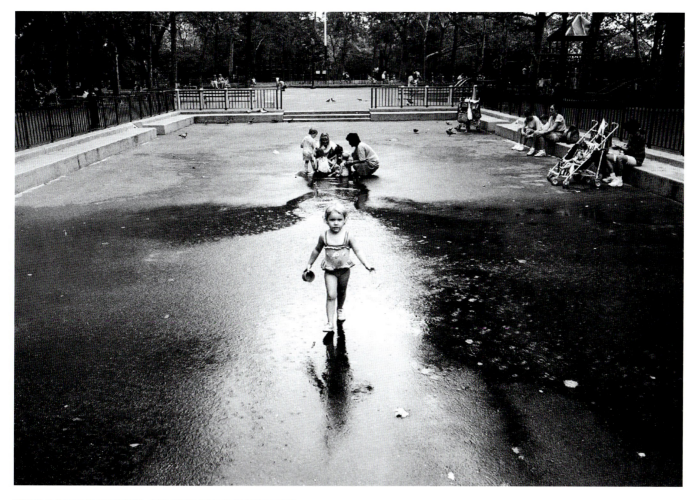

PHOTO © DAVID BECKERMAN, *GIRL WITH PAIL*, NEW YORK, 2003.

This photograph captures a young child in mid-stride, freezing her motion (and the motion of others around her) in such a way as to draw connotative meaning between her outstretched arms and the light which seems to emanate from her amid a large field of darkness. His use of a 21-mm wide angle lens adds to the feeling of space engulfing the girl in part due to exaggeration of size–space relationships and in part due to edge distortion. www.davebeckerman.com

can be delineated in a photograph; only practice and experimentation allow you to understand and predict the effects of slow shutter speeds in relation to time and motion.

Two particularly useful tools for blurring motion are tripods and neutral density filters. When you want to use a long shutter speed, but want to record only the motion in front of the camera as blurred (eliminating camera movement and thereby making the viewer's point-of-view stationary), the best way is to place the camera on a tripod. Remember that it is only possible to confidently handhold a camera at a shutter speed close to 1/focal length of the lens, so depending on the focal length and the degree of subject movement you want to record as blur, you will need to use a tripod.

Often, you want to blur motion beyond the capabilities of your camera's exposure settings. For instance, you are trying to blur the motion of a waterfall. You set your digital camera to the slowest ISO or buy slow ISO film to assist you, and you set your aperture to the smallest setting your camera lens offers so that you naturally get the slowest shutter speed you can for proper exposure. If the lighting conditions are very bright, you still might not have a shutter speed sufficiently slow enough to blur motion to the extent that you'd like. This is where a neutral density

filter comes in handy. A neutral density filter is designed to absorb light while not affecting the color balance of the scene (at least not much). They are sold in increments that absorb varying amounts of light according to the stop-factor chart (for information on the stop-factor chart, see page 178). An ND 2 filter absorbs 1 stop of light; an ND 4 filter absorbs 2 stops of light; an ND 8 filter absorbs 3 stops of light.

Here is how an ND 8 filter would be used to blur the waterfall in the above example:

Your camera is on a tripod, so everything in the frame except the moving water will be frozen. You are focused on a waterfall, and are using the following exposure setting:

100 ISO f/32 1 second … you are achieving proper exposure, but you want to blur the water more. You add an ND 8 filter to your lens, which absorbs 3 stops of light, so your new exposure is: 100 ISO f/32 8 seconds. Now the water is blurred to a silky texture!

Neutral density filters are an indispensable tool for photographers who want control over the degree of motion in their images, and a high-quality glass screw-mount filter will provide that control.

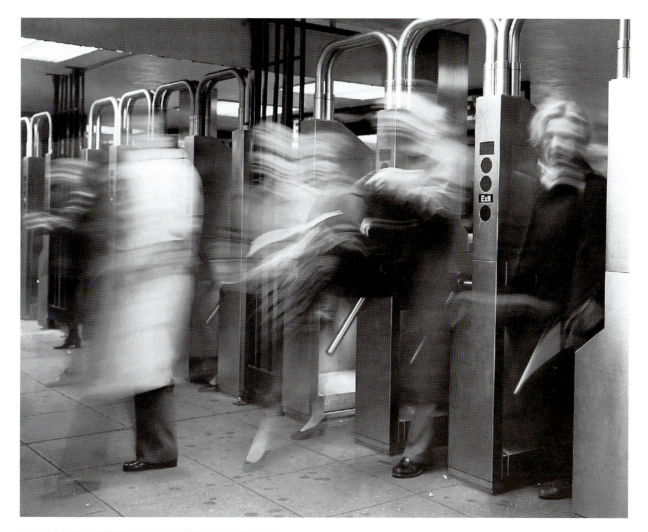

PHOTO © DAVID BECKERMAN, *TURNSTILE*, NEW YORK, 1994.

Here, New York photographer David Beckerman placed his camera on a tripod and used a slow shutter speed (1 second) in order to capture with clarity the environment of the subway turnstiles and simultaneously blur the motion of the fast-moving commuters moving through them.

Finally, in order to insure that a scene will be sharp during a long exposure, you should do one of two things: use a cable release or use the camera's self-timer. Either option removes the possibility that your own hand's pressure on the shutter-release mechanism will cause the image to be blurred overall.

IN-CAMERA AND DIGITAL DARKROOM BLURRED TIME TECHNIQUES

Painting with light: A particular instance of using blurred times in creating unique visual effects is in a technique commonly known to studio photographers as "painting with light." Painting with light is accomplished by using a long exposure in a darkened environment, which allows the photographer to literally "paint in" areas of the scene using a flashlight or any small, controllable light source. The effect seems to be one of softening the overall focus of the image, but what is really happening is that a soft, diffuse, and often color-cast glow appears around painted aspects of the photograph because the light which reveals the image content is emerging from a fluid rather than a single, fixed source.

Photographers who paint with light often use colored filters or gels over the light source to control the color of light in particular areas of the scene as well as diffusion filters over the lens during the painted aspects of the exposure. In the following images, travel and editorial photographer Anna Zoromski photographed an automobile graveyard using the technique in-camera. She arrives on location before dusk in order to survey the site, and with her camera on a sturdy tripod she makes her long exposures using two flashlights. Her camera is generally set to an aperture of F22 and a shutter speed of 30 seconds, using ISO 100 on her digital camera to reduce noise in the images.

Although the effects of this technique cannot be reproduced in the traditional darkroom, in the Digital Darkroom a sense of painting with light can be created beautifully.

© ANNA T. ZOROMSKI, *BONE-YARD SERIES*, PHOENIX MINE, IDAHO SPRINGS, COLORADO, 2007.

In these images, travel and editorial photographer Anna Zoromski employed the technique painting with light, and added a sense of dark mystery and weight to her images.

Before

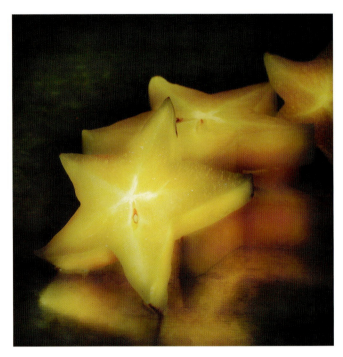

After

DIGITAL PAINTING WITH LIGHT: STAR FRUIT IMAGES © JOE LAVINE.

A tutorial developed by Denver food photographer Joe Lavine demonstrates how. See the Technical Tutorials Section for Chapter 3.

Panning: Another means of registering blurred time in a photograph is commonly known to photographers as panning. The technique is often used by sports photographers; it's relatively difficult to master, but lends itself to a unique combination of motion against frozen elements within the frame. In order to pan, you use a long shutter speed (say, 1/4th of a second to 1 second), handhold the camera, and literally move the camera in the direction of the motion of the subject moving across your field of vision. If the moving

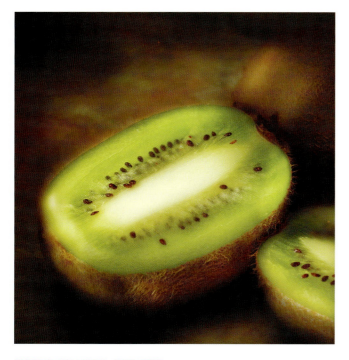

IMAGE © JOE LAVINE, *KIWI*, 2007.

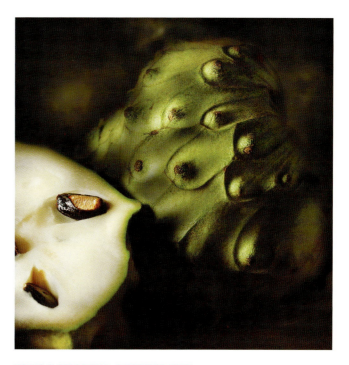

IMAGE © JOE LAVINE, *CHERIMOYA*, 2007.

subject stays in the same place in the frame throughout the long exposure, and everything else is moving (due to the motion of the camera) a successful pan is created, which renders the moving subject as frozen and all of the stationary content as blurred. The key is to move the camera at the same rate of speed as the subject's motion, to keep the moving subject at exactly the same point in the frame so that its motion is not extruded across the picture plane.

3. Static Time

In order for time in a photograph to be rendered as static (as stationary, or "still time" as Stephen Shore refers to it) there must be no movement in front of the camera, and the camera itself must not be moving, so that no freezing or blurring is possible. In these instances, time literally seems to be standing still. Photographers from Karl Blossfeldt (1865–1932) to Edward Weston (1886–1958) have created

iconographic images from objects in a seemingly perpetual static state. Static time is really a case of frozen time taken to the extreme, as eventually everything in the universe moves or changes. But in a photograph, static time appears quite different from frozen time in that the contents of the image seem at rest, as opposed to seeming arrested in time as they move; as such, these images connote very different meanings in relation to their specific subject and content.

An indispensable tool for creating images of static time is the simple tripod. With it, an image can be made to have maximum depth of field and still be static, since the smaller the aperture gets, the longer the shutter speed needs to be and the more often blur becomes apparent. If the subject is still (a still life, an interior space, or anything else which is not moving or changing rapidly) and the camera is on a tripod then the length of time the exposure takes is inconsequential, so with respect to motion a slow shutter speed can be used to the same visual effect as a fast shutter speed. The primary difference in this case is the change in depth of field which is created when you change the aperture to maintain proper exposure.

As stated before, a subject can be captured in static time while using a long shutter speed, since nothing in the image

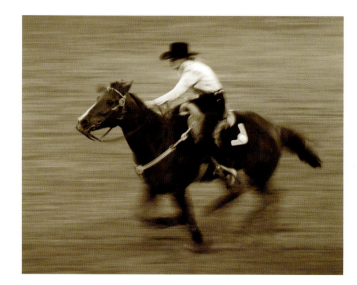

PHOTO © KATHY LIPPERT, 2007.

This image was made at the 2007 National Western Stock Show and Rodeo in Denver, Colorado. Panning captured not only the power and speed of barrel racing, but also the beauty of the fluidity of motion created by horse and rider. Kathy Lippert is a photojournalist and freelance editorial photographer specializing in sports, recreation, outdoor lifestyle, and, in particular, western lifestyle.

is moving. However, one major factor in relation to static time when using a long shutter speed is that the build-up of ambient light which occurs in the scene can make a dramatic difference in the visual outcome of the image. For example, in architectural photography it is desirable most of

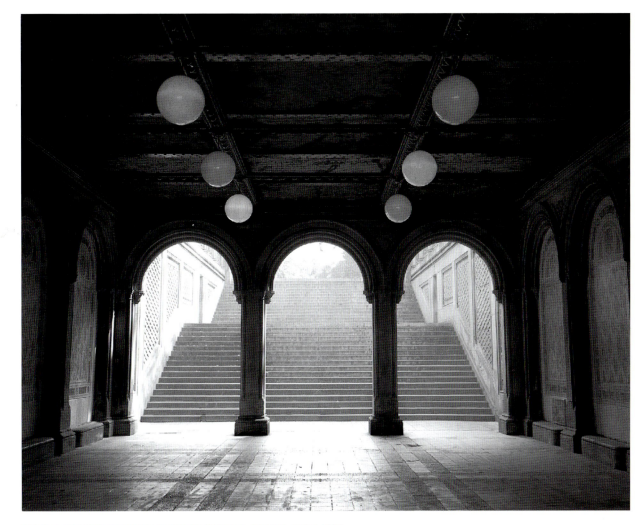

PHOTO © DAVID BECKERMAN, *BETHESDA PASSAGE*, CENTRAL PARK, 1994.

This image captures the nature of static time; there is nothing moving in the scene, and the camera itself is still, so the scene carries with it a feeling of solitude, calm, and quiet. The image was made with a 4 × 5 view camera with a normal focal length lens (150 mm).

the time to produce sharp, clear images of the place photo-graphed using a small aperture to achieve maximum depth of field. When doing so, it is essential to use a sturdy tripod to be able to meter the difference between various ambient light sources in the scene and to be able to "light balance" that is, to adjust your flash or strobe output in relation to the ambient light readings in the scene in order to produce your desired results.

In the following examples, architectural photographer Paul Weinrauch produces images which reveal static time in jux-taposition with interior ambient light for his personal port-folio. He finds that the technique of using a slow shutter speed to build upon the ambient light exposure at dusk and dawn, in relation to interior lighting, produces a beautiful visual effect in conjunction with the Victorian architecture that he loves. He uses the mix of different Kelvin temper-atures from the various light sources in the scene to add color and character to the images in relation to the color and style of the houses themselves.

4. Overlapped Time

Time can be overlapped onto static media by making sev-eral exposures in order to record multiple discreet instances in time layered on top of one another onto the same media

Paul Weinrauch is an architectural photographer living in Denver, CO.

FOUR PHOTOGRAPHS © WEINRAUCH PHOTOGRAPHY, 2006.

plane. Photographers as far back as Eadweard Muybridge (1830–1904) and Harold Edgerton (1903–1990) have overlapped time. Overlapping time necessarily includes one or more types of time capture; for instance, you might make multiple exposures recording frozen time, or you might combine exposures of frozen and blurred time. In any sense, if you take multiple "discreet parcels of time" and overlap them onto a single plane, you are creating an image which constitutes overlapping time; this could potentially have significant implications with respect to particular subject matter, and so should be considered as an important tool in the service of visual communication.

In this chapter's Artist Portfolio Pages, David Stephenson uses multiple (overlapped) exposures of blurred time in order to create kaleidoscopic images tracing the stars. This recording of time can also be achieved in the traditional darkroom using multiple printing techniques, as is famously done by artist–photographer Jerry Uelsmann, and similarly can be achieved in the digital darkroom as well using layers and layer blending modes. What makes this a distinct form of time capture in a photograph is the fact that it allows the production of images which could not exist without overlapping time within the frame.

Technical Considerations for Overlapping Time

One of the difficulties of achieving images which overlap time in the camera is determining the correct exposure for each of the individual frames. Well … help is on the way! There is a simple chart that outlines the amount to reduce the exposure depending on the total number of exposures you will make to a single frame, and it works in the darkroom as well as in capture. It is the stop-factor chart, and it's handy for more than just multiple exposures. It is the standard way that filter factor (how much light a filter absorbs) is described, and it is used when determining the number of multiple flash or strobe "pops" needed to build up exposure when using an insufficiently large aperture—a technique used primarily in studio photography in order to achieve greater depth of field. The chart is also used in describing ratios (the difference between the amounts of light in the highlight versus the shadow areas of a scene).

Stops	0	1	2	3	4	5	6
Factor	1	2	4	8	16	32	64

Here's how the chart works: the difference between amounts of light allowed to strike the photographic media is determined in what is referred to as "stops." For each 1 stop change, the media receives 2 times or $1/2$ the amount of exposure to light—that is, an exposure factor of 2. Each subsequent change entails applying a simple multiplication factor, and the chart provides it for you. Therefore, as a starting point, if you want to overlap two images onto a single frame, you will need to underexpose each image by 1 stop; if you want to overlap four images onto a single frame, you will have to underexpose each image by 2 stops and so on so that the final image has the correct overall density. Many cameras do the math for you simply by programming in the number of exposures you wish to overlap, but knowing the mathematics behind it allows you to control your results when your camera doesn't offer this capability.

In the following example, Michael Davidson of Florida State University's Institute of Molecular Biophysics creates wholly original images using overlapping time through exacting microscopy exposures.

Above is a multiple exposure image of ascorbic acid (the wheat field in the foreground), liquid crystalline xanthin gum (the mountains), the field diaphragm defocused with an orange filter (the moon), and polybenzyl-L-glutamate

IMAGE © MICHAEL W. DAVIDSON, *ASCORBIC ACID*, IDAHO; *COURTESY*: THE NATIONAL HIGH MAGNETIC FIELD LABORATORY, FLORIDA STATE UNIVERSITY.

spherulites with a blue filter (the stars). Michael Davidson says, "My interest in microscopy has led me to explore the possibilities of multiple exposure color photomicrography using crystals grown from a wide variety of chemicals, biochemicals, polymers, thin films, and biological macromolecules. The basic construction of these photomicrographs involves the classical microscopy techniques of brightfield and darkfield illumination, in addition to … cross polarization, differential interference contrast, and Rheinberg illumination assisted by basic visible light color-filtering processes. This effort has resulted in the generation

of a portfolio of images which I have termed *microscapes*. Microscapes consist of multiple exposures fashioned on a single frame of a 35-mm transparency film. They are intended to resemble unusual and/or alien-like landscapes and are designed to have the highest contrast and color saturation available with current commercial processing techniques."

TRADITIONAL DARKROOM TECHNIQUES FOR USING OR CREATING OVERLAPPED AND BLURRED TIME

While in-camera techniques are used to control the translation of the world in front of the camera onto the capture media, darkroom techniques using the element of time are used to translate the captured image onto the output media (the print). The printing aspect of this element of photography only comes into play in a real sense in the traditional (wet) darkroom, because in the digital darkroom the passing of time during printing does not directly affect the visual outcome of the print.

In the traditional darkroom, the enlarger's timer operates as the equivalent to the camera's shutter speed; this aspect of photographic image making happens in "real time" and is the aspect of print exposure that allows the opportunity to dodge and burn, and to manipulate the print through movement of the printing paper, the negative, or additional elements during the exposure. It also allows the creation of combination prints, the addition of motion onto the print by moving the paper or objects positioned between the paper and the enlarger light during exposure, and enables photographers to make multiple exposures onto the printing paper.

Technically, exposure works the same way in the darkroom as it does in the camera, though the longer exposure times allow a greater degree of creative control. The stop-factor chart works the same way in the darkroom, so that if you have a 20-second exposure to place proper density onto the print, then you can split that time into any number of increments in order to manipulate the element of time to your advantage. You might make two 10-second long exposures, and place text printed onto acetate in the light path for one of the exposures. You might make one 10-second exposure, and two 5-second exposures, and move the negative slightly in-between. There are countless ways to use the element of time to your advantage during the printing process; the key is to do so in such a way as makes sense for the content and subject of your images. Photographers also use these practices when making photograms or when combining exposure to both objects and negatives. Perhaps the most significant (and at times frustrating) aspect of

manipulating this element during the print exposure is that each print will be unique, since it is difficult to impossible to reproduce the exact degree of movement throughout an edition of prints.

In the following image example, Carol Golemboski uses the element of time to create finished images during her printing process; she states, "All manipulations occur in the printing process … I incorporate photograms into the pictures by laying objects on the paper during exposure to achieve a reverse (white) silhouette of the object, or a dark (black or gray) silhouette if I am using an Ortho–Litho template." The resulting images are complex and would be unattainable if the artist limited her creative process to in-camera capture and direct printing of the negative. Not only is the concept of *time* central to her work (in that the objects depicted in her images had previous lives in the world complete with meanings of their own and are now resurrected in second lives in a completely different context) but it is also central to the physical means through which she creates her work in the darkroom—the process of darkroom manipulations which depend on the exposure time and additional objects that she uses to make her final prints. View more of Carol Golemboski's work in the Artist Portfolio Pages of this chapter.

© CAROL GOLEMBOSKI, *SKINNING BIRDS*; TONED GELATIN SILVER PRINT, 2003.

Because the speed of light is constant, time and motion, arrested or extruded, are to some degree predictably written on to light-sensitive pages of photographs. Through the confluence of time, motion, and the duration of the exposure, image content is traced into a position on a continuum

from frozen to blurred. In translating time and motion onto a two-dimensional plane in this way, a new meaning to the photograph's subject is created; conceptual ties bind the content to the way it is recorded in time, thereby utilizing one of the medium's most valuable gifts.

As photographic processes continue to evolve, the ways in which frozen, blurred, static, and overlapping time are delineated in their images will also evolve. The potential for heightened understanding of any subject that can be rendered through the action of light in a photograph is endless. By uniting photographic processes with other time-related processes the potential is exponentially increased. From cinema's evolving time to image projection, film stills, scanner-as-camera, and animation through photographic sequencing, the medium is rich with possibility. But in order to capitalize on that possibility, practitioners must understand how the media's grammar operates with respect to the physical laws of time and light, and how static media relates to a moving world.

CHAPTER EXERCISES

In these exercises you are urged to consider in what ways time and motion relate to your chosen subject or concept. How can freezing, blurring, overlapping, panning, or a combination of these help a viewer to understand your subject or your point of view about it? These exercises are designed to help you explore your subject and practice your effective use of shutter speeds relative to the world of motion.

Exercise No. 1: Blurring Time and Motion from the Camera's Perspective

This exercise is intended to familiarize you with how your own movement or the movement of the camera itself can be used for communicative effect. In other words, you are placing the location of the movement at your own perspective, and therefore at the perspective of the viewer. Approach your subject using a range of slow shutter speeds, and, while moving around your subject or through the content of your images, make photographs. Don't worry about the results yet; just make photographs.

In this exercise, the editing process—really looking at the resulting images on your contact sheets—is where you will really discover the potential for unique possibilities that your own movement in relation to the subject can create. How do your own movement and the movement of the camera during the exposure create images and meanings that differ from those images in which the camera is stationary and the subject is moving? The differences can be dramatic in terms of their visual and conceptual implications.

Exercise No. 2: Freezing Time

The use of frozen time can lend a great deal of insight into a given subject, in that it gives the viewer the opportunity to pause over an event which has been sliced from and held in time. In this exercise, you should consider your subject in relation to Henri Cartier-Bresson's "Decisive Moment."

Use a sufficiently fast shutter speed to freeze the motion of your camera if it is handheld and to freeze any activity in the frame's content, or you might choose to freeze motion using a flash or strobe in a darkened interior, since the duration of many strobe units is faster than the shortest shutter speed in most cameras.

How does a frozen moment relate to your subject, or how could some secondary contents frozen in mid-movement relate to your stationary subject? Consider the natural moving aspects of the content surrounding your subject, or the meanings that might be conveyed about the movement of your subject itself.

Exercise No. 3: Personal Direction

Experiment with your own ideas on how to communicate about your chosen subject, genre, or concept as it relates to time and motion. You might choose to use a flash (to freeze motion) coupled with long exposure (to add faint blur) or rear-curtain flash coupled with long exposure. You might decide to create multiple exposures or to use the traditional or digital darkroom to explore the nature of motion as it relates to your subject. The idea is to use your knowledge about the nature of time and motion as it relates to your particular subject. Be inventive, creative, and think conceptually about your subject, topic, or genre!

PORTFOLIO PAGES

The artist–photographers represented in this chapter's portfolio pages focus on a wide range of techniques in which the shutter speed and the world of motion are intertwined to produce images with specific meaning and unique visual character. The photographers manipulate shutter speeds, time and motion in the camera, and in the traditional or digital darkroom; they overlap time upon several frames or overlap several frames over time; they freeze or blur motion in order to clarify meaning; and they document the world of motion in ways that our eyes cannot apprehend. As with all of the portfolio pages in this text, they are intended not as exhaustive examples of this element's possibilities, but as a source of inspiration from artist–photographers who have successfully employed the element in the service of making images that more accurately communicate their meanings.

CAROL GOLEMBOSKI

PSYCHOMETRY

ARTIST STATEMENT

Psychometry is a series of black and white photographs exploring issues relating to anxiety, loss, and existential doubt. The term refers to the pseudoscience of "object reading," the purported psychic ability to divine the history of objects through physical contact. Like amateur psychometrists, viewers are invited to interpret arrangements of tarnished and weathered objects, relying on the talismanic powers inherent in the vestiges of human presence. These images suggest a world in which ordinary belongings transcend their material nature to evoke the elusive presence of the past.

Through an examination of fortune-telling and clairvoyance, many of the images confront the desperate human desire to know the unknowable, historically referencing the Victorian interest in spiritualism as well as the look of the 19th century photographic image. Illegible text and arcane symbols in pictures with themes like palm reading, spoon bending, and phrenology force the viewer to consider man's insatiable need to anticipate his own fate.

The success of these images relies on the viewer's expectation of truth in the photograph, expanding upon age-old darkroom "trickery" to suspend belief between fact and fiction. The romantic ideas suggested by these photographs are enhanced by the nostalgia that accompanies historic photographic imagery, the process of traditional printmaking, and the magic of the darkroom.

Process Notes

The photographs in the series begin as straight negatives. I hunt for objects to photograph at flea markets and antique shops, arrange them in a space, and shoot them with a medium format camera under natural light. The negative size is $2^{1}/_{4}''$ square.

All manipulations occur in the printing process. The marks that appear in the image are the result of a combination of

scratching the negative and printing through drawings I've created on frosted mylar, drafting vellum or tracing paper with charcoal, graphite, and ink. I also use Ortho–Litho film to create templates for black marks, drawings, and text.

To further the sense of illusion, I incorporate photograms into the pictures by laying objects on the paper during exposure to achieve a reverse (white) silhouette of the object, or a dark (black or gray) silhouette if I am using an Ortho–Litho template.

After a traditional archival printing process, I tone the photographs with sepia toner. Despite the various manipulations that take place in the darkroom, I have always refrained from altering the surface of the print once it is finished.

The concept behind each picture ultimately dictates its darkroom manipulation, sometimes requiring research and revisions that last for weeks or months. Combining photography with drawing, seamlessly incorporating photograms, integrating appropriated text, and scratching the emulsion of the negative create images where horror, history, and psychology occupy the same imaginative locale.

Blind Bird, 2005.

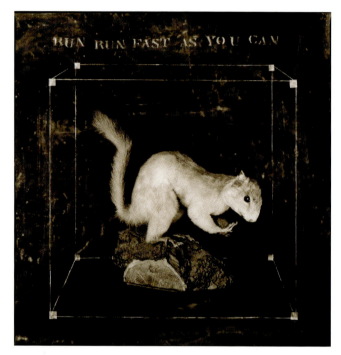

Run, Run, Fast as You Can.

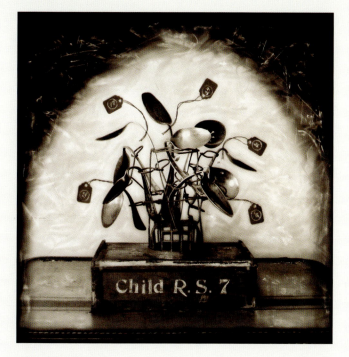

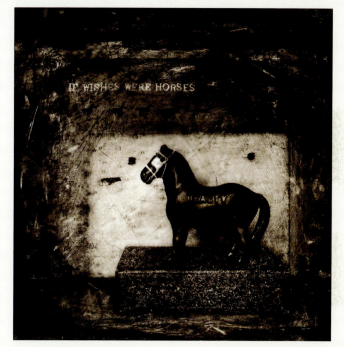

Bending Spoons, 2004. If Wishes Were Horses, 2006.

IMAGES © CAROL GOLEMBOSKI, FROM HER *PSYCHOMETRY SERIES*; TONED SILVER GELATIN PRINTS, 17.5″ × 17.5″.

SEAN WILKINSON

SOMETHING MORE AND LESS

ARTIST STATEMENT

Relationships between what is in front of a camera and what ends up as a picture are never as direct or simple as they seem. A picture always shows both more and less than what was there. These pictures make a point of emphasizing such discrepancies. The method of making the picture comes overtly into play. The thing seen is plainly affected by the instrument of seeing. These pictures are not unmediated, evidentiary, or dispassionate documents. They are quirky, rough, sketchy, and somewhat elusive.

Process Statement

I click the shutter of my plastic camera several times for each picture, the number roughly gauged depending on the light available. The camera moves slightly between exposures, and each successive click adds to the accumulation of time. The visual effect is impossible to predict. I can only guess how what I see before me will be transformed. The main event of picture making is therefore an act of imagination, and the result is always a surprise.

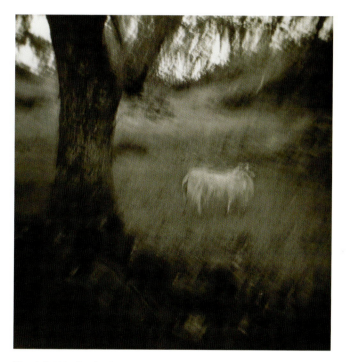

Untitled, 2005, Dayton.

Untitled, 2006, Scotland.

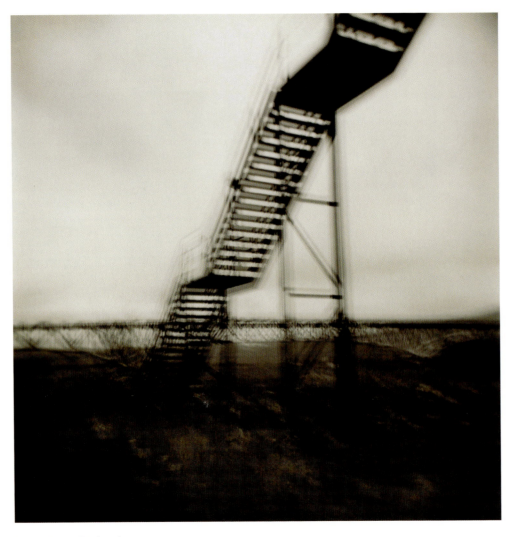

Untitled, 2006, Pittsburgh.

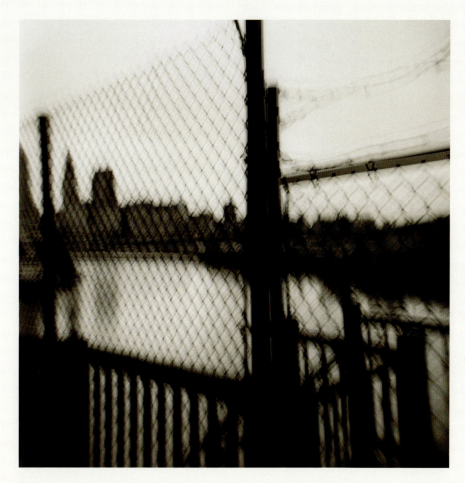

Untitled, 2005, Cleveland.

ALYSON BELCHER

SELF PORTRAITS

ARTIST STATEMENT

My work combines pinhole photography with improvisational performance and stems from the idea that everything we experience is stored somewhere in our bodies. Movement is one way to access and give visual form to what lies beneath the surface of the skin. The making of these photographs is an exploration of the nature of each movement and where it originates internally.

Because of the unpredictable nature of pinhole photography, there is no way to really know how an image will turn out. I don't always begin with a clearly defined idea. The images often reveal stories that may or may not have been known to me previously. That doesn't mean that they aren't my stories. Often the body remembers what the mind has forgotten.

The pinhole camera is low tech; it is the most basic tool for making a photographic image. There is no lens to interfere with the light as it travels from the subject to the film. Because there is no viewfinder through which to preview the image, it's a relatively blind process.

Process Statement

The photographs in this series are self-portraits made with a pinhole camera. I use a hand-made 4 × 5 pinhole camera with a pinhole of unknown size. I work in a studio that is filled with natural light, and my exposures range anywhere from 30 seconds to 2 minutes, depending on the weather. All of the figures in my photographs are me; I move around in front of the camera during the exposure, and when I remain still for more than a few seconds my image is recorded. The importance of this process to my work is the way it reveals the relationship between my inner experience and my physical body. Over time, the boundaries between inner and outer, physical and non-physical begin to blur as I experiment with varying degrees of movement and stillness.

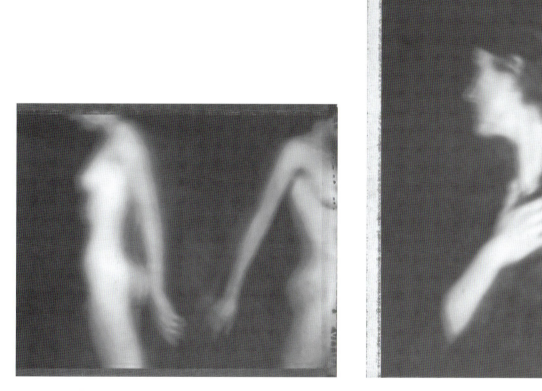

Self-Portrait #75B, 2002.

Self-Portrait #77A, 2002.

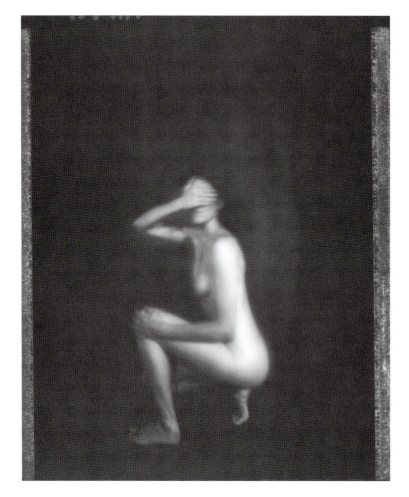

Self-Portrait #85B, 2002.

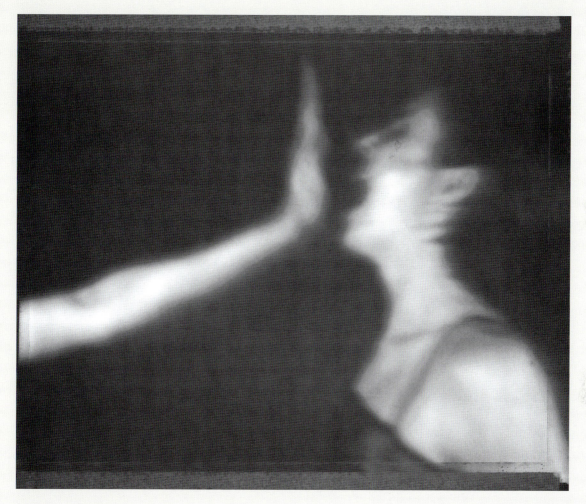

Self-Portrait #81A, 2002.

DAVID STEPHENSON

Stars

COMBINED ARTIST AND PROCESS STATEMENT

My photographs of star-filled night skies in 1995 and 1996 looked to the celestial realm for a sublime space in nature. Any photograph records a specific moment when light strikes film or paper—and in this sense is always a document of time itself. In my photographs of the night sky, the light of distant stars may take tens of thousands of years to reach us, and so my camera was recording the present moment but also looking back into time, using light originating from distant prehistory, and the movement of the earth, to "draw" on the film. The Stars evolved from an initial exploration of black and white silver prints in 1995 to the color images of 1996. By rotating the camera while overlaying as many as 72 multiple exposures, I was able to build up complex patterns which have affinities with the geometric structures of cupolas and mandalas, as well as system-based minimalist art. Extending Talbot's metaphor of photography as the pencil of nature, the Stars are drawings whose marks result from the movement of the earth, and a stationary camera that is periodically moved through a sequence of pre-determined positions.

Stars No. 1211.

Stars No. 1004.

Stars No. 1103.

Stars No. 1207.

ALEXEY TITARENKO

ARTIST STATEMENT

When the Soviet Union collapsed in the winter of 1991–1992, chaos reigned. I was one of the participants in this drama and shared the general mood of sadness, fear, and hopelessness. Crowds of people were wandering blindly in tired desperation through the city streets in a vain attempt to find food, medicines, and urgent supplies. St. Petersburg—a northerly city that during the autumn and winter is in the grip of an eternal twilight—was poorly illuminated, and the human figures, dressed in the dark clothes typical of the Soviet order, resembled phantasmagorical shadows from another, unreal world. They suggested living analogs for favorite works of mine by Dmitry Shostakovich (e.g., his Second Violin Concerto) or Fyodor Dostoevsky. It was as though time had stopped. This sensation was so powerful and precise that I felt a compelling desire to capture it on film. Capture, that is, not the reality that was unfolding before our eyes, but the idea of it: the reflection of that reality, colored by personal emotions. Thus I conceived the idea of employing prolonged exposure in the series of photographs that later came to be called *City of Shadows.*

I believe one of the most important objectives of an artist is to make inner emotions and feelings visible to others, to promote understanding and empathy, and thus to get people to feel compassion and love for their neighbors.

Process Statement

In the creative use of prolonged exposure the most difficult question the photographer faces is how long the exposure should be. The following fundamental principle needs to be kept in mind: the faster objects in the frame are moving, the shorter the exposure should be (and vice versa). If this principle is not followed, the only objects to be rendered successfully in the photograph will be those that are stationary (houses, trees, etc.); moving objects (people, cars) will disappear (although this approach is acceptable if what you need is a feeling of empty space). I was faced with this problem when photographing crowds trying to get into a metro station. A mad avalanche of desperate

people squeezed up against each other and holding on to a handrail for dear life was moving very slowly and jerkily, in spasms. At the entrance to the station a policeman stood, admitting only small groups at a time. So I needed as long an exposure as possible. The maximum length possible was 3 minutes—this is the exposure I set for all photographs of the crowds. Because people's hands remained motionless on the rail for longer than their bodies, the hands stayed in sharp focus, while the figures themselves were blurred.

When photographing street scenes, I had, on the contrary, to reduce the exposure. Because people were moving quickly, the exposure I set was around 2 seconds. If the weather was clear and sunny, I employed a neutral density filter and the smallest aperture (f/22, f/32).

In order to create the impression of sunrays, the camera had to be held still during the initial stage of exposure and then moved smoothly. Of course, this is a difficult operation to perform in a mere 2 seconds. So I had to use an appropriate aperture setting and density of filter to allow an exposure of at least 4–5 seconds—and for at least half this time the camera had to be held still.

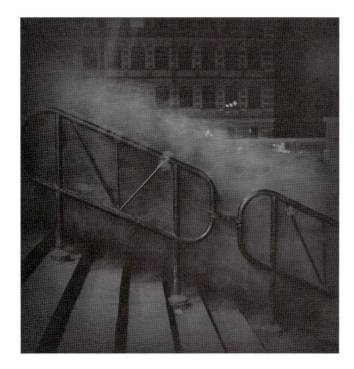

Untitled (Crowd 1), 1993.

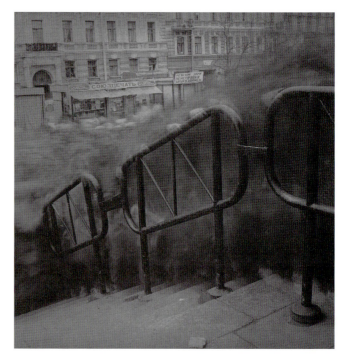

Untitled (Crowd 2), 1993.

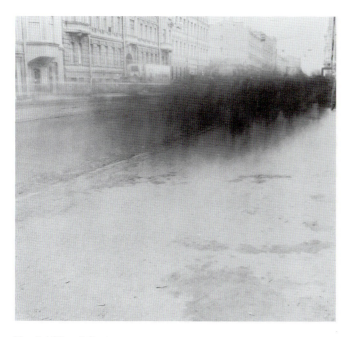

Untitled (Crowd 3), 1993. Untitled (Boy), 1992.

PHOTOGRAPHS © ALEXEY TITARENKO, FROM HIS SERIES *CITY OF SHADOWS*; GELATIN SILVER PRINTS; *COURTESY*: NAILYA ALEXANDER GALLERY.

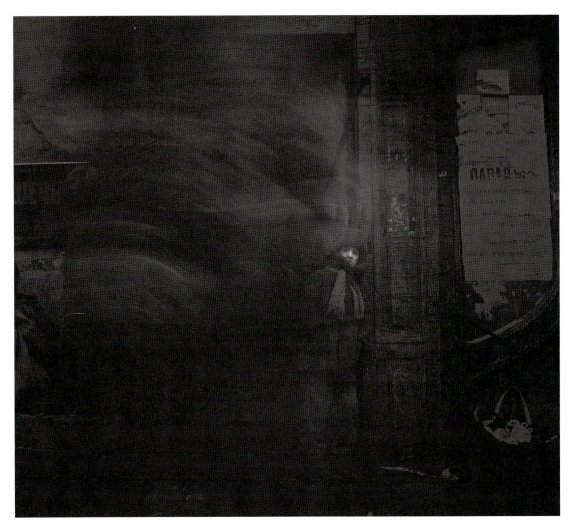

Untitled (Woman on the Corner #2), 1995, from series *Black and White Magic of St. Petersburg*.

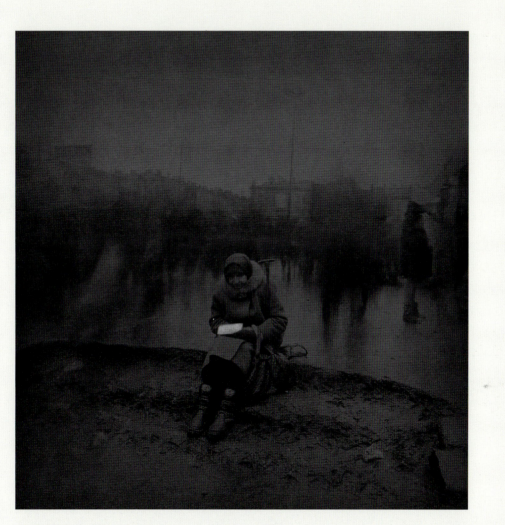

Untitled (Begging Woman), 1999, from series *Time Standing Still.*

MARTHA MADIGAN

BOTANICAL PORTRAITS

ARTIST STATEMENT

The cycles of the seasons and the rhythms of the sun dancing through days, months, and years fill me with awe and inspiration. The gentle whisper of dawn envelops me within its subtlest suggestion of the infinite realm of possibility that is contained within human experience. The space of deepest silence when day changes into night draws me into an experience of oneness that transcends words. These timeless experiences of consciousness continue to powerfully beckon to me as an artist. The process of my work reflects the passages of life, seeking not an understanding of time, but rather an experience of the sacred presence within it.

The radiance of the sun as the essence of creation becomes a direct experience within the work. The sun reveals the truth of human nature—that what we seek dwells quietly within the core of our beings. The exquisite form of a newborn baby embodies this teaching with the sweetness of absolute trust. The sublime perfection of a young woman's body with all its sensuality and mystery suggests hope. The character and unique form of an elder human being speaks of wisdom. May my work be a boat that carries me safely down the relentless river of time across the ocean of worldliness.

Botanical Portraits

Botanical Portraits is an extension of my solar photogram work since the mid-1980s, titled *Human Nature*. The direct solar photograms use human scale plant forms as subject matter, which express a powerful and vital energy. The plants in this body of work are chosen for both their scale relationships and healing properties for the human condition. We all know clearly that our current relationship to the natural world is a fragile one. The simple, direct truth of the subject matter is revealed, alternating between dark and light, suggesting both the benevolent and terrible beauty of the natural world. These prints measure 6 ft high by 2 ft wide.

Process

The human scale 6-ft tall plant is placed on a slow-speed printing-out-paper and exposed in the direct sunlight for 5–30 minutes, relative to the foliage density. The resulting print is then gold toned and fixed for archival permanence. This print is then contact printed to an unexposed sheet of printing-out-paper to make the positive print. High-resolution direct scans are made of the unique prints. Finally, digital editions are created of both the original photogram and the positive print. The resulting full-scale digital prints are made using pigment dyes on archival paper.

Botanical Portrait: Alium.

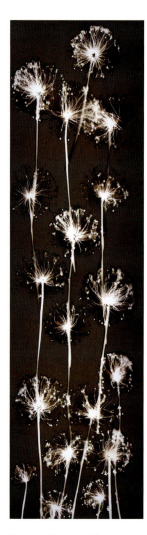

Botanical Portrait: Alium.

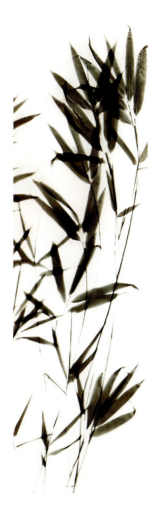

Botanical Portrait: Bamboo III.

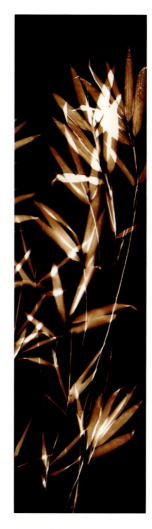

Botanical Portrait: Bamboo III.

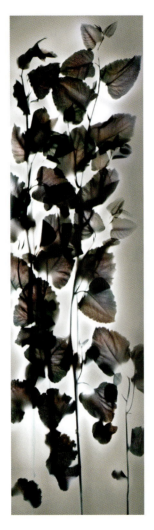

Botanical Portrait: River Lily.

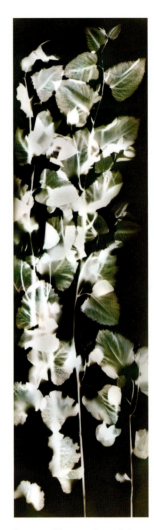

Botanical Portrait: River Lily.

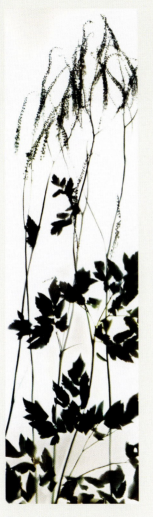

Botanical Portrait: Snakewort.

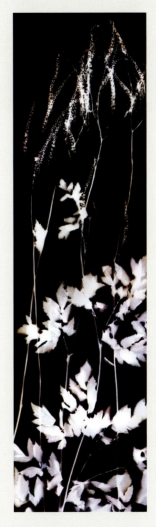

Botanical Portrait: Snakewort.

ADAM JAHIEL

The Last Cowboy

ARTIST STATEMENT

I like to look and I like to share what I see. But I like to do that sharing wordlessly. Over the years, some of my peers have accused me of being mostly interested in the "fringe" people. Maybe so. But I like to think I am drawn to those who seem to exist outside of time in forgotten corners and cultures. Somehow, they seem more in touch with, or part of, the human condition.

The FSA photographers of the depression have always been my role models. They documented people and life in a difficult period of our history, in an honest, straightforward, respectful, and intimate way, and they did so beautifully. And they preserved it forever.

I work in black and white because it allows me to boil elements down to their very essence—shape, lines, and light. Light can be indescribably beautiful and fascinating. I love to watch it completely transform something. The same scene can go from being unremarkable, to extraordinary, and back to unremarkable in a heartbeat. Even after all these years of working, the ability to freeze a moment in time, and preserve it forever, although mostly science, to me is really more like magic.

Process Statement

"Photography takes an instant out of time, altering life by holding it still."—Dorothea Lange

"To take photographs means to recognize—simultaneously and within a fraction of a second—both the fact itself and the rigorous organization of visually perceived forms that give it meaning. It is putting one's head, one's eye, and one's heart on the same axis."—Henri Cartier-Bresson

The concepts of "holding time still," "fractions of a second," "the decisive moment," "seconds snatched from eternity," and "the fleeting moment" are all phrases used by great photographers, to describe their most important goal in their work.

Subject matter often dictates my approach, and in this body of work, I am interested in capturing as much detail of texture, light, and atmosphere that I can. To this end, I work with a medium format rangefinder camera. This type of camera gives me the ability to use the largest negative that is practical for me to create images in a constantly changing situation. Technically, I have two main challenges. The first challenge is that much of what I shoot is in very low light conditions. The use of a rangefinder camera lets me shoot at slow shutter speeds, avoiding the inherent problem of camera vibration that would pose a problem by using any kind of single-lens reflex camera. My second challenge is to be able to freeze rapidly changing action, at the absolute peak moment. I observe, anticipate what is going to take place, press the shutter, stopping time at just the right instant. A split second before or after, and the moment is gone, forever.

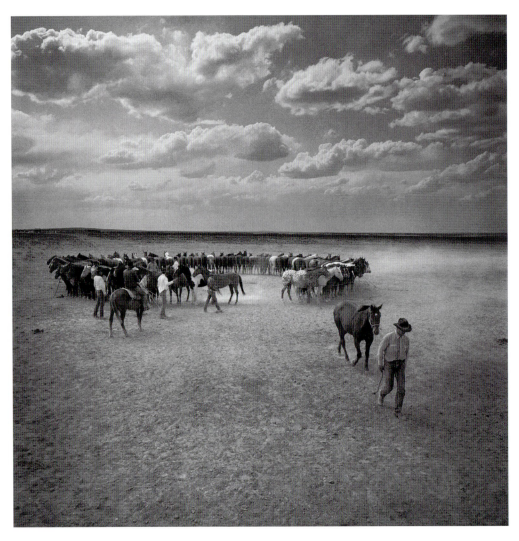

Part of his String, 1993, YP Ranch, NV.

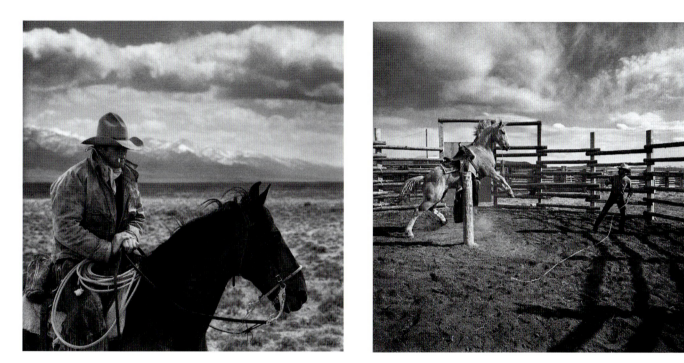

Fish Creek 1990, Fish Creek Ranch, NV. Rancho Grande, 1990, NV.

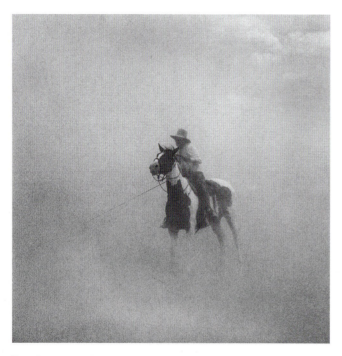

Dust Storm, 1993, YP Ranch, NV.

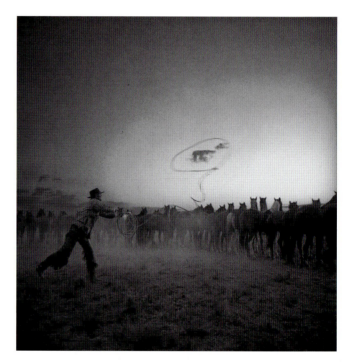

Roping a Cloud, 1994, Winters Camp, IL Ranch, NV.

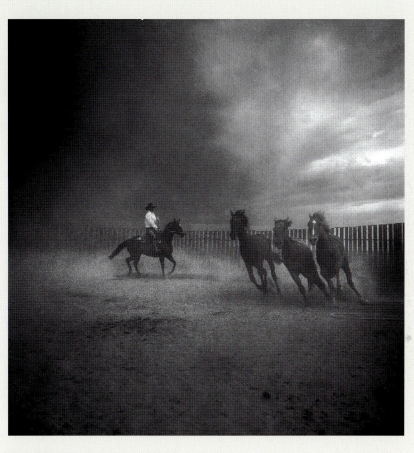

Three Horses of the Apocalypse, 1994, ID.

ANDREW DAVIDHAZY

STRING THEORY IMAGES

STATEMENT OF CONCEPT AND PROCESS

Some time ago I received an e-mail message from an editor who had been exploring my website and who thought I might have some photographs that could be applicable to an article about a theory that has the world of science abuzz. It is the "String theory." The truth was I had no photographs of strings in any shape or form but the inquiry started me thinking and I thought I pre-visualized what these images might look like and how they would be made. The fact I had a digital camera at my disposal made it possible to check out my ideas in short order.

Since the request was for an image that would show strings moving in odd ways and vibrating this reminded me of strings in musical instruments where a taut string is held on both ends and plucked in the middle to produce sound waves. I also remembered from somewhere, maybe a physics class, that one could also simply hold one end and make the other end move up and down. If done properly this would induce a wave-like motion on the string that under some conditions would be a "standing wave." This started me thinking about other ways to induce vibrations in a string and I built a set-up where the string was attached on one end to a fastener located on the edge of a rotating disk driven by a small electric motor whose speed could be varied by changing, with a rheostat, the voltage driving the motor. I then attached a small weight to the other, free, end and let gravity pull the string down.

I decided to go contrary to convention, and instead of making a sharp record of the string I purposefully chose an exposure time long enough to allow the string to make several rotations during the exposure cycle. This, now, revealed the rotating string not as a single

line in space with a wave in it but rather as a "volume," something that seemed to have a three-dimensional quality to it. This was a bit more interesting than the plain string picture but then something unexpected happened. While adjusting the voltage to the motor, the voltage went so high as to cause the rotating string to assume a changing wave pattern as the weighted-down string could not keep up with the speed of the disk powering it. The string wrapped up onto itself pulling the weight upwards and causing the string to perform rather erratic motions in the process.

I continued photographing and when these images were displayed on the camera's LCD screen it became clear that as far as an interpretation of a vibrating string that might accompany an article about the string theory, these photographs seemed to hold much more promise than a simple image of a plain string with a wave pattern on it.

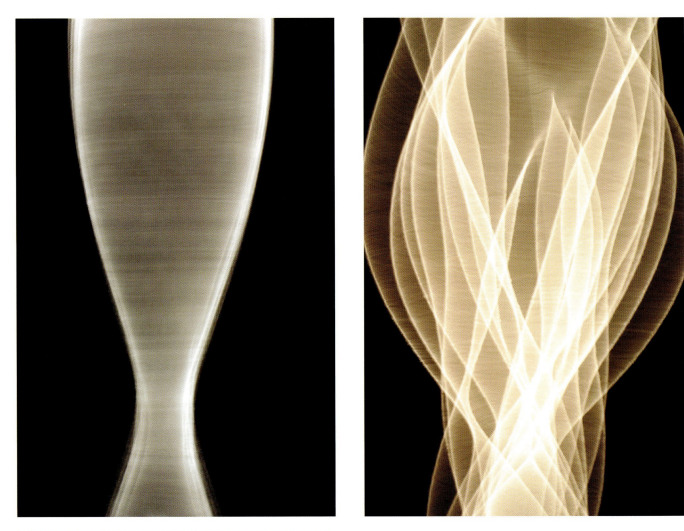

PHOTOGRAPHS © ANDREW DAVIDHAZY, *STRING THEORY* PHOTOGRAPHS.

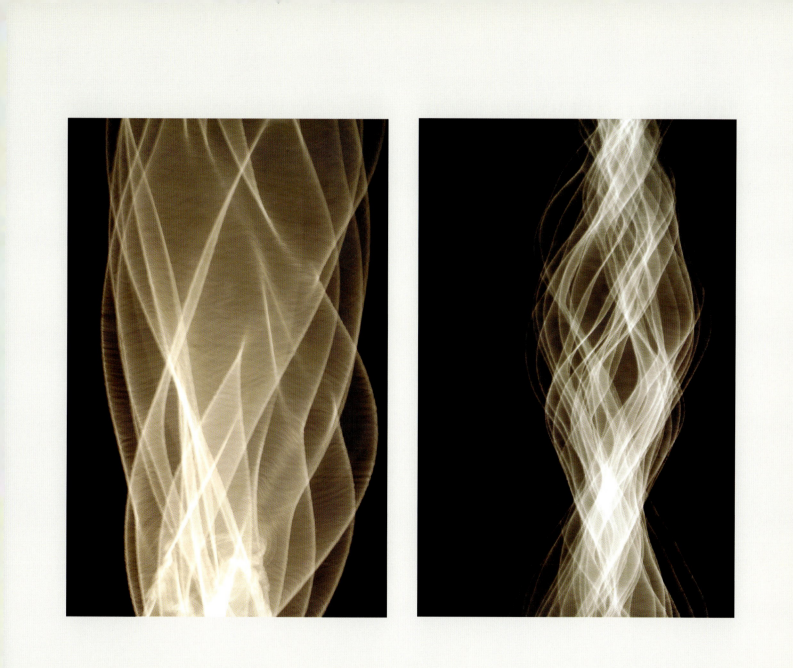

ANDREW DAVIDHAZY

PERIPHERAL PORTRAITS

Andrew Davidhazy's Visual Transformations, by A. Becquer Casaballe
"From the time of its invention, photography has been characterized by its capacity for capturing in a fraction of time, each time a smaller fraction as advances were made not only in the technology of emulsions and papers, a given scene, following the laws of optics.

Instantaneity and photography, governed by rules of perspective, in this sense have become almost synonymous, where light, in a single action, discharges its energy over the photosensitive material. The history of photography was constructed in this manner: light, instantaneous recording, and a space recorded over the angle of view of the camera's lens. Behind these physical and chemical underpinnings we find the creative will of the photographer who brings to the final product personal vision and sensibility.

On the other hand, the work, the research, and the photographs of Andrew Davidhazy are endowed with a new dimension from the moment that the factor of time, inescapable in every photographic image, reconstructs space by a disengagement from the traditional and conventional methods.

Technologically, his photographs are based on the basic operating parameters of focal-plane shutters that move from side to side of the focal frame and thus control the exposure time. Davidhazy inverted this positive process: he holds the shutter slot still in the center of the frame and makes the film move behind it at a uniform speed.

Thus a new dimension of space manifests itself since the resulting image—the photograph—is created over a period of time and following the movement of the subject. This transformation is somewhat unnerving but at the same time it is a revelation of this new spatial dimension that can only be obtained through photography.

The work of Davidhazy makes us consider a new reality which our conventional perception of the nude is incapable of perceiving, but which is there—his photographs are a direct and indisputable evidence that this reality exists—and which only reveals itself through the most realistic of abstractions."

—*This text was provided by Becquer Casaballe from a May 1998 Exhibition at Club Fotografico de Mexico, in Mexico City. Becquer Casaballe is the Owner and Editor of* Fotomundo Magazine *published in Buenos Aires, Argentina.*

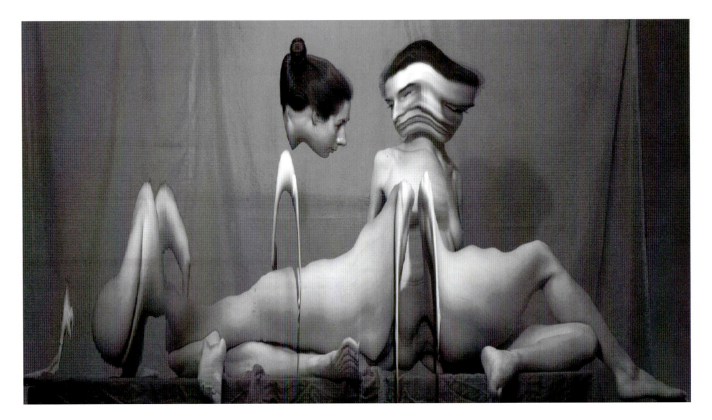

Peripheral Portrait, Koola.

Peripheral Portrait, Linda.

JOHN DANEHY

France in Passing

ARTIST STATEMENT

We spend so much time in transit from "here to there." This series is about the journey in-between. Our perception of the world is of things always being in motion, as if passing us by. My use of in-camera motion-induced blur reflects the experience of viewing the landscape in transit.

Buddhists say the world is illusion. Modern physics tells us that material objects are mostly space. I'm interested in the way motion in a photograph can dematerialize objects we normally regard as solid. Here space and the object begin to merge. It suggests the idea of impermanence and moves the images closer to memory or dreams.

It's a visual expression of ourselves as visitors here, not as tourists, but as ephemeral beings just passing through. The best of these fleeting glimpses begin to resonate on a more symbolic level: the solidity of a tree vaporizing in air as it bridges earth and heaven.

Is a momentary glance necessarily less revealing than a stare? The photograph remains for us to contemplate after the moment seems to have passed. As the old song goes, "such a long, long time to be gone, and a short time to be here."

Process Statement

This project began some years ago with film. Last year I switched to a Canon G6 digital camera for the series and found, as expected, that the immediate feedback allowed me to adjust technique more efficiently in response to results. Shutter speeds vary from $1/2$ second to $1/30$th of a second depending on light and speed of travel. I count on random chance, look for pleasant surprises, and a combination of motion/blur and sharp definition. Once in the computer, a 17" Mac Powerbook G4, I've used the new Adobe Lightroom program to edit and adjust the large number of images in the series. An Epson 2200 printer was used to print for the first exhibition.

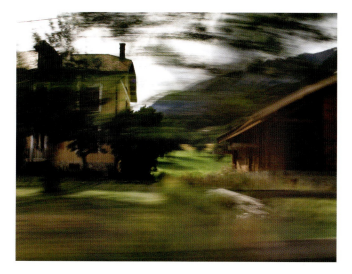

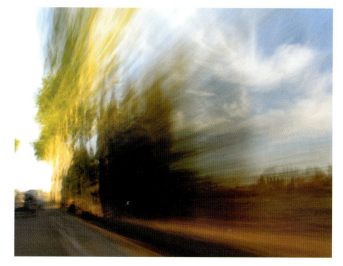

Untitled (Space Between Two Houses), 2007.

Untitled (Trees, Light, Sky), 2007.

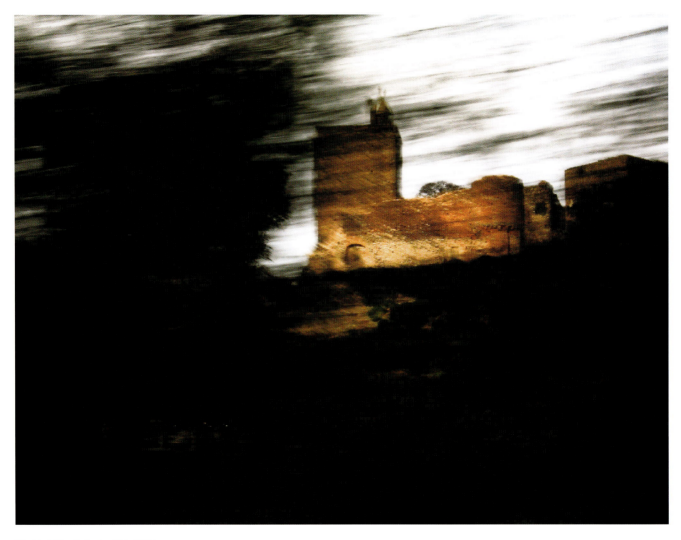

Untitled (Castle in the Air), 2007.

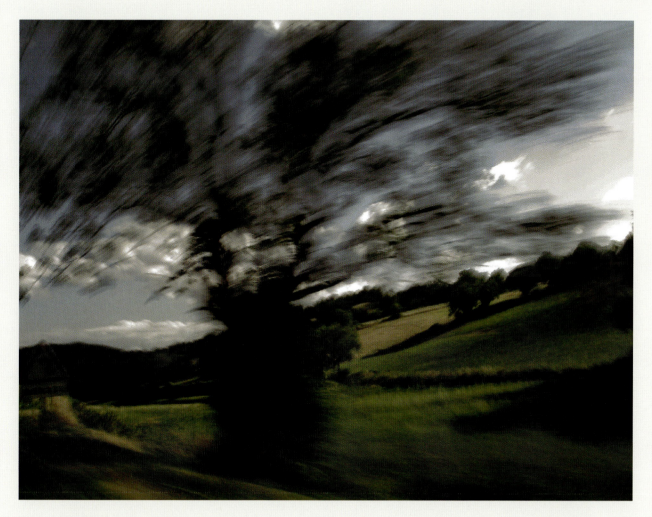

Untitled (Tree), 2007.

MATERIALS AND PROCESSES: THE AGGREGATE IMAGE

"THE PHOTOGRAPH IS NOT A PICTURE OF SOMETHING BUT IS AN OBJECT ABOUT SOMETHING." —ROBERT HEINECKEN

PHOTOGRAPH © MYRA GREENE, *Untitled,* from her series *Character Recognition;* 3″ × 4″ black glass plate Ambrotype.

How many Americans, in particular those interested in U.S. history, have read the Declaration of Independence (or the Bill of Rights or the Constitution) in a textbook, online, or in any other publication? If you are moved by the words in this influential document, how much more so would the words affect you if you gazed upon the actual, hand-written object (housed in the Rotunda of the National Archives in Washington, DC)? What is it about being in the presence of the physical document that imbues its words and their message with more power? Perhaps it allows us to connect, through time and space, with the document's creator. Perhaps we recognize in the object itself the ability to bridge time and space, its physical presence a testament to the enduring nature of the things we create. The central component of a historic document or a work or art that loses impact, in whole or in part, in a reproduction is its *form*. The subject (or theme) and the content (in this case the words) are present in reproductions, but the form they take ... in the color of ink used, in the quality and tone of parchment, as well as the style of handwriting ... are all absent. This is a central element, the part of the work that can communicate a sense of the thing itself when tied to its subject and content.

A discussion of the Declaration of Independence might seem misplaced in a book about photography, but it isn't.

The physical object of the photograph also holds significant meaning. While a reproduction of a photograph in a book, magazine, or on the Internet can carry the message of the image, in many cases it cannot embody its entire meaning. A photograph that is intended to take a particular physical form beyond the ephemeral image in the camera is intended to be regarded as an object. The ability to view reproductions of objects in various forms is an advantage in terms of sharing and disseminating information to a wide or even global audience, but copies fall short in their ability to translate the experience of the thing itself.

This is the fourth element of photography: the physical materials and processes comprising the object that contribute significantly to the meaning of the image. All photographic images are affected to some degree by the materials and processes from which they are made; some images, such as photojournalistic images, surveillance photographs, x-rays, ID photos, and the like are not particularly *dependent* on materials and processes in order to communicate their meaning fully. Other images, however, are greatly affected by the specific materials and processes used to create them, and rely on this element of photographic language in order to communicate their meanings. Those images are the ones addressed most specifically in this chapter.

MATERIALS AND PROCESSES: TECHNICAL CONSIDERATIONS AND VISUAL OUTCOMES

As stated in the introduction, this book is about the four elements that comprise the technical foundation, as well as dictate the visual outcomes, of all photographic images. They form what I refer to as the grammar of photographic language. Framing, focus, and the rendering of time and motion are all associated with image capture, but are also controlled in post-capture image production. The final element, *materials and processes*, is different from the first three in that this element is not controlled through the camera mechanism, but it is integral in that materials and processes is the very stuff of which the image is made. Included in this discussion are aspects of the physical object that are important in forming the image. There are three primary aspects of this photographic element: grain structure; surface structure (tint, tone, and texture); and size and scale. Additional discussion is devoted to the impact of the viewing space on the image.

Grain Structure

Since light-sensitive media is itself a physical object, its surface texture and physical composition impact the quality of the image it captures, literally imposing an image of its own physical nature into the image it captures. Both traditional film and digital sensors have similar characteristics pertaining to light-gathering ability and its effect on images; "grain" is not the technically correct term for referring to the makeup of digital sensors, but for this discussion it helps to think of a digital sensor as being composed of millions of evenly spaced, identically sized light-gathering particles.

The light-gathering ability of photo-sensitive media is rated by the International Standards Organization (ISO); the lower the ISO rating for a given media type, the slower the media responds to light to record an image. ISO numbers are explained at length in Appendix B of this text. As a general rule, slower ISOs produce images with finer grain (traditional) or noise (digital); faster ISOs produce images with larger or more apparent grain or noise. The reason for this is that with traditional film, the faster the ISO, the larger the actual grains of silver have to be; this provides a larger surface area for light to render adequate exposure faster. With digital media, the effect is similar—increased noise with increased ISO—but the reason is different; digital sensors are optimized at their slowest ISO, and the electrical signal created upon exposure to light is amplified when you move to higher ISOs, thus rendering faster exposure but with noisier image quality.

There are two other image quality considerations related to light-sensitive materials. They are resolution and acutance.

Resolution refers to the material's ability to produce a detailed image; acutance refers to the material's ability to produce fine edges and transitions between tonal differences. In general, the slower the ISO the finer the resolution and acutance, but other factors such as lens quality and differences between media—say, slide film versus negative film, and digital sensor types—are also significant.

The following example represents an image captured digitally at both 100 ISO and 1600 ISO sensor speed ratings. The blow-up versions show the increased noise caused when a faster ISO is used.

PHOTOGRAPH © ANGELA FARIS BELT, 2007.

Generally speaking, photographers choose the ISO rating that best suits the lighting condition and exposure needed, but often the decision about ISO can be made for purely aesthetic reasons. For example, consider that since slower ISO media creates a finer image, it might communicate more seamlessly or transparently about a subject, while faster ISO media might draw a viewer's attention to itself through added texture. In addition to the capture material's ISO characteristics, the processes used in the traditional or digital darkroom can emphasize either extreme. Using the materials and processes together enhances your ability to communicate to your viewer.

Imagery about difficult subjects, for instance poverty, war, disease, social injustice, or violence, created with the grainy, gritty texture of the materials enhanced, transmits a more concrete and visceral experience to a viewer than could the same imagery using the finest grain structure. The potential impact of maximizing the light-sensitive material's structure is apparent in Robert Frank's *The Americans*, and is underscored in the storm of American public response to the work. More recently, it is powerfully utilized in Jim Goldberg's *Raised by Wolves*, a social documentary account of San Francisco and Los Angeles inner cities' homeless teens. The images use grain as a communicative element, since

100 ISO renders finer image quality.

1600 ISO renders rougher image quality.

ENLARGED VIEWS.

smooth, silky imagery that minimizes the light-sensitive material's structure is in many ways at odds with the intellectual and emotional response their subject should evoke.

Surface Structure (Tint, Tone, and Texture)

A second significant aspect of the materials and processes from which the photographic image is made has to do with the surface structure of the image—the hue (actual color), value (relative degree of light or dark of the color), and intensity (the saturation or purity of the color) of both the substrate and the image material, as well as their texture. These are considerations even when the image is said to be black and white, because neither the substrate nor the image material may be a pure neutral tone, and even a subtle degree of color can make a dramatic impact on the feeling of an image.

That the surface structure so dramatically affects the *appearance* of the final image is a reason enough to understand its nature, since the appearance of the image affects its interpretation. Understanding how color forms in a photograph does not take a degree in chemistry, but only the ability to research the materials you wish to use. Although the two terms are often used interchangeably, for this discussion, I will use the term *tint* to refer to the substrate's color characteristics (the paper, fabric, etc., that the image is printed on), and I will use the term *tone* to refer to the color characteristics of the image material (the inks or emulsions that form the image).

Tint: This refers to the paper or substrate's density and color characteristics including its hue, value, and intensity. Some papers look warm, some neutral, and others cold. Some papers look bright white, some natural white, and others dingy white. Alternative printing materials can also be used, such as linen and other fabrics, 3-dimensional substrates, and even clear glass, to which photo-sensitive emulsions are added. It should be understood as well that the tint of the substrate is often responsible for the perception of contrast in the image.

The tint of the substrate is a factor in both traditional and digital imagery. While pre-sensitized substrates for traditional darkroom use are becoming more limited, coated inkjet substrates are becoming more varied. Rather than use coated substrates for inkjet printing, some artists use traditional watercolor papers and other materials for printing with inkjet technology, and others are transferring inkjet prints from one substrate onto another similar to Polaroid Transfer techniques. The results of these printing methods vary widely, and experimentation is required for greater understanding and control.

Tone: This refers to the color characteristics of the image material; these are the inks, dyes, or emulsions that form the image on the substrate.

When using chemical emulsions, the degree of light sensitivity (how fast or slow the emulsion responds to light) might be a consideration that limits aesthetic choices about tone. Additionally, the chemical processes used in developing the prints affect the color of the image. There are three basic emulsion formulations of black and white darkroom printing papers, though the numbers of available papers are dwindling.

1. *Chloride emulsions*: These emulsions are generally used for contact printing, as they have slow sensitivity to light and will often fog before an enlargement can be

made. They tend to produce warm tones, and can be used for split-toning using a heavy selenium bath.

2. *Bromide emulsions*: These emulsions are generally used for making enlargements, as they are more sensitive to light. They tend to produce a more cold tone print.

3. *Chloro-bromide emulsions*: These emulsions are a mixture of the previous two, and can produce exposure and color qualities anywhere in between, depending on the ratio of chloride to bromide.

Texture: Substrates, emulsions, and other image materials have texture that imprints itself onto the final image. Textures range from smooth, slick, high gloss, to toothy matte; they have a dramatic effect on how the image tone is applied to the material as well as on the reflective value of the surface. They also affect how the materials must be handled, since many more glossy materials must be handled with extreme care as they are prone to surface scratches. High gloss materials often are associated with commercial photography applications while more matte surfaces carry with them connotations of hand-made quality.

Various tints and tones, as well as surface textures of prints greatly affect image appearance, thereby influencing how the viewer interprets the image. Decisions regarding these

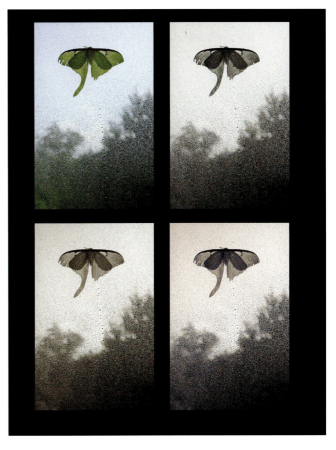

PHOTOGRAPH © ANGELA FARIS BELT, *LUNA MOTH*, 2006.

Clockwise from upper left: The original color image, a grayscale version, a split toned version, and sepia toned version.

aspects of image production are important throughout the process, and research and experimentation are invaluable guides.

DIGITAL DARKROOM GRAIN AND SEPIA EFFECT

Although digital sensors are capable of producing very fine detail, sometimes that's not what you need to make your images work well. Sometimes you want grain or noise to add perceived texture to the image, and there are ways to enhance it in the digital darkroom. The "Grainy Effect" tutorial found in the Tutorials Section for Chapter 4 walks you through a simple procedure developed by one of my students, Jennifer Hardman.

Size and Scale

Materials and processes determine important aspects of the appearance of photographs precisely because we relate to them physically in a visual sense. The image's appearance affects us, not only because of its subject and content, but also because of its form, including all of the physical attributes of the image. One of these attributes, which exists somewhat outside of materials and processes, is the size and scale of the image. Just as the aesthetics of focus range from uber-sharp to unrecognizably diffused, the aesthetics of size and scale also display a range. But the determining

factor for the size of images shouldn't depend on the current trend; rather, it should depend on factors such as practicality (what is the end use of the image and what is an appropriate size for this end use) as well as how the size of the image content relates to its viewers, and what the size of the image says about the subject.

Susan Stewart, in her critical text *On Longing: Narratives on the Miniature, the Gigantic, the Souvenir, the Collection*, states that, "The body is our mode of perceiving scale." Our perception of the size and scale of anything outside our bodies is relative to our own (human) size. Stewart says that, "The miniature is considered … as a metaphor for the interior space," it is personal, secretive, sensual, private as a family snapshot and nearly as sentimental. "The gigantic," on the other hand, "is considered as a metaphor for the abstract authority of the collective state and the collective, public life"; it is engulfing, overpowering, open to all and thereby impersonal.

Two contemporary artist–photographers come to mind when discussing size and scale relative to the content of images. Andreas Gursky, the German photographer, is known for photographing public spaces, retail stores, and large landscapes from high vantage points. He has printed images at an enormous scale, sometimes exceeding 6 ft at

Before and after the Grain effect is applied.

PHOTOGRAPHS © JENNIFER HARDMAN, *HANDS*, 2007.

their minimum dimension, by combining several over-sized sheets of photographic paper. The photographs, like the places depicted in them *feel* public. Their saturated color and crisp detail throughout packed frames is almost overwhelming, and commands perhaps more tactile presence than would the scene itself. At the opposite extreme is Japanese artist Masao Yamamoto's ongoing series of photographs entitled *A Box of Ku*. There are hundreds of unique images in the series, each small enough to fit in the palm of a hand. In this work, not only is the scale that of a personal souvenir, but the print surfaces are manipulated to feel as though each has had its own life in the world; they are torn, creased, stained, and feel as though they have lived in a pocket. The scale makes the work feel simultaneously universal and personal, and speaks to the understated beauty of the individual print's varied and enigmatic content.

A CASE STUDY IN THE EFFECTS OF MATERIALS AND PROCESSES

Aging and antique images carry with them a unique aesthetic; the natural decomposition of papers, emulsions, metal, dyes, etc., all contribute to this aesthetic, and their contribution will continue to evolve as their materials continue to change over time. The effects—a distinct range of appearances from mould to flaking to discoloration and decomposition—are tied to the original physical and chemical composition of the materials and their response to time and environmental factors. This is all largely an unpredictable phenomenon because photography has not been in existence long enough for its practitioners to carefully study the effects of aging on the aesthetics of the medium. But as this aesthetic emerges, it has had a significant effect on both traditional and digital photographic practices, and has been mimicked and utilized in both fine art and commercial realms. To a certain degree, the resurgence of alternative chemical and historic photographic processes owes as much to the aging of old photographs as it does to the rise of digital imaging technologies.

IN THE GALLERY: DISPLAY MATERIALS AND CONSIDERATIONS

Like Jack Teemer said about his use of carrier edge implying a world that extends beyond the confines of the frame, the gallery space (or alternative means of sharing images) operates as an extension of the frame. It does so in that everything we see before and after the image, everything adjacent to the image, and the conditions of the gallery environment itself, imposes itself to a certain degree onto the images and affects viewer interpretation.

One significant factor in displaying two-dimensional photographic work is the spacing between images. The established spacing is by default usually set to equal increments, but this display spacing ignores the fact that the *space* between images helps to set the *pace* and rhythm for viewing them. Ideally, when spacing images in a gallery setting, one should consider proper pacing for the images (i.e., are there several distinct groups within the series, like stanzas in a poem; are there images that should act as punctuation, and stand out from the others; etc.) as well as the size and configuration of the gallery space.

In addition to spacing, the type of glass or protective surface over the image, as well as the lighting conditions in which the images are viewed, play important roles in the way images are perceived.

Most two-dimensional photographs set for display are placed into a frame behind glass. We do this to protect the image, but often do not think about the effect the extra surface layers have on the appearance of the print. The importance of this consideration is not unlike the importance of choosing lenses for the quality of glass: the higher-quality the glass, the better the image will look. There are several types of glass and Plexiglas on the market for framing purposes, and both have common benefits and drawbacks to consider. The benefit of Plexiglas is that it is shatter resistant, which is necessary for shipping work to remote locations. However, the drawbacks of Plexiglas are several: it gets scratched easily, is not as clear as glass, and can have significant color casts. Whenever possible, the choice for framing two-dimensional work should be glass. But, beyond being breakable and so not suitable for shipping, glass has the significant drawback of being highly reflective. This problem has been solved with the production of non-reflective or non-glare glass. These types of glass work to reduce reflections, but can have a foggy appearance if not coated properly. The other consideration for both glass and Plexiglas is the UV light which passes through them can begin to destroy the image. Both Plexiglas and glass manufacturers make UV-coated products, and both can be distinctly hazy when they are thick enough to be effective (the thicker the material, the more UV they absorb). The best option, though quite costly, is to frame two-dimensional work behind museum-quality (so clear that it disappears in front of artwork) glass that is anti-reflective coated and UV protected.

One final consideration about the appearance of photographic prints in gallery settings is the type and quality of lighting in the space. If you take great care in making prints

that are the exact color and density that you want them to be under your studio lighting, you might be shocked when you see your work in a gallery setting under different lighting conditions. This is caused by metameric failure. Briefly explained, this phenomenon is the same one that causes your chosen paint swatch in the hardware store to look different when it is mixed as pigment, and different again when you put it on your walls at home. Essentially, the same color can (and usually does) look different under various lighting conditions. Unless you can control the range of lighting conditions under which your work will be viewed, one recommendation is that you evaluate your prints under color-corrected D50 viewing lights. These lights are balanced to 5500 K temperature, which is equivalent to daylight. If you are working in the digital darkroom, you can calibrate your monitor to the same temperature, so that the image on your screen more accurately reflects the image as it will appear under the viewing lights. While most galleries use tungsten spotlights balanced to 3500 K or warmer, it is impractical to color balance prints to gallery viewing conditions, since they vary widely and are often mixed with window light or fluorescent lighting. Ideally, the prints will not exist in the gallery permanently, as they will find a home in a personal or corporate collection, and you cannot predict the lighting that will exist there. Therefore, best practices indicate that color correction under daylight-balanced lighting is ideal; in this way, you know that your images look the way you want them to look under a standardized quantity of light.

CHAPTER EXERCISES

This chapter's exercises are designed to get you to consider carefully the materials and processes you use to make your photographs and to determine if those materials and processes help you to create images that communicate the way you want them to. Try a variety of capture and output methods, and consider the ways in which the materials and processes you use imprint themselves on your images.

Exercise No. 1: Color or Black and White

Most photography practitioners tend to make images either in color or in black and white. For this exercise, make both grayscale and color prints of a section of your images. Once complete, consider and discuss with others which set of images seems to work best with your chosen subject and content, and your approach to them.

Exercise No. 2: Changing Texture

For this exercise, if you tend toward materials and processes that render the finest detail and smoothest images (using

slow ISO speeds, traditional or digital processing methods that minimize grain and maximize detail, and printing on smooth surface papers), try the opposite. Use any technique necessary to maximize the grain structure of your images (high ISO, grainy developers, increased noise, etc.), and consciously address the resulting images with an open mind, critically evaluating if the lowered fidelity of the images adds to their meaning or aesthetic quality.

If you tend toward materials and processes that render the grainy, low-fidelity images (using fast ISO speeds, traditional or digital processing methods that maximize grain and minimize detail, and printing on textured surface papers), try the opposite. Use any techniques necessary to minimize the grain structure of your images, and consciously address the resulting images with an open mind, critically evaluating if the increased fidelity of the images adds to their meaning or aesthetic quality.

PORTFOLIO PAGES

The artists represented in this chapter's Portfolio Pages engage in a wide range of photographic practices. To create their work they use traditional, digital, and hybrid media, and they consciously (visually as well as conceptually) address how the materials and processes they employ affect the appearance and meaning of their photographic images. As with the previous chapter portfolios, the work in these pages is not *about* process; rather, it consciously uses the visual outcomes created by specific processes in order to support or address the subject of their images. The artists here push the envelope in terms of combining and hybridizing media; they use the gallery space and framing conventions to affect how viewers interpret the work; some use scanners and alternate means of capturing the image made by light; some consciously draw attention to process and methods; and all of them customize the process to the meaning they wish to infuse in their images.

These images are intended to inspire creative thinking and critical debate about the content and subject of the work as it relates to the materials and processes used to create it. They are intended to urge you to keep seeking out new photographers whose work would add insight to your own research, to keep expanding your scope of appreciation, and to find your own unique voice.

DAVID T. HANSON

"THE TREASURE STATE": MONTANA 1889–1989

ARTIST STATEMENT

During the past 25 years, my photographic work and mixed-media installations have investigated the contemporary American landscape as it reflects our culture and its most constructive and destructive energies. These works explore a broad range of American environments, from mines and power plants to military installations, hazardous waste sites, and industrial and agricultural landscapes, examining the relationship of humans with their environment in the late 20th century. Collectively, these works begin to reveal an entire pattern of terrain transformed by human beings to serve their needs.

"The Treasure State": Montana 1889–1989 is a personal response to the state's centennial celebrations: "100 Years of Progress in Montana." This series (1991–1993) is a study of land use in Montana, examining the primary economic and industrial forces that have shaped and radically altered the state's environment. I photographed farms and cattle feed lots, timber clear-cuts and paper mills, mines and smelters, military bases, the oil and gas industries, industrial waste sites, railroads and airports, hydroelectric dams, urban and suburban environments, and tourist recreation areas. Each site is paired with one of Montana's imperiled wildlife species that have been impacted by it. The Latin and common names of the species have been etched onto the glass covering the print. Under a gallery spotlight, the etched text is projected onto the recessed print below, casting a kind of "ghost shadow" of the name onto the photograph. The works are sequenced by the species' name, alphabetically within taxonomic class. The correspondences between sites and species are in most cases direct and documented: for example, the siltation and contamination of streams by logging and paper mills have severely impacted the bull trout, and the damming of major regional rivers like the Missouri and Big Horn has destroyed the breeding habitat for several bird species and disrupted the spawning of pallid sturgeon and other native fish. In some cases, the correspondences are more broadly

representative of the toll taken on native wildlife and habitat by increasing agriculture, industry, human population, and tourism. All of the animals included in this series have been heavily impacted by human activities; their numbers have declined significantly, and they are now vulnerable to extinction. Most of them are officially listed as endangered or threatened, or are candidates for listing; some of them are already extirpated. All that remains are their names, faint traces evoking those that have disappeared.

In November 1995, a flock of snow geese migrating from the Arctic to California stopped over in Butte. They landed in the Berkeley Pit, the world's largest toxic pond, which is filled with 28 billion gallons of highly poisonous mine wastes. Within the next 2 days, 342 snow geese were found dead in the lake, all of them poisoned and internally burned. Surrounded by one of the largest open-pit copper mines in the world, Butte is a part of the biggest Superfund hazardous waste site in the United States. Wastes from 130 years of gold and copper mining and smelting have heavily polluted the neighboring hillsides, grasslands, and 100 miles of the Clark Fork River. Lush mountain valleys, pristine creeks and rivers, and abundant wetlands have been replaced by a barren wasteland of frequent fish kills, toxic dust storms, and the carcasses of snow geese floating in a sulfurous, poisoned pit. © 2007 David T. Hanson

The following are installation views of framed Ektacolor prints behind etched glass.

Kootenai River Valley timber clear-cut, Kootenai National Forest, Lincoln County.

Alkali Creek subdivision, Moon Valley, Billings, Yellowstone County.

Yankee Doodle tailings pond, tailings dam and waste dumps, Montana Resources' open-pit copper mine [EPA Superfund Hazardous Waste Site], Butte, Silver Bow County.

Fort Peck Dam spillway, Missouri River and irrigated cropland, Valley County.

Oncorhynchus clarki lewisi
Westslope cutthroat trout

ASARCO East Helena Lead Smelter and waste ponds [EPA Superfund Hazardous Waste Site] and town of East Helena, Lewis and Clark County.

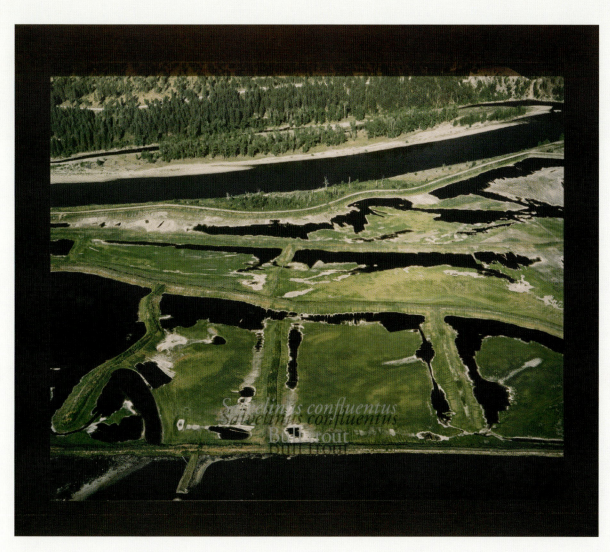

Stone Container Co. Pulp Mill and settling ponds along Clark Fork River, Frenchtown, Missoula County.

ANNA NORTON

THE ROAD TO STILLMORE

ARTIST STATEMENT

Photographs from the series *The Road to Stillmore* begin my current exploration into the medium of digital photography, in particular video capture. Iconic stills are collected from video recorded while passing briefly through the landscape of my childhood home in southeastern Georgia. The resulting image quality creates photographs that speak to impressionistic landscape painting when viewed from a distance, however, from close range the forms of the landscape break apart into digital texture. While the images are captured in a particular place, these scenes of apparent rural simplicity combined with pixilation leave the viewer with a mixed sense of the past and present.

Process Statement

These photographs are first captured as short digital videos, ranging in length from a few seconds to a few minutes. The stills are then selected through editing software, and minor adjustments are made to the image color and contrast. All soft focus, pixilation, and image degradation result from using the video camera for image capture rather than from manipulation after capture. The final images are printed 24″ × 30″ with archival ink on watercolor paper mounted on hardboard.

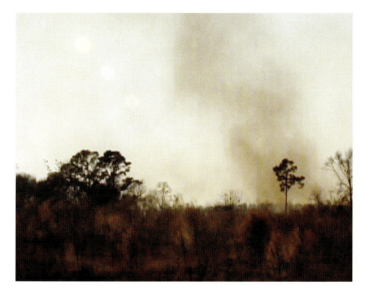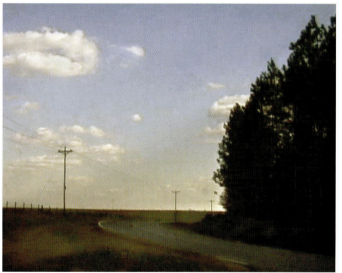

Untitled from the series *The Road to Stillmore*, 2006. *Untitled* from the series *The Road to Stillmore*, 2006.

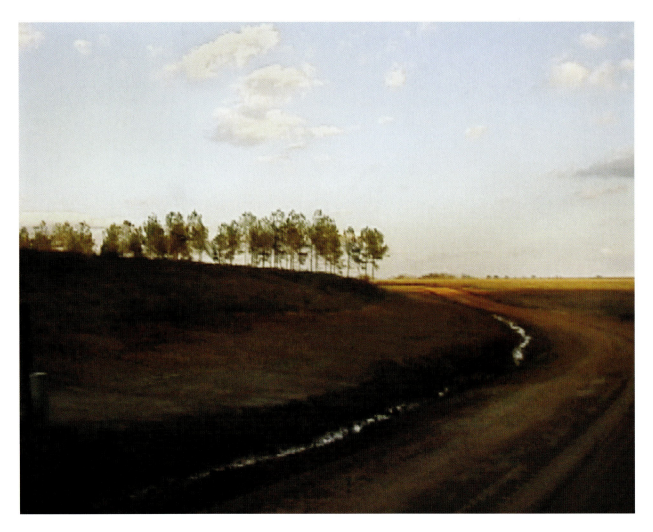

Untitled from the series *The Road to Stillmore*, 2006.

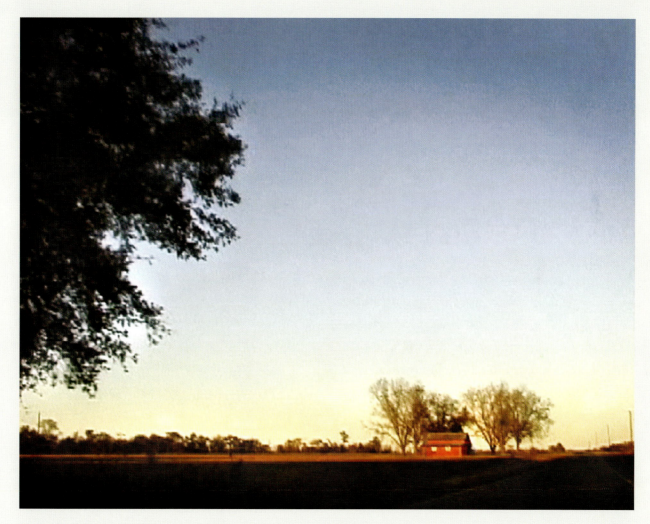

Untitled from the series *The Road to Stillmore*, 2006.

ANGELA FARIS BELT

Traces

ARTIST STATEMENT

My ongoing series, *Traces,* is a phenomenological study of Beauty as perceived through the sense of sight. Through this series I document visible manifestations of Beauty (what some might call the Divine) within the physical universe. To me, Beauty is best described by how it differs from what we call beautiful; while "beautiful" is a superficial attribute of things, Beauty embodies ineffable truths of our existence, allowing us to glimpse the larger Universe through the thin veil of physical reality. I find beauty in moments of temporality and transcendence held in balance; coherent form emerging from chaos; gestures of grace, accordance, and transformation; perennial, persistent, and recurring processes; the rapture of living existence tangled with the inevitability of its own impermanence; and the perfection of the present. Running in tandem with *Traces,* I create discrete, and often more abstract series of 4 or 8 images such as those entitled *Sparks in Air, Hand Prints, Fractal Shorelines,* and *Perfect Circles.* These operate as visual poems or koans, tracing the invisible threads that tie fallen leaves to the tree.

I concentrate on natural phenomena as the content of my work because of their purity, mystery, and myriad forms all seamlessly adhering to the same rhythmic patterns and laws. I am drawn to visible evidence of human interaction with the more-than-human world—the land and its non-human inhabitants—and the ability to transform clearly discernable natural forms through camera manipulation.

Process Statement

I make photographs using a DSLR camera and process them in the digital darkroom where I can carefully control their density, contrast, and fine details. In most series, the completed files are printed as limited edition archival pigment prints, or are transferred to fine art papers using

archival inks. In these examples, the completed files are transferred to inkjet transparency film with an appropriate output adjustment curve applied. The transparencies are then contact printed onto photo-polymer plates using a UV point light source. The plates are processed in tap water, hardened, inked, and proofed. Finalized plates are printed as limited-edition intaglio-type polymer photogravure prints. This hybrid process enables me to avoid the toxicity of traditional darkroom and photogravure processes while maintaining their technical and aesthetic advantages. I am able to print with a range of archival papers and inks through which I control tint, tone, and texture, allowing me to produce images perfectly representative of my conceptual and aesthetic vision.

As it relates to photographic image making, polymer gravure is still somewhat an experimental process. Although several master printmakers have developed consistent, controlled results using polymer plates, most of these are limited in their ability to produce highly resolved photographic images with sensitivity to subtle tonal shifts and detail. My desire was to apply this printmaking technology and its techniques to photographic output. Upon moving to Denver, Colorado, in 2006, I met with fellow artist Jon Lybrook, owner of Intaglio Editions, who has developed a procedure that produces more photographic quality polymer photogravure plates resulting in finer detail and more continuous tone prints. Jon and his company assist artists in achieving more photographic imagery on their own and have made their standard procedure freely available at http://intaglioeditions.com/procedures/polymer_photogravure.html. They are also available to make polymer plates and run large or small editions (for information on their services, see http://www.intaglioeditions.com). I have found his methods produce extraordinarily beautiful intaglio-type photographic prints, and I am adopting the process for some specific series within the range of my creative work.

The following copy images of intaglio-type polymer gravure prints on Reeves BFK show the embossed edge of the plate.

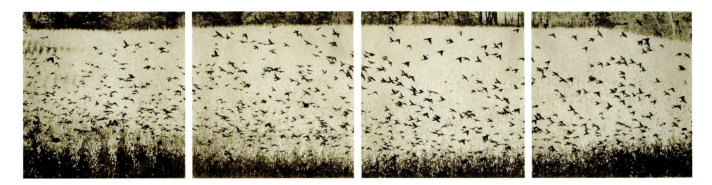

Flocking, 2005–07.

IMAGE © ANGELA FARIS BELT, 2006, FROM THE SERIES *TRACES*; 5″ × 21″ INTAGLIO-TYPE POLYMER GRAVURE PRINT ON REEVES BFK.

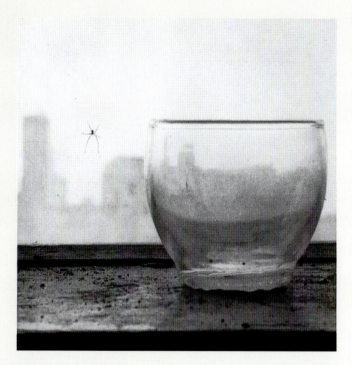

Urban Landscape with Spider, 2005–07.

I Heart, 2005–07.

ALIDA FISH

FROM THE CABINET OF CURIOSITIES

ARTIST STATEMENT

During the 17th century in Europe, some privileged individuals assembled collections known as *Cabinet of Curiosities*. These Cabinets displayed marvels that were rare, foreign, or exotic. Sometimes they contained the bizarre, the unusually large, the unusually small, triumphs of technical skill, the remarkable, and the unexpected.

I have been frequenting small museum collections looking for and photographing, in situ, objects that might have been part of a Cabinet collection. In addition, I have been taking objects from my own shelves and borrowing pieces from friends to photograph in the more controlled environment of my studio.

The final prints are 8″ × 10″ Tintypes. There is a pearly, rich patina to the surface that enhances the image's straightforward presentation. The prints have a tendency to be dark, suggesting the way one might discover the objects cloistered in a Cabinet.

Process Statement

My process involves the use of contemporary film photography, digital imaging, and a modern version of the historical Tintype print. (The Tintype process, light-sensitive emulsion on metal, was first used in 1853 and was most popular during the U.S. Civil War era.)

I capture source material by using the camera most appropriate for both the image quality and for the shooting context: medium format view camera or high-resolution digital camera. I employ black and white film, color film, and also use high-resolution digital files.

The next step is to move the source images onto the computer by scanning the film or by directly loading the original digital files. Using Adobe Photoshop, I adjust, rework, and/or fabricate a final digital image. Using a "film writer" (Polaroid ProPalette), this final digital image is converted to a film positive that I use in the darkroom to produce the Tintype print.

In the darkroom, I sensitize an aluminum plate by melting and pouring liquid silver emulsion (Rockland AG Plus) onto one surface of the plate. Once the plate is dry, it is developed in a special reversing developer (Rockland Tintype Developer). With this method, I can create an edition of "sister" prints but cannot make exact duplicates.

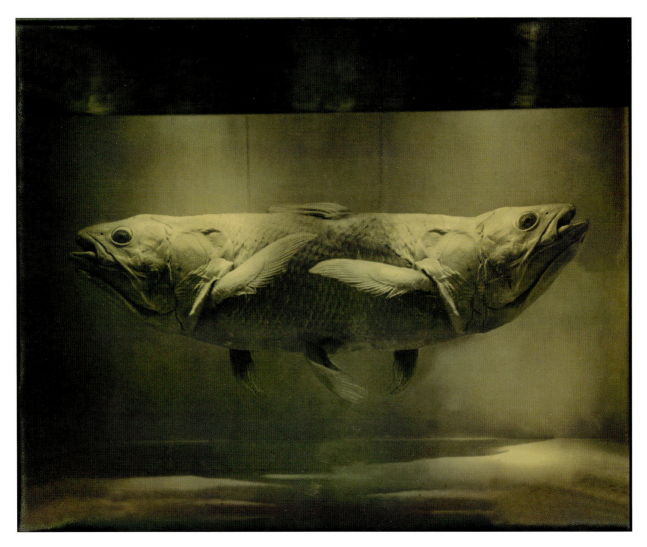

Conjoined Fish, 2006.

Hinged Feet, 2006.

Pyramid Hand, 2007.

Snake, 2006.

MYRA GREENE

CHARACTER RECOGNITION, 2006

Throughout my artistic practice, I have returned to the body to explore a variety of issues. Issues of difference, beauty, melancholy sentiment, and physical and emotional recollections have played out on the surface of the skin.

ARTIST STATEMENT

Confronted with an up swell of bigotry both personal and public (the rhetoric surrounding Katrina) I was forced to ask myself, what do people see when they look at me. Am I nothing but black? Is that skin tone enough to describe my nature and expectation in life? Do my strong teeth make me a strong worker? Does my character resonate louder than my skin tone? Using a process linked to the times of ethnographic classification, I repeatedly explore my ethnic features.

Always fascinated by historical processes, I wanted to learn how to make wet-plate collodion. This process, which is coated onto black glass and was popular from the 1850s through the 1880s, creates a singular unique image. The glass is first coated with a thin layer of collodion, and then sensitized in a silver bath. While still wet, the glass is exposed using a large format camera. The plate is then developed and then fixed. When I applied this old process to my interest in the black body and self, the imagery described my body in a way never imagined. Tainted with the visual history of American slavery, these images point directly to the features of race. Thick lips and nose, and dark skinned; these contemporary studies link the view to a complicated historical past. The lessons learned are haunting and frightening in these modern times.

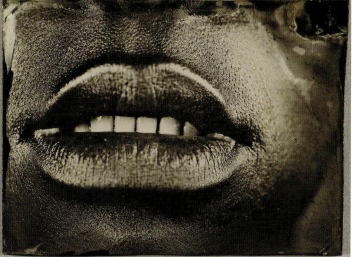

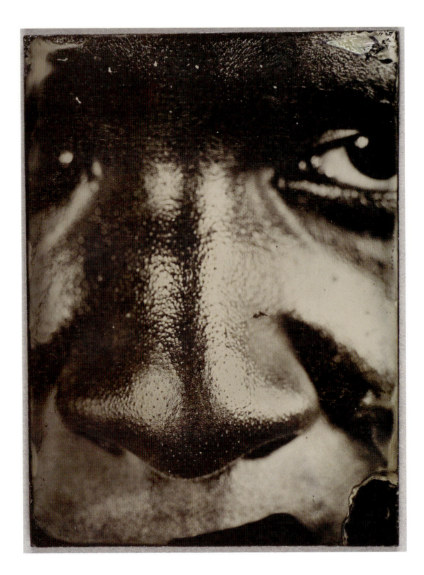

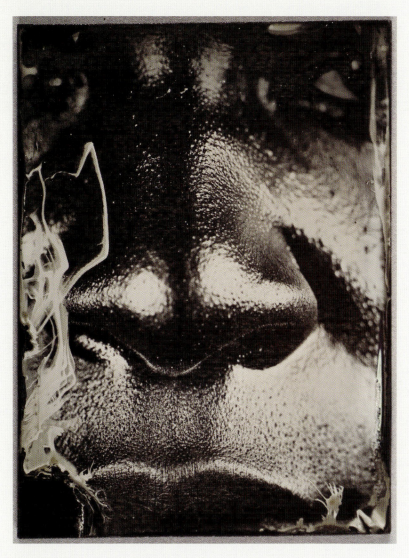

PHOTOGRAPHS © MYRA GREENE, FROM HER SERIES *CHARACTER RECOGNITION*, 2006;
3" × 4" BLACK GLASS PLATE AMBROTYPES.

MICHAL MACKU

GELLAGE

ARTIST STATEMENT

"I use the nude human body (mostly my own) in my pictures. Through the photographic process [of Gellage], this concrete human body is compelled to meet with abstract surroundings and distortions. This connection is most exciting for me and helps me to find new levels of humanness in the resulting work.

I am always seeking new means of expression and, step by step, I am discovering almost unlimited possibilities through my work with loosened gelatin. Photographic pictures mean specific touch with concrete reality for me, one captured level of real time. The technique of Gellage which I am using helps me to take one of these 'time sheets' and release a figure, a human body, from it, causing it to depend on time again. Its charm is similar to that of cartoon animation, but it is not a trick. It is very important for me to be aware of the history of a picture and to have a sense of direct contact with its reality. My work places 'body pictures' in new situations, new contexts, new realities, causing their 'authentic' reality to become relative. I am interested in questions of moral and inner freedom. I do what I feel, and only then do I begin to meditate on what the result is. I am often surprised by the new connections I find in it. Naturally, I start out with a concrete intention, but the result is often very different. And there, I believe, lies a hitch. One creates to communicate what cannot be expressed in any other way. Then comes the need to describe, to define."

Process Statement

In the gellage process, gelatin is separated from its base chemically and is worked with while it's wet, in effect in the form of a gel. The changing, unstable forms the figures have in the water always fascinated me during my work. Then I transfer the image to the soaked paper and that's what enables me to manipulate it precisely into the form I want. When the composition is finished, I simply let it

dry and it sticks together. The first gellages were only one layer, and step by step I was discovering the technique and adding other elements. For instance, with the first gellages of crowds I used a background to which the figures were applied, so that the resulting image was compact. I also began to discover other possibilities, for example, amplification of the figure through repeating one negative. And then I was adding more negatives and their combinations, etc. The themes as they emerge little by little, and they go hand in hand with the development and discovery of the technique. The glass gellages are an extension of the process, and are more complex in their three dimensionality.

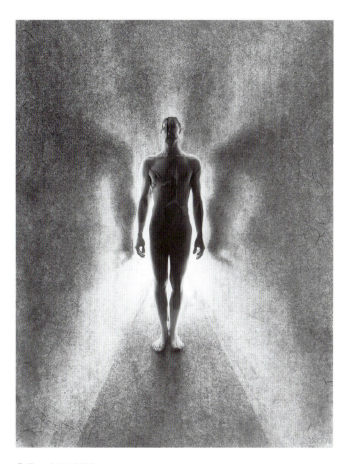

Gellage #116, 2000.

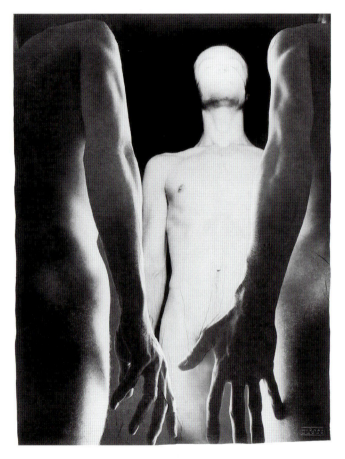

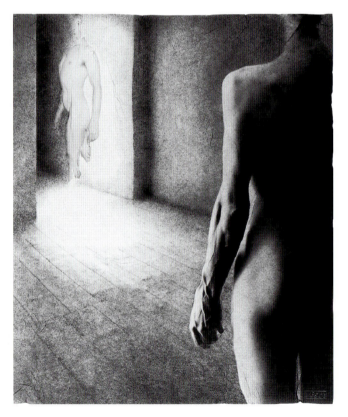

Gellage #92, 1996.

Gellage #111, 2000.

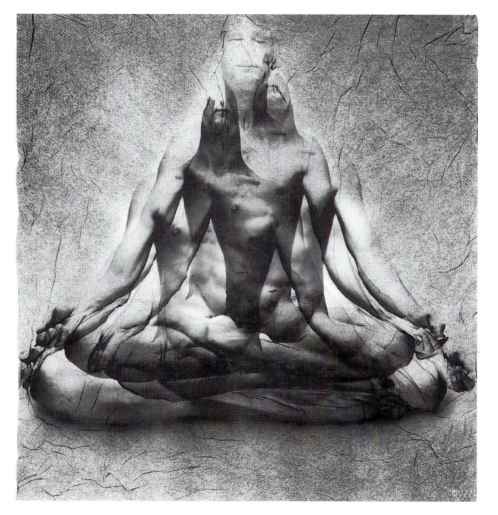

Gellage #93, 1999.

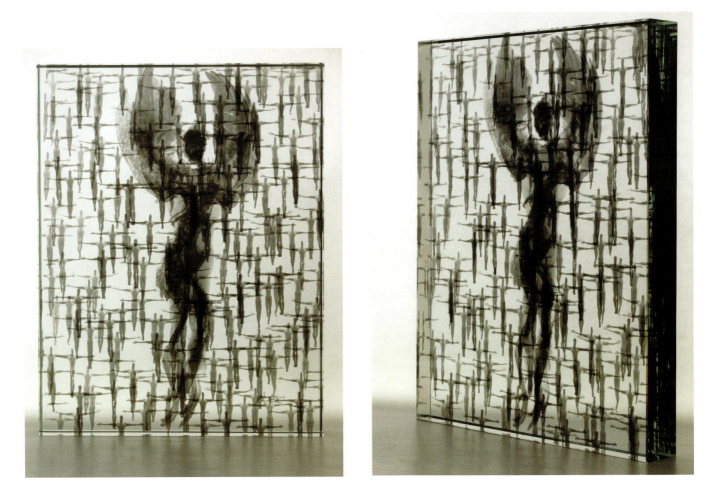

Glass Gellage # VII, 2006.

Glass Gellage # VII, 2006, ¾ view.

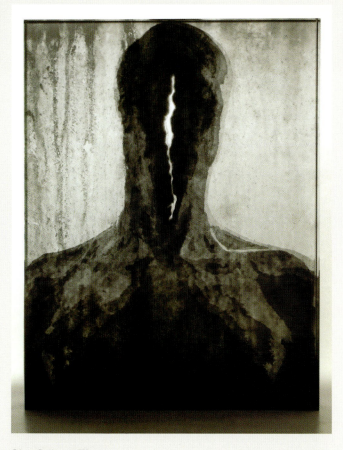

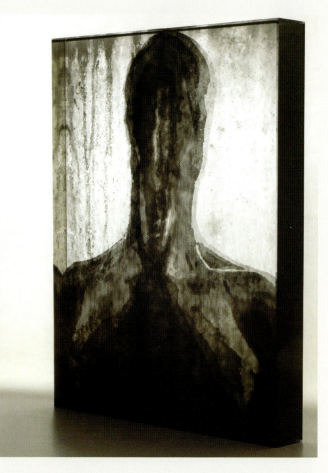

Glass Gellage # IX, 2006.

Glass Gellage # IV, 2006, ¾ view.

JOEL WHITAKER

REFERENT

ARTIST STATEMENT

I am interested in the family photograph as a physical and metaphorical thing, a piece of paper that transcends all other pieces of paper—a reliquary of memory, hope, and utopian dreams. In the photographs, entitled *Referent*, I look to re-define and re-invent the family snapshot and explore its greater mysteries by interacting with the image and the physical piece of paper on which it is printed. Through a varied method of mark making and alteration, I intend to draw attention to the often overlooked, and in many cases, more poetic nature of the material and image.

Process Statement

I work into the original family photograph stressing the physicality of the medium. I look at the age, emulsion cracks, discoloration, and scratches, as well as the lighting, fragmented subject, focus, composition, etc., as a way to explore meaning in simple, often repeated, gestures and actions. I scratch, bend, and mark the photograph, and then utilizing various directional lights, re-photograph a small section of the manipulated image area stressing the breakdown of the physical surface and the fragmented form. I continue to alter the image in digital form manipulating color, density, and format. I do this with the intent of maintaining many of the original qualities of the image, at the same time stressing my interaction with the material and the image. Although I utilize the digital environment to meet my aesthetic demands, I do not use all of the tools commonly associated with the digital process. I do not want to lose the original subject because it grounds the resulting photograph in the family snapshot and the notion of the record. This fact is very important because the original photograph is where the mysteries exist. I utilize

the preexistent image and my interaction with it to draw attention to the often overlooked, and in many cases, more poetic nature of the material and the image. Once the digital process is complete the images are printed using a large format pigment-based inkjet printer.

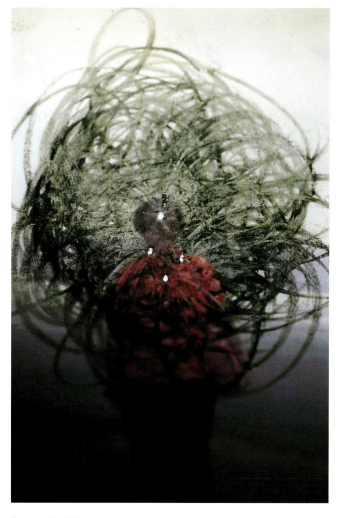

Referent No. 101.

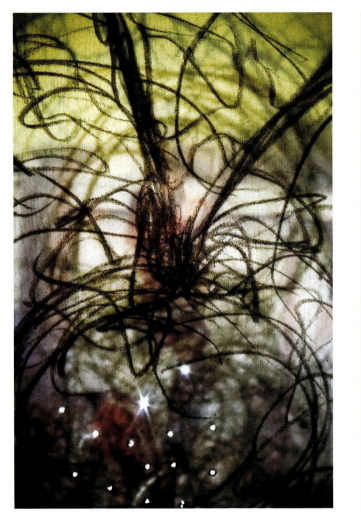

Referent No. 121.

Referent No. 150.

Referent No. 152.

CYNTHIA GREIG

REPRESENTATIONS

ARTIST STATEMENT

As a kind of playful homage to Henry Fox Talbot's 19th-century treatise, *The Pencil of Nature*, my series *Representations*, combines color photography and drawing to create what I like to call photographic documents of three-dimensional drawings. Choosing objects from the recent past, I first whitewash them with ordinary house paint and then draw directly onto their surfaces with charcoal so that they appear to be simply sketched outlines when viewed through the camera. No digital manipulation is involved; however, the angle of view is imperative as the monocular vision of the camera's lens helps to produce the illusion. The resulting images present visual hybrids that vacillate between drawing and photography, black-and-white and color, signifier and signified, and explore the concept of photographic truth and its correspondence with perceived reality. Examining the conventions for representing, identifying, and categorizing the world around us the series draws attention to how we see, and considers to what degree human vision is learned or innate. I'm interested in creating images that unite what appear to be opposites, to throw perceptual expectations off-guard, and subvert passive viewing. Ultimately, my photographs examine the camera's role in negotiating what we consider to be real, as well as those assumptions we might have about photography and its relationship with what we believe to be true.

Representation No. 32–35 (cup), 10″ × 8″, 2004.

Representation No. 22 (black and white TV), 24″ × 20″, 2002.

Representation No. 36 (shoes), 20″ × 24″, 2004.

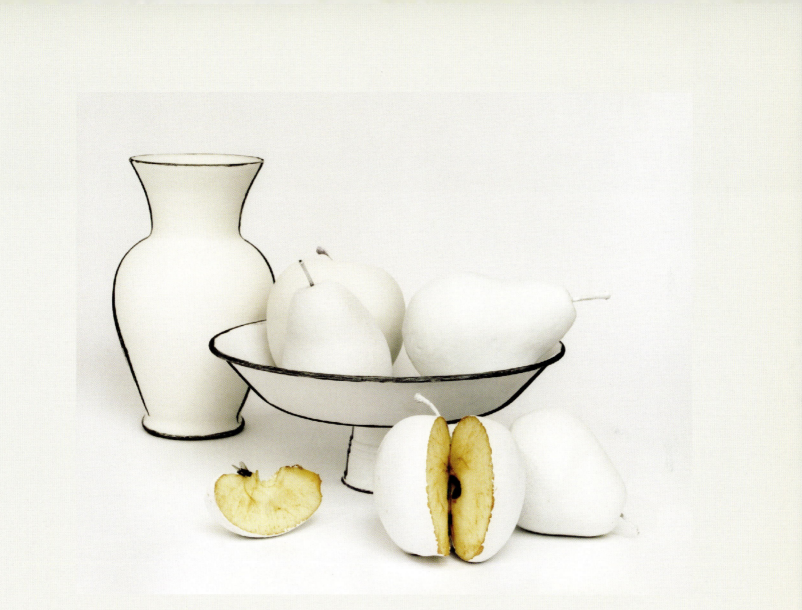

Representation No. 31 (still life #1), 20″ × 24″, 2003.

SUZANNE E. SZUCS

JOURNAL, IN PROGRESS

ARTIST STATEMENT

Journal, In Progress, is the accumulation of an instant Polaroid self-portrait made everyday since January 1994. Started as a visual diary, the project soon evolved its own set of guidelines. Not quite snapshots, the images seem at first to catch random moments. Together the unassuming and approachable images present a narrative time line measuring growth, change, and regression. Individually, they address issues of the body and identity in a direct and non-glamorous way.

The simplicity of an instant image undermines fine art photography, at the same time belying the complexity of meaning the photographs hold as a group. The randomness of the moments depicted and their equal treatment subvert the importance of any single portrait. Their diaristic candor breaks down personal boundaries and presents a series of surrogate selves for the viewer. Together the photographs depict universal experience; their raw, personal, and sometimes frivolous nature demythologizes the self with humor and vulnerability. The text written on them—at the least recording the time and date—ranges from the factual to the absurd, becoming more about mark making than dialogue.

The images document, yet remain elusive. Viewed close up, they suggest individual transformations, recording momentary changes. Seen from a distance, the figures evaporate, the ritual becomes more apparent, and the measurement of time emerges. Whereas the regularity of the image making imposes structure, the formal qualities of the piece as a whole—color, shape, light—are determined by chance. The images will fade and change over time, like memory, imprecise and shifting, an imperfect memorial to the everyday. Their deliberate presentation—like a figure traveling across the wall—contradicts the immediacy with which the individual images are made.

As an installation piece, *Journal, In Progress* grows around the viewer. The 4″ × 4″ Polaroids are arranged chronologically as vertical strips of 17 images, equaling the artist's height of 5′6″ and growing an average of 7 ft a year. Since each of the strips is put

up individually they can wrap around and turn corners. Because of this, the project transforms to whatever space it is displayed in, mimicking our own tendencies to transform to ever changing situations. When installed, new images are constantly added, the piece literally accumulates itself, even as we accumulate experience and memory. Through its process, *Journal, In Progress* becomes a constantly changing piece of art—different each time it is displayed, its parameters of height and chronology allow for flexibility in its presentation keeping the piece lively and engaging. The project has been shown four times in its entirety, most recently during its 10th year at Flatfile Gallery in Chicago.

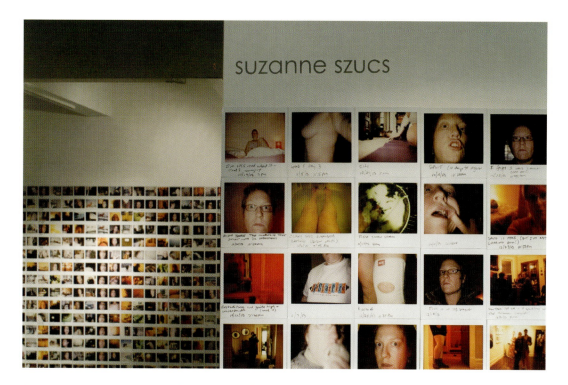

Journal, In Progress, installation views Flatfile Gallery Chicago, 2004.

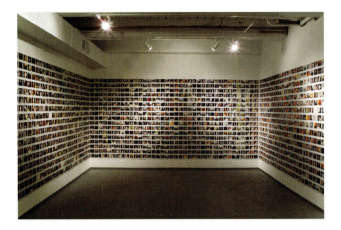

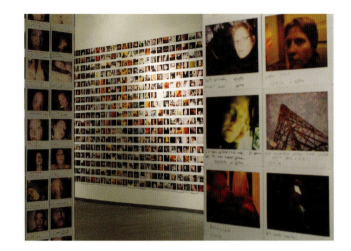

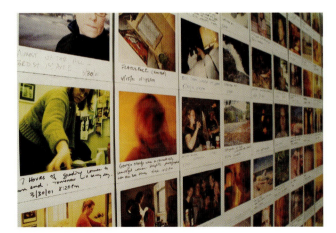

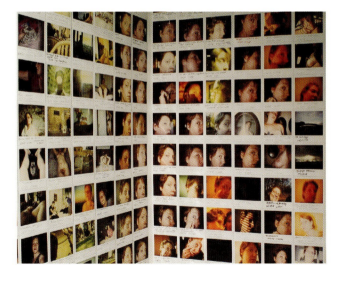

Journal, In Progress, installation view Flatfile Gallery Chicago, 2004.

Aura, from *Journal, In Progress*, 4″ × 4″ Polaroid Spectra, 2004.

JOSEPH LABATE

LANDSCAPES

ARTIST STATEMENT

I learned and practiced photography in the era before the introduction of photographic digital technology. I exposed film in a camera and then proceeded to my darkroom to develop the film and make prints. I studied the art of photography at university programs learning theory and critical thinking based on the medium as we then understood it. I immersed myself in that world and, as an artist, was challenged to explore its potential.

Then along came Photoshop. A few years ago, after long and serious deliberation, I closed down my darkroom and sold my darkroom equipment. I replaced the darkroom with a computer, software, inkjet printer, and various other new digital wonders and set off to explore their impact on my practice of photography. I am fortunate to have a history with chemical darkroom photography and now have available to me this new digital technology. I have a foot in both worlds.

I am most interested in that converging space between the traditional definition of photography and the imagery of the newly emerging digital arts. I am not trying to replicate traditional photography with the now available digital tools but yet am trying to maintain some connection with it. My work draws on both the history and practice of traditional photography and the language of the new technologies.

Process Statement

This work is from a series of "landscapes" with the term referring to both its use in the history of photography and to the horizontal format for digital printing. The images first begin as photographs I made with a digital camera. The pictures are then opened in Adobe Photoshop and manipulated. The "natural" color is replaced with an "artificial" one and I add a few simple digitally drawn components. Exhibition-size prints are made on cotton rag paper using an Epson 7600 and ImagePrint software.

On one hand an image closely resembles a "straight" photograph, yet on the other, appears to be an obvious contrivance. The work treads the boundary between traditional photography and new technology and examines the landscape of my life.

Landscape #0582.

Landscape #1033-2.

Landscape #1288-2.

Landscape #1992.

AMY HOLMES GEORGE

AWAKENING TO A DREAM

ARTIST STATEMENT

For as long as I can remember, I have been a collector of objects. My archive of objects always seems to find its way into my work. I enjoy juxtaposing these seemingly ordinary things with the figure fragmented as a way to speak to the fragility of life and the body. By constructing these still lifes, I can invest meaning into simple object forms, using the body as a vehicle for expressing human emotion and reinforcing a figure presence.

This body of work is part of an ongoing project titled, *Awakening to a Dream*. Each piece is intended to render a vision associated with a common dream experience such as flying and falling or pregnancy and relationships. This work is driven by an affinity for the biological sciences, human anatomy and psychology in addition to everyday dream encounters. The images are not intended to illustrate specific dream stories as much as render the idea of something fleeting more real, more tactile—like the memory of a dream.

Process Statement

These images are archival pigment prints composited in Photoshop using digital photographs and drawings as well as scanned prints, objects, and texts. I believe that these pieces exemplify how traditional and digital photographic techniques may be synthesized. My working methods include: (1) painting and photographing a background for my images; (2) digitally photographing the human figure; (3) scanning and/or photographing selected objects, silver prints, line art, and found texts; (4) assembling all of these components in Photoshop so that I may tweak color, scale, layer order, etc.; and finally (5) incorporating computer-generated drawings utilizing the Wacom graphics tablet.

On the computer I can manipulate my photographs with much greater control, integrate layers of visual and textual information, and create illustrations in the style of conventional studio media. Also, I have the freedom to explore an expressive color palette and suggest painterly surface textures that translate nicely on watercolor paper. This way of working allows me to expand my image-making processes beyond the darkroom and still embrace the photographic.

Egg Head.

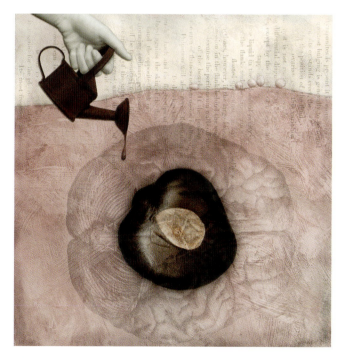

My Watering Pail.

Never.

Past and Present.

CARA LEE WADE

Insidious Charms

ARTIST STATEMENT

Throughout history, women have put their bodies, and, thusly, their psyches through torturous measures trying to live up to the elusive thing, that is beauty. We have constricted our breathing and injected ourselves with poison. We have teetered precariously, balancing on miniscule pedestals; we have crafted our flesh into acceptable contours. But we have not been forced into doing so. We have consensually, if not violently, subjected ourselves to these dangerous tribulations.

This is a condition that I not only detest but also welcome and embrace. It has left me in a love/hate relationship with the idea of beauty and the quest to attain it. These images have emerged from this dichotomy. Through a combination of technical processes, I am able to merge representations of the accepted and established beautiful with those of my own manufactured grotesque. In this manner I am able to create imagery that manages to, at once, glorify and chastise, ultimately giving way to a different definition of beauty, one of engaging oddity and lush ambiguity.

Process Statement

All source images are appropriated and collaged from fashion and bridal magazines because I believe these propagate what we perceive as beautiful. The collaged images are then contact printed onto black and white fiber-based photographic paper in the wet darkroom. Next, the images are treated with the Mordancage process in which a copper chloride and acid solution causes deterioration to the black portions of the photograph. The print is then left out to oxidize. Once the oxidation process has occurred, oil paint is hand applied to the portions of the image to ensure the ideal color palette and to create additional texture. Then the

Mordancage image and the source images are all scanned into the computer and then digitally collaged and manipulated using Adobe Photoshop. The finished image is printed onto archival canvas and treated with a varnish sealant.

A thing of beauty is a joy certain to pass into nothingness.

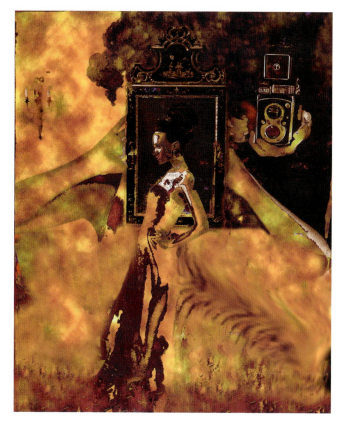

The lie that leads to the truth.

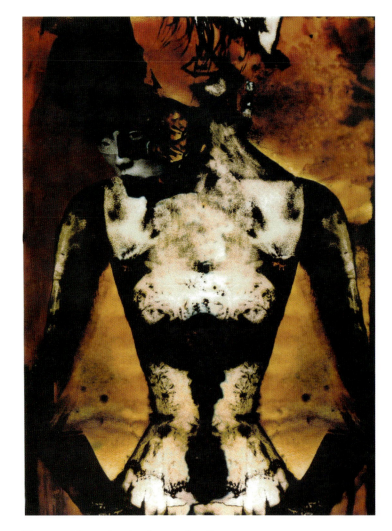

The season I lost my breath and accepted my future.

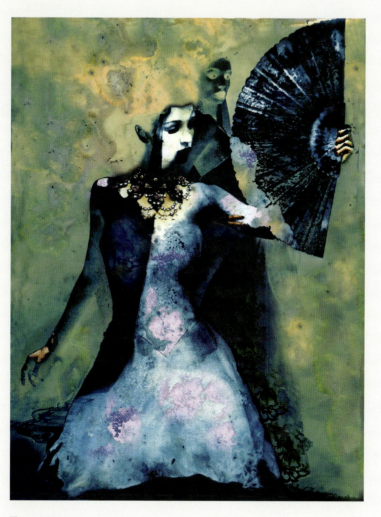

Twisted illusion.

IMAGES © CARE LEE WADE, FROM HER SERIES, *INSIDIOUS CHARMS*, 2004;
MIXED MEDIA MORDANCAGE AND DIGITAL COLLAGE, 24″ × 36″ PRINTED ON
EPSON CANVAS.

JOY CHRISTIANSEN

FURNITURE SERIES

ARTIST STATEMENT

The *Furniture Series* addresses issues of body image, personal experience, and memory by combining photographs and autobiographic writing with furniture. The combination of furniture, photography, and text is used to express hidden thoughts or subjects that prove difficult for engaging dialogue. The comfortable and familiar veneer of the furniture serves as a welcome invitation to the viewer.

The piece titled *The Dialogue* consists of two chairs facing each other as if joined in conversation and confronting each other in battle. Conversations occur within the text that is embroidered on the fabric of the chair. The text and images of a figure transferred onto the fabric bring the chairs to life.

Hidden Secrets is a desk that is a contemplation of self-image. Autobiographical writing obsessively covers every surface of the interior space. The piece is intended to be inspected and upon closer examination, secrets and thoughts are exposed.

Eating Rituals examines the relationship between food and rituals of anorexia and bulimia. Working with imagery and text fused to dinnerware, secrets about eating rituals typically kept private are revealed.

Process Statement

Through the use of photography, furniture and text, I create large-scale photographic sculptures. Each piece starts by intuitively searching for furniture that fits my conceptual idea. Next, I transfer photographic imagery and text onto the surface of the piece and then re-assemble the work to give it new life.

The Dialogue was created by transferring images onto fabric, using Epson iron-on transfer material. The fabric was then embroidered by machine and upholstered by hand.

The process, which is labor intensive, methodical, and repetitive, explains a great deal about my artistic approach to most projects.

Hidden Secrets consists of self-portraits of my body mounted to the bottom of desk drawers. To create this piece, I built a box with the same ratio as the drawer, but large enough to fit my body. These images were enlarged in the darkroom to fill the inside of the drawers. The rest of the drawer was painted white and then covered with hand-written text.

Eating Rituals is a china cabinet with images fused to dinnerware. Using Lazertran transfer material, decals of mouths were transferred onto the china and then baked in the oven to harden.

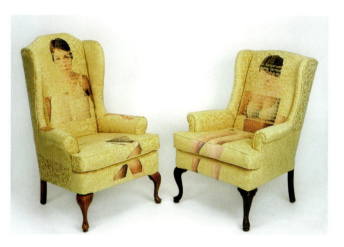

The Dialogue, from the *Furniture* Series, 2003; 72″ × 48″ × 36″, two Victorian wingback chairs, iron-on transfer images on upholstery fabric, and embroidered text.

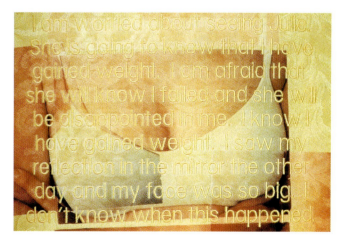

The Dialogue, 2003 (detail).

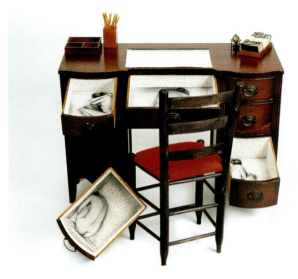

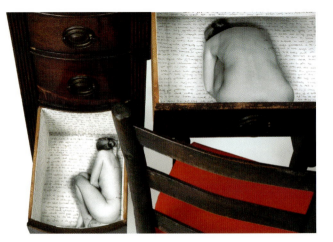

Hidden Secrets, from the *Furniture* Series, 2002; 48″ × 32″ × 18″, desk and gelatin silver prints mounted to desk drawers.

Hidden Secrets, 2002 (detail).

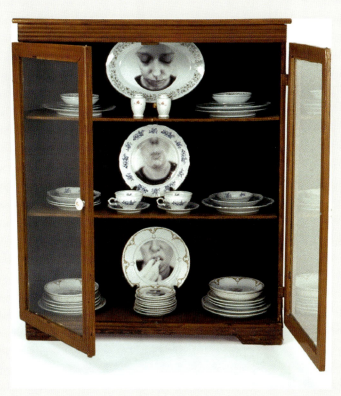

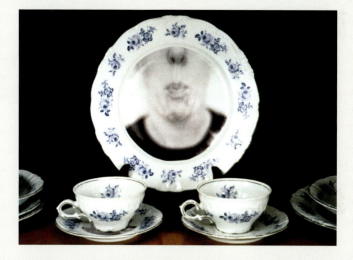

Eating Rituals, from the Furniture Series, 2003; 36″ × 48″ × 12″, cabinet and Lazertran images fused to china.

Eating Rituals, 2003 (detail).

PHOTOGRAPH© ANGELA FARIS BELT, FROM THE SEIRES MY GRANDMOTHER'S HOUSE, 2007. CHROMOGENIC PRINTS SIZED 4″ × 4″.

Place a camera in the hands of a chimpanzee at the zoo, and in a short time the chimp will prove that taking pictures is easy. On the other hand, *making photographs*—creating images from light as practiced by the best photographers—is a complex and deliberate process. Unlike taking pictures, making photographs entails not only pointing the camera at something and releasing the shutter, but consciously regarding the ways in which photography's technical elements relate to the subject at hand. The technical elements of photography—the photographic frame and its borders; the quality of focus as determined by the aperture or lens; shutter speeds and their effects in relation to time and motion; and the physical media used to create the aggregate image—constitute the grammatical basis of photographic language. As such, they impose both visual qualities and aesthetic meanings upon the images they create.

Practitioners have to understand and use the elements of photographic language in order to make photographs successfully, since they are the means through which the photographer is able to communicate and create. A solid foundation of technical understanding and practice, combined with visual literacy, independent research about the subject, and a sensitively trained eye, allow photographers to use the medium accurately and effectively.

PHOTOGRAPH© ANGELA FARIS BELT, FROM THE SEIRES MY GRANDMOTHER'S HOUSE, 2007. CHROMOGENIC PRINTS SIZED 4" × 4".

As stated in the introduction to the text, these tutorials are not intended to represent the range of techniques that can be employed. They are intended as a starting point for experimentation with the elements of photography, and can lead to increased understanding of tools and capabilities with respect to photographic image making.

CHAPTER 1

Negative Carriers Tutorial

One alternative to using a standard negative carrier is to use a glass negative carrier. Glass negative carriers are sold for 4 × 5 enlargers, or can be made simply by having two sheets of clear $\frac{1}{16}''$ glass cut, its edges seamed for safety, and "sandwich" your negative between them. The advantage to glass carriers is that they work for multiple size frames, but they have the added disadvantages of trapping dust particles, as well as decreased image clarity due to the extra surfaces through which the image is printed. Because light surrounds the entire glass carrier and is not blocked,

increased flare around the image area can be a problem, so it is wise to mask the area beyond the intended printed area with black paper tape.

A better alternative to using a standard negative carrier or glass carriers is to make your own "filed out" negative carrier; that is, a standard negative carrier in which the opening is enlarged to reveal some amount of the film base plus fog surrounding the image area, so that that part of the film can be printed as well. There are a few ways to "file out" the opening of a negative carrier. You can do it yourself by hand or you can take the carrier to a machine shop and have the opening professionally enlarged. I prefer the latter method, since it is relatively inexpensive and the results are precise and consistent. If filing out the carrier by hand, you simply need to measure the size of the image area versus the size of the carrier's opening, and, using a sturdy file, begin making the opening larger. As you progress, be sure to check the size of the opening against the film size so that you don't create a larger opening than the

size you need. Hand-filing the edges of a carrier tends to leave minute jagged edges which will easily scratch your negatives if not smoothed properly; therefore, once the opening is of the proper size, showing perhaps 1 cm of the film base + fog around the image area, smooth the edges of the carrier with a fine file and last with fine sand paper. Once complete, paint the inside of the carrier with flat black paint to insure that no unwanted light reflects from the interior edges; you might bevel the inside edges to insure this as well.

A third means to customize a negative carrier is to simply trace a template of your enlarger's standard negative carrier. Then, using black 4-ply or 8-ply mount board and a mat cutter, cut an interior hole to the precise dimensions you need. It is simple to do, and allows you to reveal the exact amount of the negative you want to print without spending a lot of money on customizing several different standard negative carriers. You can even make your own negative carriers for printing three-panel panoramic images from 35-mm negatives when printing with a 4 × 5 enlarger, or two 6 × 7 negatives that form a diptych, or a grid of four 35-mm frames stacked, or … The options are limitless, really, as long as the image area falls within the diameter of the enlarger's projected light.

Digital Darkroom Borders
TECHNIQUE NO. 1: FINE BLACK BORDERS

The image below was digitally captured on a foggy day in the Front Range foothills west of Denver, Colorado. The area of sky backlighting the scene blends too much into the surrounding white of the paper and window mat that will lie on top of it, so I decided that the image would benefit from a fine black border, similar to the one I would make in the darkroom. This type of technique is also used in graphic design and other imaging applications in the form of drop shadows and other unobtrusive borders.

Making a fine black border around your image is even easier in Photoshop than in the traditional darkroom. There are many ways to do it, but the following is a simple, two-step process:

Step 1. Open an image and perform all your usual tonal, color, and creative adjustments before proceeding to make a border.

Step 2. Go to the Image Menu, and select Canvas Size. Change the "New Size" view of the canvas to Pixels in the pull-down menu (this gives you finer control over the width of the border) and add an equal number of pixels to both the width and height, say, 8 pixels. Under "Canvas

Step 1.

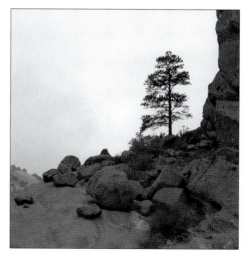

Step 2.

Extension Color" choose black (or you might choose from any of the millions of other colors available in Photoshop). Click OK.

That's it! This simple technique allows the image to separate from its surrounding base support in a quiet, inconspicuous way, and clearly indicates the boundary of the image to the viewer.

"Final Image with Fine Black Border".

TECHNIQUE No. 2: PAINTED BORDERS

The image below of the spider on my studio window overlooking the city has a calm, meditative feeling to me, so I wanted to experiment with how adding an edgy border would alter the feeling.

Making a hand-painted border around your image is straightforward in Photoshop, and produces countless variations and subtleties once you really begin to work with it. There are innumerable ways to create painted borders; this tutorial is simple to the point of being bare bones, and can be made much more robust by using multiple layers and blending modes to merge the border effects with the image edge. The following is a simple, four-step process that yields excellent "organic" results to start, and allows plenty of room to experiment and adjust the results for your particular image:

Step 1. Open an image and perform all your usual tonal, color, and creative adjustments before proceeding to make a border.

Step 1.

Step 2. Using the rectangular tool (for an even selection) or the lasso tool (for a hand-drawn selection) select most of the image, excluding only the area you want to give over to making the border. This selection can be rough, as you will fine-tune it in the next two steps. Once you have made the selection, go to Select > Inverse so that only the border edge is selected.

Step 3. Enter Quick Mask Mode to refine your border selection. Choose the brush tool, and select a type and size of brush that will give you the look you want. (I often use a chalk-style brush or a dry media style brush to give the edges of the selection a more uneven quality.) Using brushes in Quick Mask Mode, you add to the selection when your foreground color is white, and subtract from the selection when your foreground color is black. Additionally,

Step 2.

Step 3.

in Quick Mask Mode you can go to the Filters Menu and using any number of filters you can affect the edges of the selection. Using your brush or filters, paint the edges of the selection until you like the look of the selection in relation to the image content.

Step 4. View of the "Spatter Filter" menu prior to exiting Quick Mask. Exit Quick Mask Mode and view your selection. You can re-enter Quick Mask Mode to refine your selection until you are satisfied with the selected border.

Step 5. Go to Edit > Fill and fill the selection with black or any other appropriate color or tone. Click OK, and de-select the border area. You can then use the Dodge and Burn Tools in combination with layers, various brushes, and blending modes to fine-tune your results by blending the border with the adjacent tones in the image.

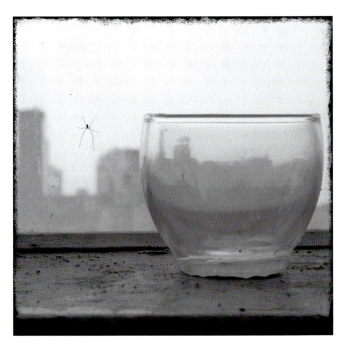

Final Image with Painted Border.
Step 5.

Step 4.

The end result of border creation and manipulation is always a product of working with the image content at its edges—with its colors and tones—to produce a border that looks and feels like a natural extension of the image, and that bounds the image in a way that allows the viewer to best enter the visual experience.

TECHNIQUE NO. 3: MAKING MULTI-FRAME PANORAMAS IN-CAMERA

If you are making panoramic exposures, whether to stitch seamlessly or not, there are several technical considerations that you should understand. The Technical Tutorials Section for Chapter 1 provides more information about how to successfully create images such as these.

1. Decide whether you want the panorama to align perfectly. In order to make a successful panoramic image in which the vertical edges of the frames line up perfectly and match horizontally across your field of view, you need to use a tripod with levels attached. There are several kinds of pan-specific tripod heads (complete with degree scales and dual bubble levels) on the market, there are aftermarket attachments that fit between your camera and tripod, or you can construct an accurate system of levels yourself. In any

event, you'll need to insure that two axes or planes are aligned with levels as you rotate the camera. First, the plane of rotation—located at the base of the tripod head—must be level to the horizon; this can be achieved by attaching a level to the top of the tripod base where the legs come together. Second, the media plane must be perpendicular to the plane of rotation; this can be achieved by attaching a dual bubble level to the horizontal and vertical sides of the tripod head where the camera sits, or by attaching a bubble level to the camera's hot shoe.

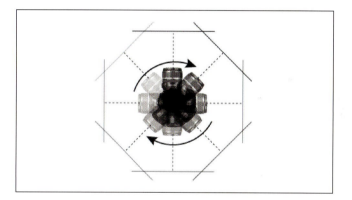

Top-view illustration of camera rotation (adjusted according to the angle of view of the specific lens) in order to make a panoramic image. The most seamless results are accomplished by placing the camera on a tripod with bubble levels. Illustration © Toby Cochran, 2007.

2. Determine where the edge of one image ends and the next begins. When making panoramas to be stitched in Adobe Photoshop's Automated Photomerge, you must overlap the frame content approximately $\frac{1}{3}$ of the way, so that the program has enough redundant pixel information to create the panorama with ease. When making panoramas to be printed in close proximity to one another, consider how much content you want to overlap; if there is too much overlap then the image will not be read as a continuous scene. Remember that camera viewfinders provide different percentages of viewable area (very few viewfinders provide an exact 100% view); if your camera does not have a 100% or fill-frame viewfinder, you will have some slight overlap because of the edge included that you can't see.

3. Keep your exposure the same throughout the images, unless there is a good reason not to. If you make several exposures over a wide or tall field of view, the quantity of light in the scene and the reflectance value of the content might change dramatically. If you want the image density to stay the same throughout the panorama, take an average meter reading and keep your exposure consistent; some images will be lighter or darker than others, but the densities will be relative to one another and will produce a more visually coherent result.

4. Keep your focus point where you want it. If you want to create a seamless panorama, keep your focus point at the same distance by turning off any auto-focus capability that the camera has. If you want to use selective focus as part of the image, you can re-focus to different distances throughout the process, and you can mimic shallow depth of field to isolate your primary subject by capturing the surrounding frames intentionally out of focus.

CHAPTER 2

Plastic Lens Effect and Diffusion

TECHNIQUE No. 1: PLASTIC LENS EFFECT

This Plastic Lens Effect Tutorial is easily modified for producing a range of plastic camera effects in Adobe Photoshop; I developed it through research and a good amount of trial and error. You can begin with the step-by-step,

Comparison between original capture and plastic camera effect applied in Photoshop.

and develop more individualized techniques based upon your needs.

The effect of plastic cameras varies, but two of the more telltale signs are slight softness, and intensified color and contrast, in particular near the vignetted edges of the image.

Step 1. Open your image in Adobe Photoshop; do any re-touching, curves adjustments, and sharpening to the image.

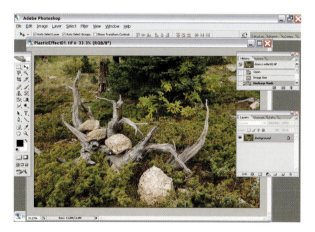

Original capture.

Step 1.

Steps 2 & 3. Create a Brightness/Contrast adjustment layer, and increase contrast by a numerical value of 20–40 points.

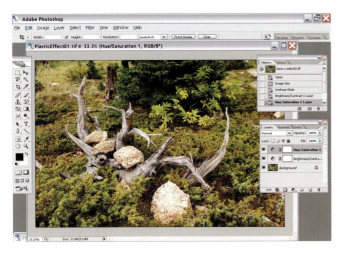

Plastic camera effect supplied.

Steps 2–3.

Note: Using adjustment layers instead of applying the adjustments to the image allows you to go back and re-adjust these tonal changes later in the process.

Step 4. Select your Rectangular Marquee Tool and set the Feathering to 1/10–1/12 of the pixel width of the image. My image is 2400-pixels wide, so divided by 12 means that I set my feathering to 200 pixels. *Note*: You can vary this amount depending on experimentation and your desired results.

Step 5. Select the inverse (so that the image edges are selected rather than the center).

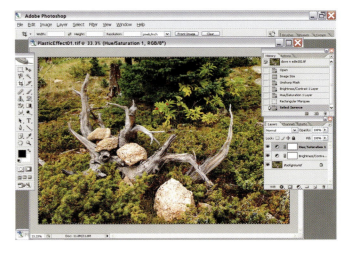

Steps 4–5.

Step 6. Create a New Layer (Layer > New Layer), and fill the selection with black using Edit > Fill. Change the Blend Mode of the new layer to Overlay (for the time being). The edges of the image will appear darkened and somewhat bizarre warm color.

Step 7. Create a Duplicate Layer (Layer > Duplicate Layer). Keep its Blend Mode to Overlay for the time being. The edge effect of the previous layer will intensify.

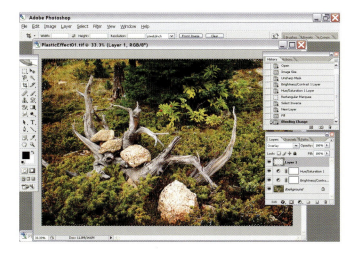

Step 6.

Step 8. Make the Background the active layer, and deselect the canvas edges. Create a new transparent layer (Layer > New Layer). Select the Gradient Tool and set its options to the following specifications: Type, Spherical; Blend Mode, Normal; Opacity, 50%; Preserve Transparency. Drag the Gradient tool from the center of the image outward to create the gradient. Set the layer's Opacity to 40% and the Blend Mode to Soft Light.

Note: Now it is a good time to go back and fine-tune your Adjustment Layers to achieve the color and tonal appearance you want.

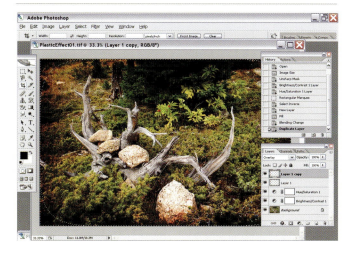

Step 7.

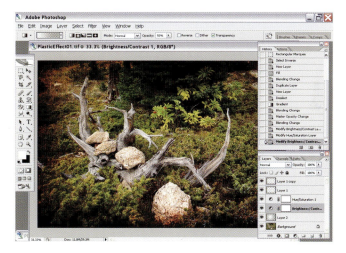

Step 8.

Step 9. Adjust the Opacity of Layer 1 and Layer 1's copy to about 90% and change their Blend Modes to Soft Light. You can mix and match the effects, and alter the opacity to create the desired effect.

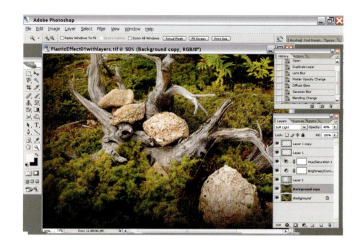

Step 9.

Step 10.

Step 10. Duplicate the Background (image) Layer. Change its opacity to 50%. Add three filters: Filter > Blur > Lens Blur: set the radius to 35 and leave everything else at the defaults. Press OK. Then Filter > Distort > Diffuse Glow: Set the Graininess to 0, Glow Amount to 5, and Clear

Amount to 20. Press OK. Last, Filter > Blur > Gaussian Blur: Set the blur amount to 20. Press OK. Change the Layer Blending Mode to Soft Light.

And that's it! In lieu of shooting film through a plastic camera and scanning it to make digital prints, this method allows you to capture digital images and convert them to a plastic camera look with unparalleled control over the degree of the effect.

Final Image with Plastic Lens Effect.

TECHNIQUE NO. 2: DIFFUSION EFFECTS, BY LINDSAY GENRY

Diffusion filters used on-camera will "bleed" the highlight areas into the shadows, creating a glowing, hazy look around highlight tones. Diffusion filters used in the traditional darkroom will "bleed" shadow areas into the highlights, creating a heavy, though softened look around the shadow tones. In the following tutorial, Lindsay Genry reproduces both techniques in the digital darkroom.

DARKROOM DIFFUSION EFFECT

Step 1. Open the image and duplicate the background layer. Change the copy layer blending mode to Darken or Multiply (setting the blend mode to Multiply will intensify the effect). The image will look strangely dark.

Step 2. Go to Filter > Blur > Gaussian Blur and set the radius to anywhere between 4 and 12. Don't be afraid to go too far, since you will adjust the opacity of the layer later. Click OK.

Step 2.

Step 1.

Step 3. Change the layer opacity to a percentage value that creates the effect you want for the image. You can also alternate the blend mode between darken and multiply while experimenting with opacity to see which method will work best for the image.

Step 3.

This technique mimics the effect of using diffusion materials or filtration in the traditional darkroom, but the opacity slider in Photoshop gives you more control. If you would prefer the opposite effect of the one obtained here, read on …

CAMERA DIFFUSION EFFECT

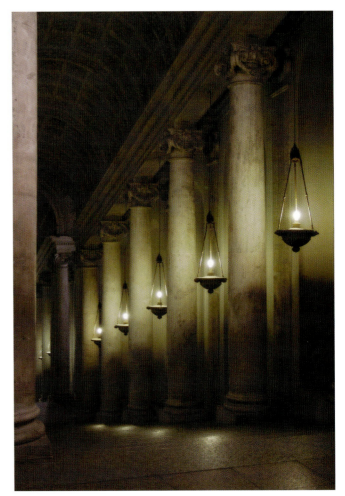

Step 1. Open the image and duplicate the background layer. Change the copy layer blending mode to Lighten or Linear Burn (setting the blend mode to Linear Burn will intensify the effect). The image will look strangely light.

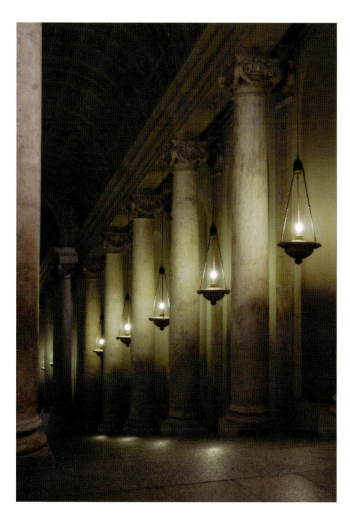

Step 1.

Step 2. Go to Filter > Blur > Gaussian Blur and set the radius to anywhere between 5 and 15. Don't be afraid to go too far, since you will adjust the opacity of the layer later. Click OK.

Step 3.

Step 2.

Step 3. Change the layer opacity to a percentage value that creates the effect you want for the image. You can also alternate the blend mode between darken and multiply while experimenting with opacity to see which method will work best for the image.

Step 4. Final Image.

Enlarger diffusion effect. Original effect. In-camera diffusion effect.

Step 4.

CHAPTER 3

TECHNIQUE NO. 1: DIGITAL LIGHT PAINTING, BY JOE LAVINE

The next image was created using a technique referred to as Digital Light Painting. Before the onslaught of digital technology many film photographers used long exposures and continuous light sources, such as flashlights or a product called a Hosemaster, to literally paint an image with light. This gave the photographer amazing control as to where to direct light.

Unfortunately CCD and CMOS chips in digital cameras generally don't do well with extremely long exposures. There are many variations in the following technique and some of the framework must be credited to Dave Montizambert's 2001 article published in PEI Magazine.

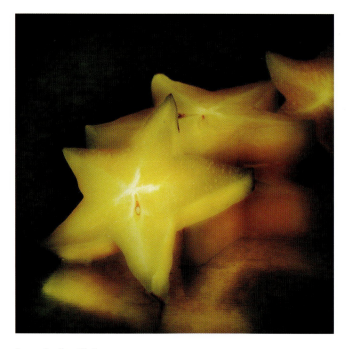

Image 1—Star Fruit.

Step 1. You'll need to begin with two separate images of your subject. One image (Image 2) should be roughly two stops underexposed. I prefer to use a very soft light source such as a soft box directly above the subject. The idea is to just fill in the shadows. The second image (Image 3) gives your subject the underlying direction of light. This image should be overexposed between one and one-and-a-half stops. For Star Fruit image, I used a single strobe head with a silver reflector to the left of the camera. If the images seem to have too much contrast you may need to add a fill card, but you want to keep a strong direction of light. It is important to remember that while shooting you should not move the camera, adjust focus, or change your aperture.

Step 2. Here is where the Photoshop fun begins. Using the move tool drag the brighter of the two images on top of the dark image. If you hold down the Shift key while using the Move tool the images should be perfectly aligned. If the alignment is a little off just lower the opacity of the top layer and carefully re-position so that they are directly on top of each other. This is a perfect time to apply a Layer Mask to the top layer. Since I prefer to paint light in instead of removing it, I recommend using a Hide All Layer Mask. With the top layer highlighted go Layer > Layer Mask > Hide All (Capture 1).

Image 2.

Image 3.

Step 3. Using the Brush or Airbrush tool slowly begin to paint on the Layer Mask using white as your foreground color. This should seem as though you are painting light into your image. You'll want to use a fairly low setting for the brush's opacity and flow settings. I usually begin with less than 25% on each. High-key subjects usually require much lower setting than low-key subjects (Capture 2).

Step 4 (optional). Although I have listed this step as optional it adds a nice color enhancement to your image. You'll need to change the Foreground color to the most pre-dominant color in your image. With the Eyedropper tool click on any part of your image that has the pre-dominant color. Remember to be on the image and not on the mask.

Capture 1.

Capture 2.

Create a new Layer and fill with the new Foreground color. From the menu bar go Edit > Fill > Foreground Color and click OK. A shortcut would be to hold down the Option Key and hit the Delete Key. You'll probably notice that your entire image is now this color. Change the

Blending Mode in the Layer's palette to either Overlay or Soft Light and once again apply a Hide All Mask. Using the same painting skills paint some of the color into your image. I will usually paint the key elements in my image that I really want to pop. See Images 4 and 5.

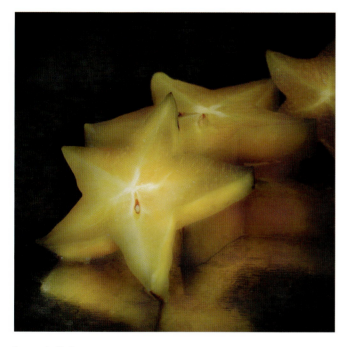

Image 4—Before.

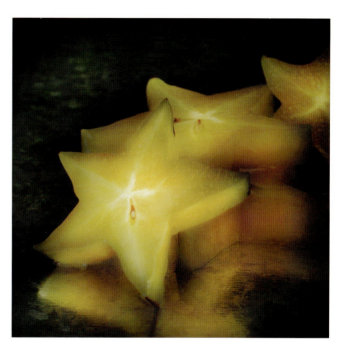

Image 5—After.

One of the key elements that gave traditional light paint-ing such a romantic and painterly feel was the soft glow within an image. When shooting with film photographers usually placed diffusion material in front of the lens while painting in these areas. Some photographers used expen-sive filters while others relied on crumpled up cellophane.

Accomplishing this look in Photoshop is remark-ably simple.

Step 5. At this point you have a couple of options. If you have a limited amount of RAM available I recom-mend saving your file, creating a copy, and begin working from the copy, as you will need to flatten the two layers.

Capture 3.

Capture 4.

Working from the copy ensures you have an unflattened image to return to. If RAM is not an issue then Photoshop gives you a little trick to create a new layer that combines all that are visible. While holding down the Option/Alt key go Layers > Merge Visible (Capture 3).

From this point duplicate the new layer (Layer 3 in the screen captures) and apply a Gaussian Blur. Go a little crazy here; you can always lower the opacity if it is too much. Filter > Blur > Gaussian Blur (radius 25) and click OK. Using the same process in steps 2 and 3 apply a Hide All Layer Mask and paint your desired amount of diffusion back into the image (Capture 4). If you prefer to start with the diffused version then use Reveal All Layer Mask and paint with black instead of white.

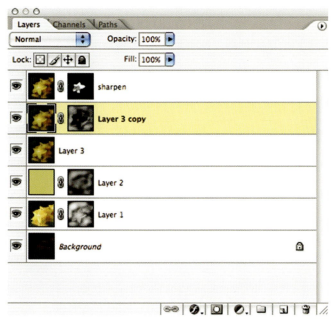

Capture 5—Final Layers Palette.

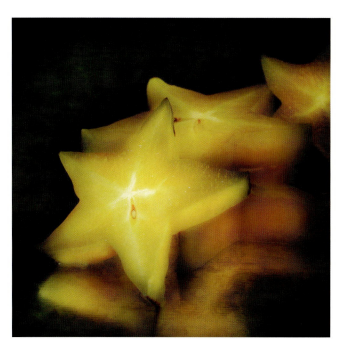

Image 6—Final Image.

Step 6. My final step is designed once again to add a little more pop to the image. So far we have painted in the bright image, a predominant color and a soft blur. The only thing missing is some very carefully placed sharpening. This will add the final touch.

Follow the process in Step 5 and create a new layer that combines all of the previous layers. Using the UnSharp Mask slightly over sharpen the new layer. Filter > Sharpen >

UnSharp Mask. Don't be afraid to over sharpen as you can always use the Opacity slider for a reduction. Apply a Hide All Mask and paint your sharpness into the image. On the Star Fruit, I painted the highlights on the front slice.

A few last thoughts: When painting with light, always try to work the brush in one direction; the goal is to follow

the path of the original light source. Don't be in a rush; I always use the brush in very low settings to allow myself to go over the area many times. Think of it as a building process. If you make a mistake, you can always paint back over the mask with black to remove what you have done. And finally, have fun with it.

CHAPTER 4

Technique No. 1: Grainy Effect, by Jennifer Hardman

For this picture, my goal was to emulate pictures made by Alfred Stieglitz of Georgia O'Keefe's hands.

In capture, start with a high ISO so that you can increase noise in the file. Bracket your exposures, but you will want to use one that is significantly underexposed (this will also increase noise).

Step 1. Open the image in Photoshop.

Step 2. Add noise to the image by going to Filter > Noise > Add noise. For "Distribution" choose Gaussian. (This image works best with Gaussian distribution, but experiment with uniform distribution to see what works for your image.)

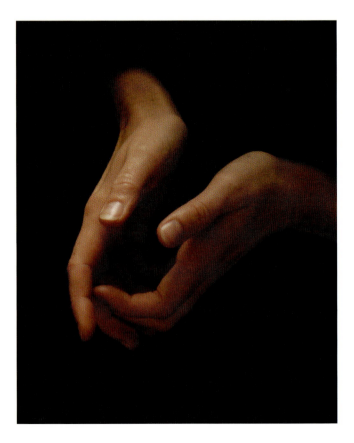

Step 1.

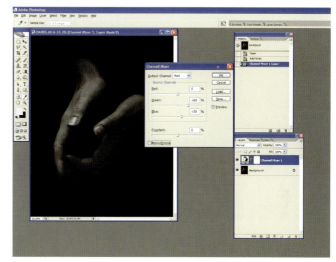

Step 3.

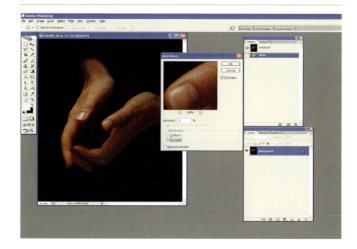

Step 2.

Step 3. Go to Image > Adjust > Channel Mixer (or better yet, make a Channel Mixer Adjustment layer). CHECK the Monochrome Check Box. Convert the image to a tonal range you like; the proportions of RGB are up to you; for this image I added green because of how it affected the skin tone. An advantage of an adjustment layer is that you can go back to it and change it later in the process.

After converting the image to monochrome, UNCHECK the Monochrome box before closing the Channel Mixer.

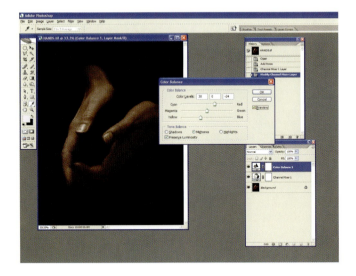

Step 4.

Step 5.

Step 4. Go to Image > Adjust > Color Balance (or better yet, make a color balance adjustment layer). Now you're going to make the image a "sepia tone." Every image requires different numbers, but I start with +25 Red in the red/cyan channel and −15 Blue in the blue/yellow channel and adjust as necessary from there. For this image, I settled on +30 Red and −24 Yellow.

Step 5. Open a Curves Adjustment layer. Adjust the curve for the mood you want to achieve. For this picture, I don't want the highlights bright, but I do want more detail in the mid-tones. I placed an anchor mark at the 1/3 highlight

and another toward the shadow end of the curve. I brought up the middle section of the curve to add detail in the mid-tones without affecting the highlights and shadows.

Step 6. Make another copy of the background. In Stieglitz's photographs of O'Keefe's hands, the wrinkles and folds of her hands are burned in. To give this image that same look I burned *very* lightly with the burn tool, and added more little by little. Burn or dodge any details that you wish, and add a vignette to the edges of the image as well.

Step 6.

Step 7. The final step is to use Unsharp Mask to sharpen the image.

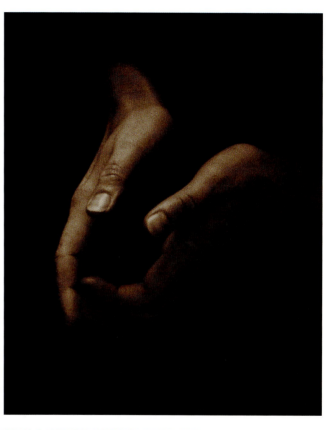

IMAGE © JENNIFER HARDMAN, *HANDS*, 2007.

Step 7.

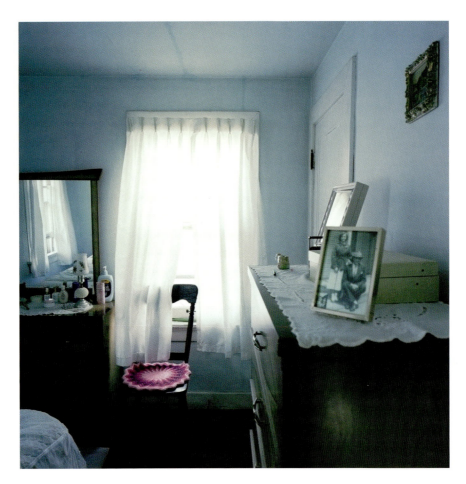

PHOTOGRAPH© ANGELA FARIS BELT, FROM THE SERIES MY GRANDMOTHER'S HOUSE, 2007. CHROMOGENIC PRINTS SIZED 4″ × 4″.

Works Cited

PREFACE AND INTRODUCTION

Jay, Bill. *Occam's Razor*. Nazraili Press, Tucson, Arizona, 1992.

Peter Stephen (Ed.). *Icons of Photography: The 20th Century*. Prestel Verlag, Munich, London, NY, 1999, p. 7.

Price, Mary. *The Photograph: A Strange, Confined Space*. Stanford University Press, Stanford, CA, 1994.

Shore, Stephen. *The Nature of Photographs*. Johns Hopkins University Press, 1998.

Webster's Third New International Dictionary, Unabridged, 1993.

CHAPTER 1

Barrett, Terry. *Criticizing Photographs: An Introduction to Understanding Images*. Mayfield Publishing, 1990.

Dillard, Annie. *A Pilgrim at Tinker Creek*. Harper Perennial, New York, 1974.

Hurn, David and Jay, Bill. *On Being a Photographer: A Practical Guide*. Lenswork Publishing, 1997.

Ocvirk, Otto G., et al. *Art Fundamentals: Theory & Practice*, 9th Ed. McGraw-Hill Higher Education, New York, 2002.

Price, Mary. *The Photograph: A Strange, Confined Space*. Stanford University Press, Stanford, CA, 1994.

Shore, Stephen. *The Nature of Photographs*. Johns Hopkins University Press, 1998.

CHAPTER 2

Barth, Uta. Quoted from Albright-Know Gallery Acquisitions web page, article by Jennifer Bayles, Educator for special projects, www.albrightknox.org/acquisitions/acq_2001/Barth.html.

Berger, John, *Another Way of Telling; Appearances*. Pantheon Books, New York, 1982, p. 114.

Rosenblum, Naomi. *A World History of Photography*. Abbeville Press, 1984, p. 23.

CHAPTER 3

Davidson, Michael W. *Molecular Expressions*: *Images from the Microscope Publications*. http://micro.magnet.fsu.edu/publications/pages/microscope.html. National High Magnetic Field Laboratory, Florida State University Research Foundation.

Freeman, Martin. *Vanishing Presence*. Walker Art Center, 1989.

Newhall, Beaumont. *The Instant Vision of Henri Cartier-Bresson*. Camera, October, 1955, p. 485; Quoted from Nomi Rosenblum, *A World History of Photography*, p. 483.

Rosenblum, Naomi. *A World History of Photography*. Abbeville Press, 1984, p. 483.

Shore, Stephen. *The Nature of Photographs*. Johns Hopkins University Press, 1998, p. 35.

Szarkowski, John. *The Photographer's Eye*. The Museum of Modern Art, 1966.

Rosenblum, Naomi. *A World History of Photography*, p. 483. Abbeville Press, 1984. *The Instant Vision of Henri Cartier-Bresson*. Camera, October, 1955. p. 485. Quoted from Naomi Rosenblum, *A World History of Photography*, p. 483.

Weinberg, Adam D. *Vanishing Presence*, Walker Art Center, 1998, p. 62.

CHAPTER 4

Heineken, Robert, quoted in *Afterimage, The Gelatin Silver Print in the Digital Age* by Thomas McGovern, November 1, 2006. Visual Studies Workshop, Rochester, New York.

Stewart, Susan. *On Longing: Narratives on the Miniature, the Gigantic, the Souvenir, the Collection*. Duke University Press, Durham and London, 1993.

In the Introduction to this text I recommend choosing a topic to research and photograph. There are many ways of working in photography, and the following terms should help to inspire and clarify some of them.

THREE MODES OF WORKING

1. *Series*: A grouping of images which stand alone but, when viewed as a group add dimension to the statement made by any single image.

2. *Sequence*: A grouping of images which must be viewed as a group in order to understand the statement being made. Nicholas Nixon's *The Brown Sisters* is an amazing example of a sequence whose structure stretches over decades.

3. *Narrative*: A sequence which tells a story. Like most stories, photographic sequences have a beginning, middle, and end. Artist Duane Michals is famous for his narrative sequences, perhaps most notably *Things are Queer*.

FIVE TYPES OF IMAGES

1. *Mixed Media*: Any artwork in which more than one medium is used. Mixed media works tend to include media which are traditionally viewed as discrete; for example, an image that combines a photograph, ink, and objects embedded in gesso.

2. *Multimedia*: A type of mixed media art that combines visual and non-visual elements (such as recorded sound, moving lights, etc.) or incorporates elements of the other arts (such as text or performance).

3. *Collage*: An image that combines various media in a single artwork.

4. *Montage*: An image that combines several images created using the same media into a single artwork.

5. *Constructed Photography/Tableau/Diarama*: These indicate that the scene was created for the camera.

INSTALLATION

- A work of art that is created for and tied to a specific environment.

- A series or sequence of images, mixed media, multimedia, or collage works installed in a gallery or other setting for the purpose of viewing.

APPENDIX B: METERING AND EXPOSURE

In order to make successful photographs practitioners must first understand the basics of exposure. "Why," you can ask, "when all of the newer cameras figure out exposure for me?" The answer is simple: these technical aspects of exposure have a tremendous effect on the way the final image will look, and to use your camera in its automatic settings relinquishes creative control to the computer tethered to the meter. The information in this appendix is straight forward and easy to learn, and learning it will make the images produced through your photographic practice much more successful and rewarding. This is the basic foundation for exposure and camera controls.

WHAT IS EXPOSURE?

Photography literally means "Light Writing." With it we transcribe an image onto light-sensitive media through the action of light. Simply put, *Exposure* refers to both the amount of light projected onto the light-sensitive media, and the resulting *Density* (the overall lightness or darkness) of the image. There are four factors which work together to determine exposure. These technical factors seem a bit difficult to master at first, but after a little study and practice they become second nature, and they become your ally.

Four Determinants of Exposure

1. Amount of light in the scene (ambient light or flash/strobe light)

2. ISO (the sensitivity to light of the media)

3. Aperture (controls the intensity or quantity of light)

4. Shutter Speed (controls the time or duration of exposure to light)

THE AMOUNT OF LIGHT IN THE SCENE

The amount of light in the scene is the first and foremost determinant of exposure; unfortunately in many instances you have little to no control over it. By using flash, strobe, or other artificial lighting equipment you may completely control the light striking your photographic media (film or digital sensor), but outdoors under natural lighting conditions, you have

to base exposure on the available or ambient light. The most straightforward way to learn to control exposure is to practice in various *available light* situations, and learn artificial lighting techniques later, as their principles build upon these.

Available light just is. Your camera's *reflected-light meter*, or a hand-held *incident-light meter*, will help you determine the amount of light in the scene.

ISO (AKA: FILM SPEED OR SENSOR SPEED)

This is the first and most basic determinant of exposure which you can control in-camera. As you already know, photographs are made by using materials that are *sensitive to light*. When dealing with most digital sensors and films, the ISO is the standard means of identifying its *degree of sensitivity to light*. When using digital photography you may change the ISO at will, depending on your light requirements; when using film you must choose the ISO that corresponds to the roll of film you are shooting (or your camera may read the DX code imprinted on the film cassette) and stick with that setting for the entire roll of film. It may be important to note that digital media sensitivity does not actually increase with the use of faster ISOs; the electrical signal produced by exposure to light is merely amplified so that the image may be recorded faster.

From the *ISO chart* you see that the slower the light-gathering abilities of the media (film or sensor), the more exposure to light it will require in order to adequately record the *latent image*. The primary advantage to slow ISOs such as 50 or 100 is greater image detail and clarity; however, it is difficult to impossible to render a moving subject with a slow ISO because it will blur due to the need for a longer shutter speed. Slow ISOs are good for still life, studio photography, and tripod work.

A medium ISO speed, such as 200 or 400 is a sort of middle of the road, best of both worlds' speed. It offers a relatively fine grain structure that, when enlarged, still retains good image clarity. The second advantage to using medium speed media is that it is fast enough that there is no need for a flash in most lighting situations, and that most movement can be frozen or the degree of blur controlled through the aperture/shutter combinations.

6	12	*25*	50	100	200	400	800	1600	3200
8	16	32	64	*125*	250	500	1000	2000	4000
10	20	40	80	160	320	640	*1250*	2500	5000

If you were going to memorize the ISO chart, I recommend memorizing the entire chart in ⅓rd of stops. *At the least, know the following: 50, 100, 200, 400, 800, 1600, 3200*

The common ISO speeds and their attributes are as follows:

ISO	Exposure requirements	Visual qualities
50 ISO	Very slow film or sensor; Good for slow or still life subjects Requires longer shutter speeds and wider apertures	Digital: very little noise Excellent fine detail Film: very fine grain Excellent fine detail
100 ISO	Slow film or sensor 2× faster than 50 ISO ½ the speed of 200	Fine grain/Low noise Very fine detail
200 ISO	Medium–slow film or sensor Requires half the light of 100 ISO Requires 2× the light of 400 ISO	Medium-fine grain/Low noise Good degree of fine detail
400 ISO	Medium–fast film or sensor Good for general purpose and moving subjects Requires 2× more light than 800 ISO	Medium grain/Acceptable noise Less fine detail
800 ISO	Fast film or sensor Good for stop motion and fast moving subjects 2× faster than 400 ISO	Large grain/Some apparent noise Low fine detail
1600 ISO	Very fast film or sensor 4× faster than 400 ISO	Very large, coarse grain/ Clearly visible noise/ Poor degree of fine detail

as these are the most common and they have the same 1-stop difference relationship as the aperture and shutter speed charts.

APERTURES, f-STOPS, LENS OPENINGS

The aperture, or f-stop, literally refers to the size of the opening through which light enters the camera. This mechanism, normally located within the camera lens, *controls the amount or quantity of light* that will strike the film or sensor for a given time, when you release the shutter mechanism. Without getting into the intricacies of how the aperture numbers operate, there is a simple way of remembering their interrelationship. *Each whole aperture number lets in exactly ½ or 2 times the amount of light allowed by the number directly before or after it.*

The whole aperture numbers are:

f1	1.4	2	2.8	4	5.6	8
11	16	22	32	45	64	90

Opening the aperture increases exposure	Closing the aperture decreases exposure
Provides more shallow depth of field	Provides greater depth of field
Requires a shorter/faster shutter speed	Requires a longer/slower shutter speed

Not all of the whole f-stops are available on all camera lenses (some lenses may offer f4–f22 only), and on most cameras you can set the aperture in-between full stops as well. For our purposes, we need to remember that the relationship between the whole f-stops is always the same. For example, f2.8 lets in half as much light as f2 and two times as much light as f4; f8 lets in only ¼th the amount of light than f4 and four times more than f16; f16 lets in two times more light than f22 and half as much as f11. Knowing these relationships makes exposure calculation much simpler.

There is also a visual aspect to apertures that you should learn, that is, *depth of field*. Depth of field refers to how much of your image from foreground to background will be in focus.

We will cover depth of field more in depth in Chapter 2, but you should keep the basic visual effect of this exposure factor in mind as it applies to aperture. Avoiding the intricacies of technical explanations here, you should just know that three things determine depth of field:

1. The focal length lens. The longer (more telephoto) the focal length, the lesser the depth of field, and the shorter (wider) the focal length the greater the depth of field (assuming the remaining two factors stay the same).

2. The focusing distance size. The closer the focus distance, the lesser the depth of field; conversely, the further the focus distance, the greater the depth of field (assuming the other two factors stay the same).

3. The aperture. The larger the lens opening (i.e., a smaller number like f2), the lesser (or more shallow) the depth of field; the smaller the lens opening (i.e., a larger number like f16), the greater (or more broad) the depth of field.

SHUTTER SPEEDS

The third determinate of exposure which you control in the camera is the shutter speed, that is, *the length of time or duration of the exposure the media receives to light*. When you depress the shutter release mechanism, a curtain within the camera opens, leaving nothing between the open lens aperture and the media (sensor or film) but light. The shutter speed determines how long the media receives light of a given quantity (which is determined by the aperture). The relationship which exists between the whole shutter speeds is strikingly similar to the relationship between whole f-stops, and this comes in quite handy when trying to determine proper exposure.

The whole shutter speeds are:

4' 2' 1' ½ ¼ 8 15 30 60 125
250 500 1000 2000 4000 8000

Slower shutter speeds let in more light	Faster shutter speeds let in less light
Slower shutter speeds = longer time	Faster shutter speeds = shorter time
Slower shutter speeds increase exposure	Faster shutter speeds decrease exposure
Begins to blur motion	Begins to freeze motion

On most shutter indicators, the number "2" refers to one-half of a second, the number "30," one-thirtieth of a second, the number "1000," one one-thousandth of a second, and so on. In photographic terms, 1/30th is considered a slow shutter speed (too slow to avoid a blurry photograph unless you're really steady or have a tripod). Average shutter speeds range from 1/60th to 1/500th, depending on the lighting situation, and anything above that, say 1/1000th, is considered a fast shutter speed. Because the shutter speed determines how much time that light is allowed to strike the media, *slower shutter speeds add exposure while faster shutter speeds reduce exposure.*

How to Hand-Hold Your Camera (No Tripod) Without Fear of Camera Shake

Camera shake is a blurry picture resulting from using too slow a shutter speed while hand-holding the camera. The basic rule to avoid camera shake is: *Use a shutter speed that is the numerical equivalent or faster in relation to the focal length of the lens you are using, and never go slower than 1/60.* Always err on the side of too fast if you don't want blurry pictures. For example, if you are using a 100-mm lens, you should use a shutter speed of at least 1/125th. When shooting with a 200-mm lens, you should use a shutter speed of at least 1/250th. When using a focal length of 50 mm or shorter (say, 16 mm) you still must use a shutter speed of at least 1/60th because this rule is for preventing blur due to the camera movement itself while hand-holding (not the movement of the subject—that's another calculation). If you use a tripod with a cable release or the on-board timer, you can use just about as slow a shutter speed as necessary (as long as the subject isn't moving).

An aside: There are two basic types of shutter mechanisms: a *leaf shutter* and a *focal-plane* (or curtain) shutter. The leaf shutter mechanism is located within the camera's lens (usually in medium and large format cameras) and the focal-plane (curtain) shutter is located just behind the lens in front of the film or sensor plane. Focal-plane shutters are most commonly seen in SLR cameras. The two kinds of shutters have several different attributes that are most significant when using flash or strobe; we won't get into those attributes here.

PUTTING IT ALL TOGETHER

Exposure determines the overall density of the image. There are essentially three ways to expose photographic media:

1. Normal exposure (N) contains all tones with proper density and detail.

2. Overexposure (+) will make the entire image lighter because the media received too much light.

3. Underexposure (−) will make the entire image darker because the media received too little light.

Because of the similar relationship between shutter speeds and apertures, any number of *Equivalent exposures* may exist for a single scene.

The Law of Reciprocity: Exposure = Intensity × Time

$$\text{Exposure} = \text{aperture} \times \text{shutter speed}$$

What this means is, if an exposure of f/8 at 1/125 is correct, then an exposure of f/4 at 1/500 will also be correct, as will an exposure of f/32 at 1/8. There are reasons to choose

one exposure combination over others, and experience will help. In the mean time, consider the following example: You are shooting digital media. You are shooting a waterfall scene, and your meter indicates an exposure of

400 ISO	F/5.6	1/125	…but you want to blur the water, you could use:
400 ISO	F/22	1/8	…if you want to blur it more, you could use:
100ISO	F/22	1/2	…and then after all you decide to freeze the water:
400ISO	F/2	1/1000	…any of the above combinations will provide the same exposure but different visual effects

UNDERSTANDING YOUR LIGHT METER

If you are working only with in-camera meters, you should understand how they work. In-camera TTL (through-the-lens) meters are a type of reflected-light meter; they read scene luminance, or how much light is reflected off the surface of the subject. Your camera's light meter is a tool, a guide to help you determine what the proper exposure will be for a particular scene under a particular quantity of light. In order for the light meter to perform its function properly it first needs one bit of vital information: the ISO or sensitivity setting. With this information, the light meter "reads" the amount of light reflected from within its field of view, and determines how much of that light it will take to sufficiently expose the media, based on the ISO.

When interpreting your light meter, know that it has one characteristic you can always count on:

Your light meter averages any light that it reads to middle (18%) gray. It does not matter if the subject you are metering is an average scene (a mix of tones from white to black), a high-key scene (a predominantly light-toned scene, for instance, a white dog in a snow drift), or a low-key scene (a predominantly dark-toned scene, say, a black cat on a dark stone path)—your meter will average the light reflected from within its field of view and give you an exposure indication which will render the scene a nice middle gray. When a scene contains tones that "fool" your reflective meter, the result is called *subject failure*; that is, the reflectance value of the subject fails to produce a middle-gray reading and the density of the resulting image is wrong. Of course, you do not always want the scenes you shoot to look gray (i.e., you want the white dog in the snow

drift to look white, not gray; and the black cat on the stone path you want to be predominantly dark to black scene, also not gray). Think in terms of tones, not colors; colors are rendered as tones to your meter depending only on how much light they reflect (green grass is a very nice middle-gray tone). Since your meter does this averaging for you, there are only a couple general rules you need to follow in order to make your photographs render the tones you want.

ADVANCED EXPLANATION OF EXPOSURE

Your reflected-light meter is reading light reflected by objects in shades of gray; this combined with the relationship between how much light various tones reflect, and the way f-stops and shutter speeds interrelate, is very convenient. Not only does a 1-stop change in either direction with the aperture or shutter speed double or cut in half the exposure, but there are 5 whole stops between white and black tones based on the fact that each consecutive tone reflects double or half the amount of light of its tonal neighbor.

Tone	**Reflectance value** (how much light a certain tone reflects)
White (with detail)	90%
Dark white	45%
Light gray	22%
Middle gray	**18%**
Dark gray	11%
Light black	6%
Black (with detail)	3%

This tonal relationship makes it very convenient to shoot an accurate exposure under high-key and low-key conditions, and to correct exposures that are wrong. Essentially, white tone with detail reflects about 2½ stops more light than middle gray, and black tone with detail reflects about 2½ stops less light than middle gray. This means, when you are shooting an average scene, you will usually go with what your meter indicates. When you are shooting a high-key scene you'll usually want to add exposure (about +2 stops) to what the meter indicated so that you will render bright tones as bright. When you are shooting a low-key scene you'll usually want to subtract exposure (about −2 stops) from what the meter indicated so that you will render dark tones as dark. Remember, your meter makes exposure recommendations that will render any scene as middle gray.

A Note About Advanced Metering Systems

Many contemporary metering systems contain thousands of digital tonal configurations; these systems compare (in about a millisecond) the scene you are currently metering

with these digital files in order to provide a much more accurate meter reading than traditional analog meters. In order to guarantee proper exposure you will have to practice using your meter under various tonal and lighting conditions, and determine how your meter responds. For instance, I have a camera meter which is accurate to within 1 stop of the correct reading under most high-key and low-key conditions, so if I add or subtract the usual 2–2½ stops I will have gone too far.

A Note About Judging Exposure with Digital Cameras

Never, never, never, ever … never ever … NEVER trust your LCD monitor. Always refer to your histogram to evaluate exposure!

Bracket to Insure Proper Exposure

To insure that you record an accurate exposure, bracketing should be in order. Bracketing is making several different exposures of the same scene. To bracket, you will usually make an exposure at the meter reading, then make a second exposure at ½ to 1 stop above the reflected meter reading (the image will be lighter), and a third exposure at ½ to 1 stop below the reflected-meter reading (the image will be darker). When in doubt, BRACKET your exposure!

THREE-SCENE TONAL-RANGE EXERCISES

You might practice metering and exposing using these exercises in order to help you to get a handle on your camera's technical operations and exposure.

Scene No. 1: Average Scene

As exposure decreases the image density becomes darker; as exposure increases the image density becomes lighter.

You are looking at an "average" scene, one in which there are tones varying from white to black and there is an average amount of light and shadow falling throughout. Your camera meter indicates that an exposure of f/5.6 at 1/60 is correct. You could shoot at this setting; however, you want more depth of field (i.e., you want more in focus from near to far within the scene). You simply move the aperture to a setting that will allow you to have more depth of field, say, f11. But now your meter indicates that if you shoot at this setting you will be underexposing the film by 2 stops. The remedy is to change your shutter speed to compensate for the change in aperture, so the shutter speed for f11 is 1/15. The exposure to the media is exactly the same; the only difference is the configuration: you are allowing 3 stops less light in through the aperture and balancing that with

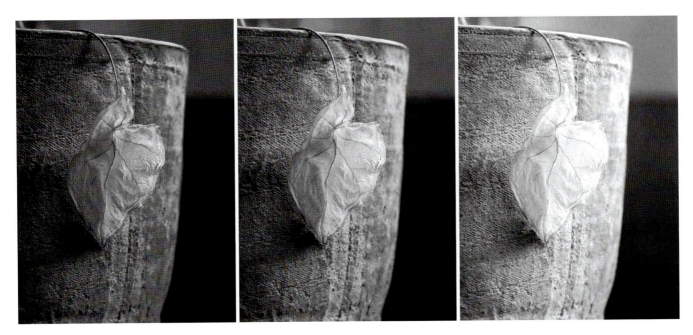

Average scene −1 stop underexposed
f/5.6 @ 1/125

Average scene related Meter reading exposure
f/5.6 @ 1/60

Average scene +1 stop overexposed
f/5.6 @ 1/30

IMAGE © ANGELA FARIS BELT.

Average scene images with bracketed exposures −1 stop underexposed, normal exposure, and +1 stop overexposed. As the exposure decreases the image density becomes darker; as the exposure increases the image density becomes lighter.

3 stops more light via a longer shutter speed. The following are examples of over- and underexposure only.

Scene No. 2: High-Key Scene

A high-key scene is one which is predominantly light in tone. For scenes such as these, you might need to overexpose; that is, add more light than the meter reading indicates so the scene looks light.

You are looking at a beautiful tree emerging from a snow drift. It is a bright day and the whole scene is white. Your camera meter indicates that one possible exposure is f/11

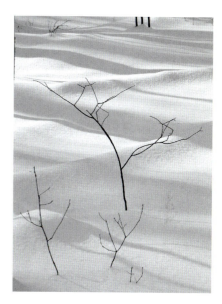

High-key scene exposed at the reflective meter reading is about 2 stops underexposed
Meter reading: f/11 @ 1/500

High-key scene exposed at 1 stop over the reflective meter reading
+1 Stop f/11 @ 1/250

High-key scene exposed at 2 stops over the reflective meter reading looks best (depending on the media and the meter used)
+2 Stops f/11 @ 1/125

High-key scene with an initial exposure at the reflected-meter reading, then bracketed at +1 stop overexposed, and a second at +2 stops overexposed. A high-key scene is one which is predominantly light in tone. For scenes such as these, you might need to overexpose; that is, add more light than the meter reading indicates so that your image has bright white tones and doesn't look too gray.

at 1/500. If you made the photograph at this setting, how would the image appear? There would be a gray tree in a gray landscape that would resemble snow if only it would have been white. That's no good. In order to remedy the situation, you would need to overexpose; that is, allow more light to get to the media (sensor or film), thereby rendering the white scene as white (remember your meter thinks it's gray, so you have to interpret and override it). Depending

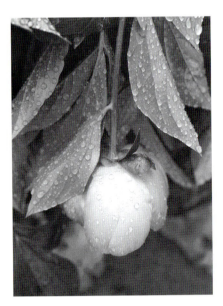

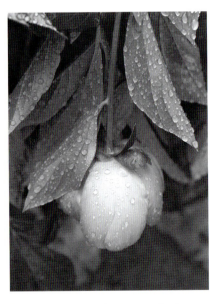

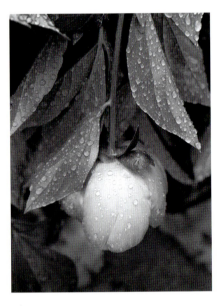

Low-key scene exposed at the reflective meter reading is about 2 stops overexposed
Meter Reading: f/8 @ 1/60

Low-key scene exposed at 1 stop under the reflective meter reading
−1 Stop f/8 @ 1/125

Low-key scene exposed at 2 stops under the reflective meter reading looks best (depending on the meter and media used)
−2 Stops f/8 @ 1/250

IMAGE © ANGELA FARIS BELT.

Low-key scene with an initial exposure made at the reflected-meter reading, then bracketed at −1 stop underexposed, and then −2 stops underexposed. A low-key scene is one which is predominantly dark in tone. For scenes such as these, you might need to underexpose; that is, provide less light than the meter reading indicates so that your image has rich black tones and doesn't look washed out.

on the media, overexposing by 1½–2½ stops is sufficient. In order to do this you could either open to a larger aperture such as f/5.6 or f/4½, or you could slow to a longer shutter speed such as 1/125 or 1/90. Either decision would be fine.

Scene No. 3: Low-Key Scene

A low-key scene is one which is predominantly dark in tone. For scenes such as these, you might need to underexpose; that is, provide less light than the meter reading indicates so that the scene looks dark.

You are looking at rain drops on a pink peonie flower in deep foliage. It is a dark scene, but you can make out all the details in the dark shadows. Your camera meter indicates that an exposure of f-8 at 1/60 would be fine. If you made the exposure at that setting how would the scene appear? The pink flower would be washed out and the dark foliage would be muddy-gray. In order to correct the situation, you would need to underexpose from what your meter indicates, that is, give the media less light so that it renders the dark scene as dark. Again, 1½–2½ stops should be sufficient. So, your correct exposure could be say, f/16 at 1/60 or in this case I would make a final exposure 1½ stops under at f/8 at 1/200.

Understanding proper metering and exposure for your particular photographic materials is essential, prior to attempting to manipulate them for creative or communicative effect. The technical elements of the photographic process—in particular aperture and shutter speed combinations—are the foundation upon which photographic images are made. Practicing metering and exposing (even bracketing) average scenes, high-key and low-key scenes, backlighting, and a variety of other scenes will help you understand how your photographic materials respond to those situations, and will in turn enable you to create images as you conceive them to be.

INDEX